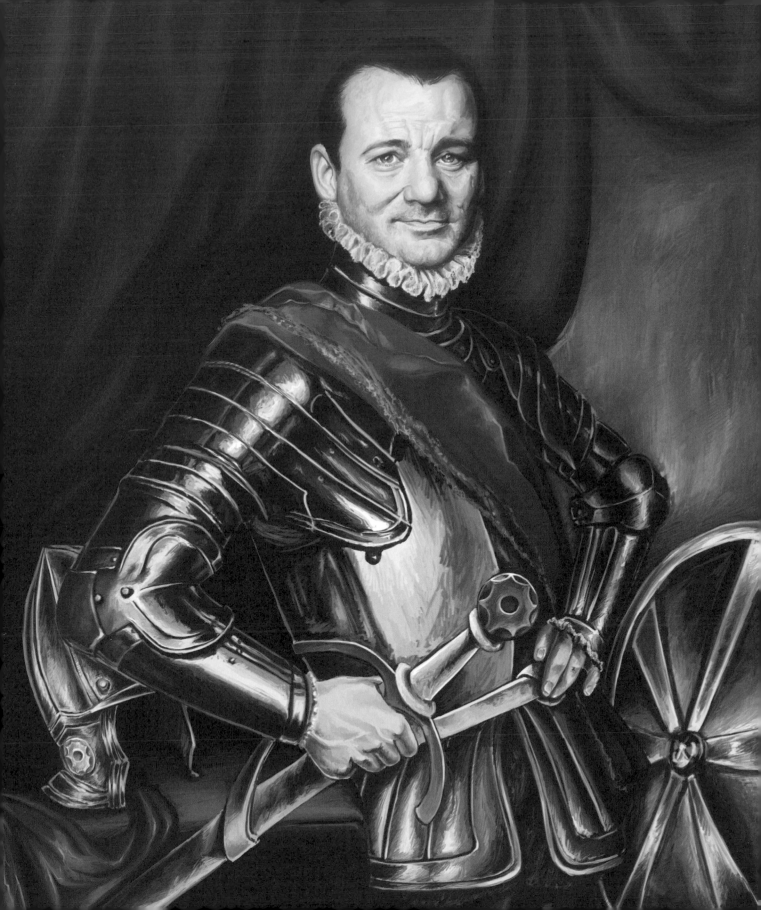

The Art of
BEING BILL
THE MANY FACES OF AWESOME

EZRA CROFT *and* JENNIFER RAISER

Race Point
PUBLISHING

To Julia and all the people who take chances on a long shot. —EC

For Meaux, who spirited me to the land of jesters and dreamers. —JR

.

Brimming with creative inspiration, how-to projects, and useful information to enrich your everyday life, Quarto Knows is a favorite destination for those pursuing their interests and passions. Visit our site and dig deeper with our books into your area of interest: Quarto Creates, Quarto Cooks, Quarto Homes, Quarto Lives, Quarto Drives, Quarto Explores, Quarto Gifts, or Quarto Kids.

First published in 2018 by Race Point Publishing, an imprint of The Quarto Group, 142 West 36th Street, 4th Floor, New York, NY 10018, USA

T (212) 779-4972 **F** (212) 779-6058 **www.QuartoKnows.com**

Race Point Publishing titles are also available at discount for retail, wholesale, promotional, and bulk purchase. For details, contact the Special Sales Manager by email at specialsales@quarto.com or by mail at The Quarto Group, Attn: Special Sales Manager, 401 Second Avenue North, Suite 310, Minneapolis, MN 55401, USA.

10 9 8 7 6 5 4 3 2 1

ISBN: 978-1-63106-455-5

Please see page 170 for artist and photography credits.

Cover illustration: *OG Murray* by Wayne Maguire
Original photograph for cover illustration printed with permission by: Gerhard Kassner / Berlinale.de
Editorial Director: Jeannine Dillon
Managing Editor: Erin Canning
Cover Design: Amy Harte
Interior Design: Renato Stanisic

Printed in China

C**O**NTENTS

· · · · · · · · · · · · · · · ·

FILL-IN-THE-BILL

AN INTRODUCTION (OF SORTS)

by Jennifer Raiser

Hey_____,
<small>TERM OF ENDEARMENT</small>

Thanks for buying this_____book. Or at least standing in the
<small>ADJECTIVE</small>

store, kind of hunched over, getting the pages grubby for the_____
<small>TYPE OF PERSON</small>

who actually buys it. Nobody said it was going to be easy to sell a book

of_____about the world's_____actor. In fact, we
<small>PLURAL NOUN</small> <small>SUPERLATIVE</small>

asked_____of his colleagues and costars to _____about
<small>NUMBER</small> <small>VERB</small>

it, and we got nothing. Zip. Zero. Nobody wanted to pierce the hemp

_____, to caddy the_____bag, as it were. They all wanted to
<small>OBJECT</small> <small>SPORT BAG</small>

stay friends with the coolest_____in town, the Midwestern
<small>DOMESTIC ANIMAL</small>

mensch, the guy who portrays our deepest _____,
<small>EMOTION</small>

insecurities,_____, and then makes fun of them all. All he wants to do
<small>OTHER EMOTION</small>

is play_____, smoke_____, and not take himself too_____.
<small>SPORT</small> <small>PLANT</small> <small>ADVERB</small>

At least that's what we_____based on watching all of his_____films.
<small>VERB</small> <small>ADJECTIVE</small>

We did meet a part-time_____named_____who claimed to
<small>PROFESSION</small> <small>NAME</small>

have known our hero since they did stand-up at the_____Bar
<small>MACHINE</small>

in_____. Since nobody else would talk to us, we decided to let him
<small>CITY</small>

write the introduction, but we had to blank out a lot of his words for privacy:

"We're talking about a_____guy. He's normal enough to be your
<small>ADJECTIVE</small>

crazy_____ (RELATIVE), the one who almost doesn't get invited back for

_____ (HOLIDAY) every year. Even then he had a wild_____ (ADJECTIVE) habit that

everyone loved. He'd mix different_____ (PLURAL NOUN) together, and drink a

_____ (LIQUOR) and_____ (LIQUID) with it. He was dating_____ (CELEBRITY) at the

time, which seemed a little_____ (ADVERB), but they were fine until that

_____ (MAGAZINE) profile. But it was really when he went to_____ (CANCELLED TV SHOW)

that he made it. His skit on_____ (DESPISED HISTORICAL FIGURE) in the_____ (PLACE) was

_____ (ADJECTIVE). And when_____ (FORMER CHILD ACTOR) guest-starred, they couldn't

stop the bromance. But he never forgot the little_____ (PLURAL NOUN).

He'd show up on set wearing_____ (NOUN) from_____ (STORE) and just ad-lib.

He'd riff on_____ (POPULAR TREND) and its role in the_____ (DECADE), and how

he had just come back from_____ (EXOTIC PLACE) where he ate_____ (ANIMAL) and

tried naked_____ (SPORT). And how the locals wore nothing but one

_____ (ARTICLE OF CLOTHING).

I remember his_____ (RELIGION) phase, when he became a philosopher of

_____ (IDEA). He moved into a_____ (SIZE) village and tried_____ (GERUND)

every day. When that didn't work, he'd smoke small amounts of

_____ (PLANT) mixed with the ash of local_____ (GEOLOGICAL FORMATION). Once directors

realized he could_____ (VERB), his_____ (NOUN) really took off. He had

stints as_____ (FICTIONAL CHARACTER) and_____ (ROYAL FIGURE), and was once cast as an

animatronic_____ (EXTINCT ANIMAL). And when he was nominated for an

_____ (FIRST NAME), it really_____ (PAST-TENSE VERB) his resolve.

Bill is the_____ (SUPERLATIVE) actor of the_____ (TIME PERIOD). He is all kinds of_____ (ADJECTIVE) awesome."

SO, BILL MURRAY. WHERE DO I BEGIN?

by Ezra Croft

Let's rewind to Christmas morning, 1985. My younger sisters and I were all under the age of seven. *Ghostbusters* had come out in theaters the year before, and we hadn't gone to see it, much to our disappointment. But a few months earlier, my dad had gotten our family our very first VCR. If you were born after 1995, it might be hard for you to understand movies without Internet streaming, but let me tell you, there was *nothing* like the joy of a VCR in 1985— excitement doesn't begin to describe it. That Christmas, we all woke up around six o'clock in the morning and were opening presents. Eventually, we came across a small rectangular box. Hoping it was a new and exciting VHS tape for our VCR, we tore it open in a frenzy, and sure enough, it was *Ghostbusters*. My sister was so excited, she was waving her arms around like one of those inflatable things you see at car dealerships. I think I screamed. We had all heard of the movie and Bill Murray, and, of course, the famous scene where Slimer slimes Venkman in the hotel. We were in a frenzy, running around in circles and screaming "*GHOSTBUSTERSSSS!*"

I might be what you call a Murray superfan. I've seen every single movie he's made (multiple times), and he's done a lot over the years, from smaller independent films and cameos to blockbuster movies, such as *Ghostbusters*. And nothing has made me happier than his resurgence in Wes Anderson's brilliant films. Actually, one of Bill's most appealing characteristics for me, and what I think makes him so perfectly suited for Anderson's oeuvre, is his subtle sense of humor, his ability to make a joke in any situation, his ability to smile at the most dire moments, his casual approach to life, and his ability to just live in a moment. Every moment. There is an aura that surrounds him, a magnetism. Even when his characters are sad, they can still make us smile.

It's that flawed perfection that I love. He has a story we want to hear. This is backed up by his almost legendary offscreen life, including his mythical appearances in random moments and interactions with unsuspecting citizens. He certainly has fame and fortune from his successful career, which has spanned decades, but it's also those moments in between movies that show us the man up close: his appearances at random events, the parties he crashes, the French fries he eats off strangers' plates. It is that understanding of true humor that makes him so beloved among his fans. A legend of his craft. His personality is his art. The art of being Bill.

Over the past few years, the world of Bill Murray and the world of art have had an interesting intermingling. The idea of Bill Murray has inspired many artists to explore the possibilities of what

our concepts of creative "Murrayism" can be. His subtle Mona Lisa smile has lent inspiration offscreen and on canvas, giving artists fuel to create and refine scenes of Murray magic. I've seen many paintings of Bill over the years, inspired by movies, photo shoots, and real-life events done in every imaginable medium—from Bill Murray cakes (see pages 58 and 111) to Bill Murray seed paintings (see page 69)—all of them creating the real and imaginary moments of a legend.

So, why paint Bill Murray? That's a question for the ages. I think the better question might be, why not paint Bill? He's nuanced. He's versatile. He's familiar. He's also fun. When artists have fun with their subject, they create something interesting. Possibly transformative. I have many paintings of Bill in my house, and each one steals a golden moment from Murray history: *Caddyshack*, *Ghostbusters*, *The Life Aquatic with Steve Zissou*, *Ed Wood* . . . all different, all pure Murray. He is inspiration in human form.

Much of the art of Bill shows him in iconic scenes, but also just doing everyday activities: smiling, yelling, smoking, napping, swimming. Many of the paintings I've seen have been simply titled *Bill* or *Bill Murray*, because that's all you really need.

A few years ago, I had the idea to put together a Bill Murray art show. I started pitching the idea to my artist friends and people I knew who were huge Bill Murray fans. I called it the *Murray Affair*, and it was going to be a carnival of celebration, a circus of creativity around a man who had shaped so many incredible moments in comedy and film. We started spreading the word. In producing the art show, we decided that we needed a mission statement of some kind, just a summary of our goals and intentions for the art show. I decided that our mission statement should be this: "It is our goal to connect artists with their community." I thought with that idea, much like Bill had done throughout his career, bringing people together

for a common goal—art of Murray—would be a noble direction for creators, strangers, artists, and curious passersby to band together and create something magical. They created ART. The show was such a huge success that we did it again, with artists selling thier original works to collectors around the world. That is when we decided to produce this book—for all those people who couldn't attend the shows.

When deciding how to organize all of the incredible artwork submitted for this book by talented artists around the world (see page 170 if you would like to check out the artists and some of the mediums they used to produce their work), we briefly considered doing it chronologically—a natural way to organize it, of course. But something about it didn't feel terribly Murray; instead, we decided to organize it by the many personalities that define Murray, by the colorful range of emotions and the variety of faces we've seen from him over the years: funny, intense, charming, exasperated, thoughtful, melancholy . . . you get it. Co-author Jennifer Raiser has also highlighted many of the key moments in Murray movie history from *Meatballs* in 1979 through today, tracing Murray's development as both a comedian and dramatic actor.

One of my favorite characters of Bill's is Steve Zissou, from *The Life Aquatic with Steve Zissou*, a particularly wonderful Wes Anderson movie. Just like many of Anderson's films, it is a story steeped in emotion and experience. Murray plays a man living with disappointment, loss, anger, lust, love, and hate, who ultimately finds redemption in the unlikeliest of places. He is a man painfully aware of time and his own flaws. Though he, in fact, leads an exceptional life, he is still a normal man defined by his battles and his quest to find purpose.

And to me, that is Murray in a nutshell.

"TRIPPER"

Meatballs

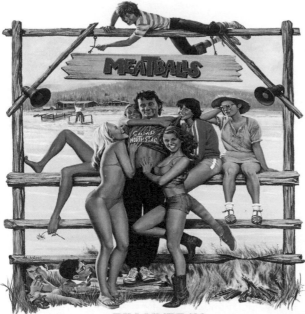

THE SUMMER CAMP THAT MAKES YOU <u>UN</u>TRUSTWORTHY, <u>DIS</u>LOYAL, <u>UN</u>HELPFUL, <u>UN</u>FRIENDLY, <u>DIS</u>COURTEOUS, UNKIND, <u>DIS</u>OBEDIENT, AND VERY <u>HIL</u>ARIOUS.

MEATBALLS

BILL MURRAY in
MEATBALLS

How fitting that Bill Murray's first starring role is set in a summer camp, because this 1979 doozy is high camp indeed. Murray plays chief counselor of a cadre surprised to be responsible for campers; this place would be so much more amusing if they could spend the summer goofing off and making out with one another. As soon as we get off the bus, we meet archetypes: the fat boy, the loner hero, the resistant love interest. There's also a class-warfare rivalry between the scrappy Camp NorthStar and the highbrow Camp Mohawk, whose "squaw" cheerleaders sport foam hatchets and frisky Farrah Fawcett hairdos. Mix in some gushing musical interludes, some uncomfortable romance, and plenty of tube socks and mullets, and mash until mushy. The most humorous aspect is the kitschy earnestness of it all. Murray even wears his own clothes in the film. He's the snarky ad-libber who announces, "Arts and crafts has been canceled due to bad taste," the practical jokester who pulls down pants to subvert authority, the avuncular suave coaching pimply boys to pick up chicks and play poker. First-time director Ivan Reitman, who later directed *Stripes* and *Ghostbusters*, offers us the germination of the proto-Murray character, walking the fine line between charming, crabby, and crass. The *New York Times* review of *Meatballs* back in 1979 confirms this Murray seedling, writing, "The character of Tripper is not funny, but I suspect that Mr. Murray really is." It's a partly painful, partly perfect introduction to the character continually played and mastered by Murray over the years. Like its title, this plate of *Meatballs* is a stomach-settling comfort comedy, smothered in sauce and doused with cheese.

BEHIND THE SCENES
Cowriter and producer Daniel Goldberg admitted he didn't know if Bill Murray was even going to show up to shoot the movie three days before they were scheduled to start!

"HUNTER S. THOMPSON"

Where the Buffalo Roam

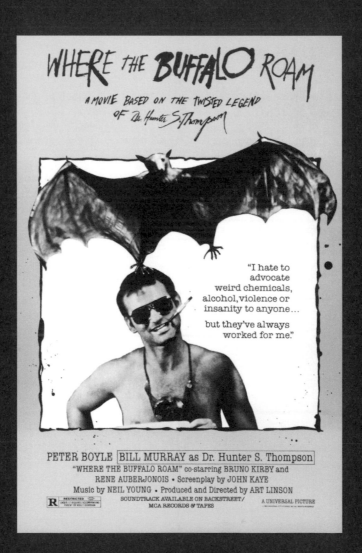

This loosely based biopic of journalist Hunter S. Thompson is as gonzo as its subject. As a spot-on rendition of the drug-and-drink-addled Thompson, Murray mugs and mumbles his way through situations that are sobering, but definitely *not* sober. The rambling narrative centers around the antiestablishment antics of Thompson covering the 1972 Super Bowl and Richard Nixon's presidential race for a *Rolling Stone*–style periodical. Intermittently, Thompson and his attorney pal Lazlo (Peter Boyle), careen through a hospital, a courtroom, and a cartel-controlled grow room on a quest to legitimize and legalize marijuana. It's hard to follow how they literally hash it out, but that's the point. To capture Thompson is to characterize chaos, and Murray succeeds in giving us the frantic nature of this near-extinct beast. The mood is helped along by a reedy Neil Young score. This film may have ended up in the dust bowl, but it gave Murray practice in capturing a character who was lit, large, and supremely in charge. And Thompson, as it turns out, was the kind of person that gets under your skin, as Murray once revealed in an *Entertainment Weekly* interview. "I'd work all day and stay up all night with him; I was strong in those days. I took on another persona and that was tough to shake. I still have Hunter in me."

BEHIND THE SCENES

Bill Murray remained close to Hunter S. Thompson after the film. He visited him in Denver while driving cross-country and writing the script of *The Razor's Edge* with writer and director John Byrum.

"JOHN WINGER"

Stripes

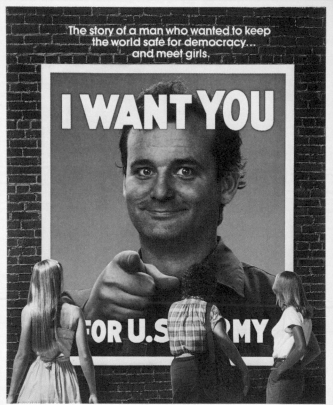

Directed by Ivan Reitman, whom Murray had previously worked with on *Meatballs,* this film holds up well as an early Murray classic. In *Stripes*, Murray plays John Winger, a bumbling, braggadocious loser who manages to grow into the leadership of his motley misfit platoon in the US Army. His nerdy sidekick, Russell Ziskey, is played by Harold Ramis (who coauthored this script, as well as *Meatballs, Ghostbusters, Caddyshack*, and *Groundhog Day*). A classic performance by John Candy as the overweight buffoon works to fine effect, particularly in the epic mud-wrestling scene.

From the ignominy of basic training through the sarcastic sergeant standoff, the slights and salutes of the US Army are treated with ironic affection. Murray's rousing ode to the patriotism of individual expression is his own St. Crispin's Day speech that rallies the riffraff into attention, including the delicious irony that actors Ramis and Candy are both Canadian. Despite the abundance of boob, the two female love interests manage to hold their own as hard-charging military police who keep their lip gloss shiny at all times. Add in an RV that saves democracy, a tangle of Eastern European sharpshooters, a military base where everything blows up but nobody dies, and you've got a formula that still manages to earn its *Stripes*.

BEHIND THE SCENES
The scenes in *Stripes* that were supposed to be happening in Czechoslovakia were actually filmed in Kentucky.

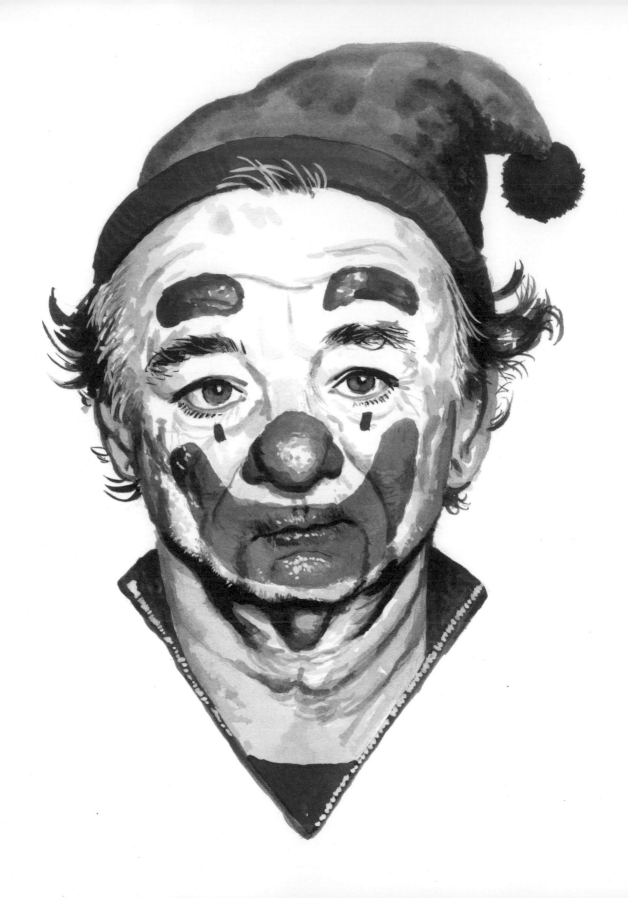

The Jester

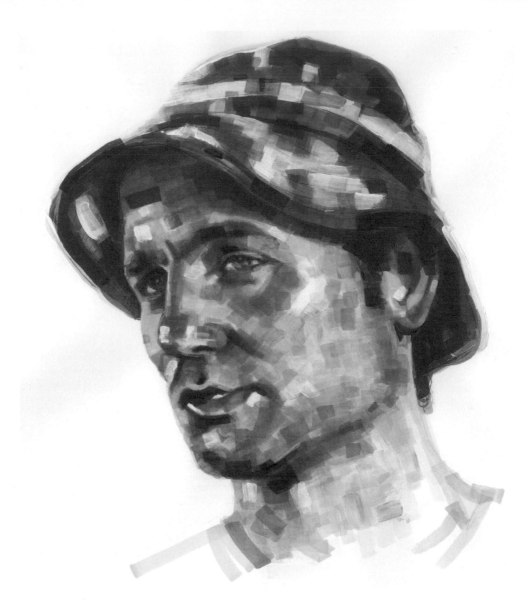

MUR-REALITY:

The opening scene of *Caddyshack* was inspired by a real-life event in the life of Ed Murray (Bill's older brother). Ed worked as a caddie at the Indian Hill Club and won the Evans scholarship from them in 1963, similar to the Danny Noonan character. Ed was an extra in the movie, and made $37 a day.

∧ *A Spit of Bill Murray* by Warren McCabe-Smith

>> *Thanks for the Memories* by Johann Strauss

Previous spread: *Funnyman* by Ken Meyer Jr.

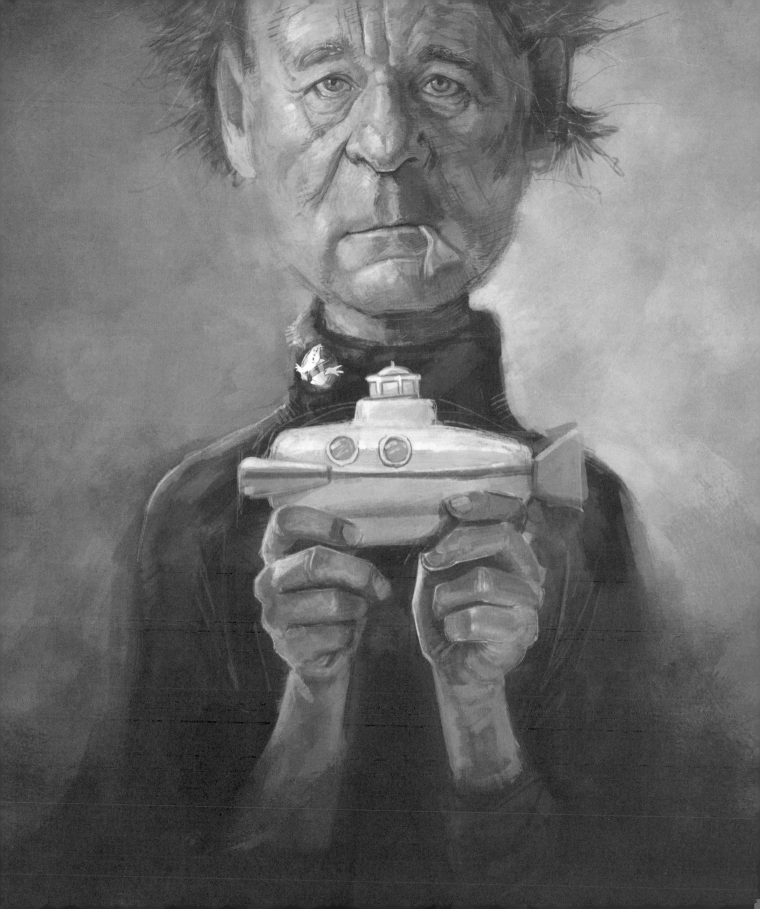

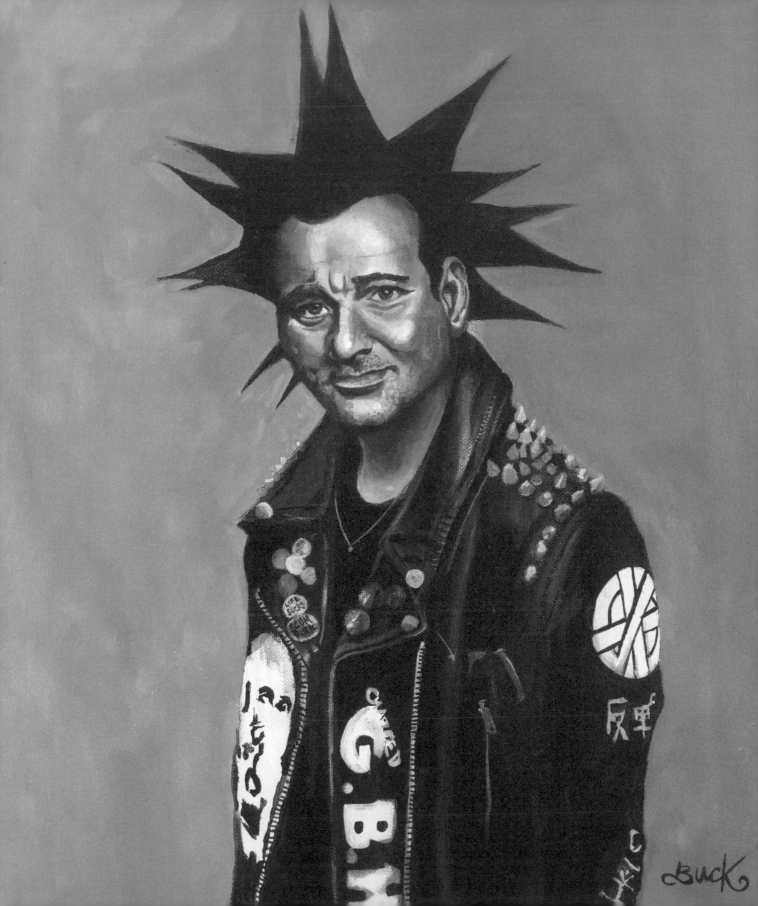

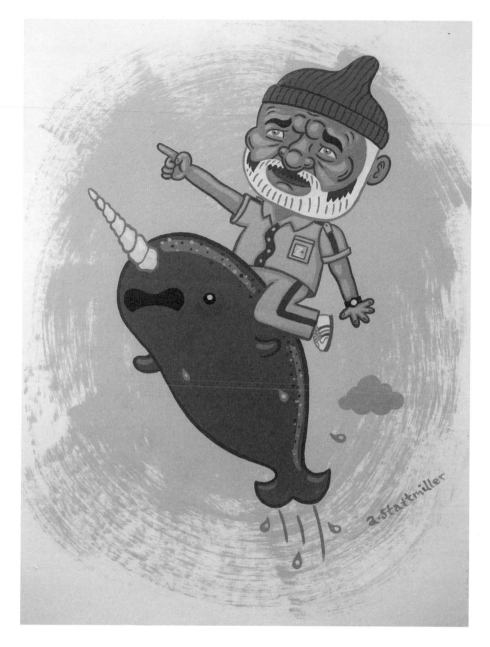

A VERY MURRAY MOMENT

Murray once shot a short promotional video for his son's school where he ad-libbed with nearby stuffed animals.

∧ *Steve Zissou* by Andy Stattmiller

<< *Dropkick Murray* by Buck Amaya

∧ *Bill 4* by Jason Matthews

> *Bill 2* by Jason Matthews

MUSICAL MURRAY

Murray released a classical music album called *New Worlds* with cellist *Jan Vogler* in 2017. Murray rocked the vocals while Vogler handled the cello!

< *Bill 3* by Jason Matthews
v *Bill 1* by Jason Matthews

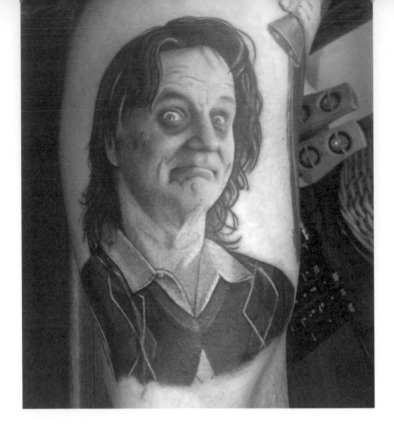

A VERY MURRAY MOMENT

While on *Jimmy Kimmel Live*, Bill Murray sported a fake tattoo of a fan's face on his forearm.

∧ *Zombieland Tattoo* submitted by David Corden

> *Coffee Bill* submitted by Max McCartney

>> *A Bicycle Built for Two* by Lori Paine

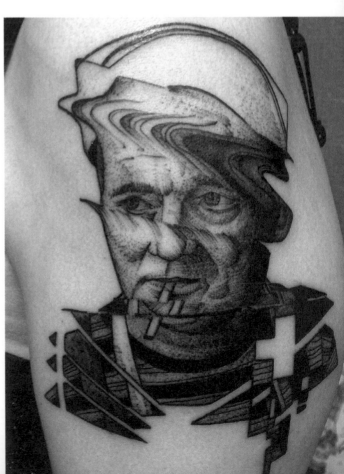

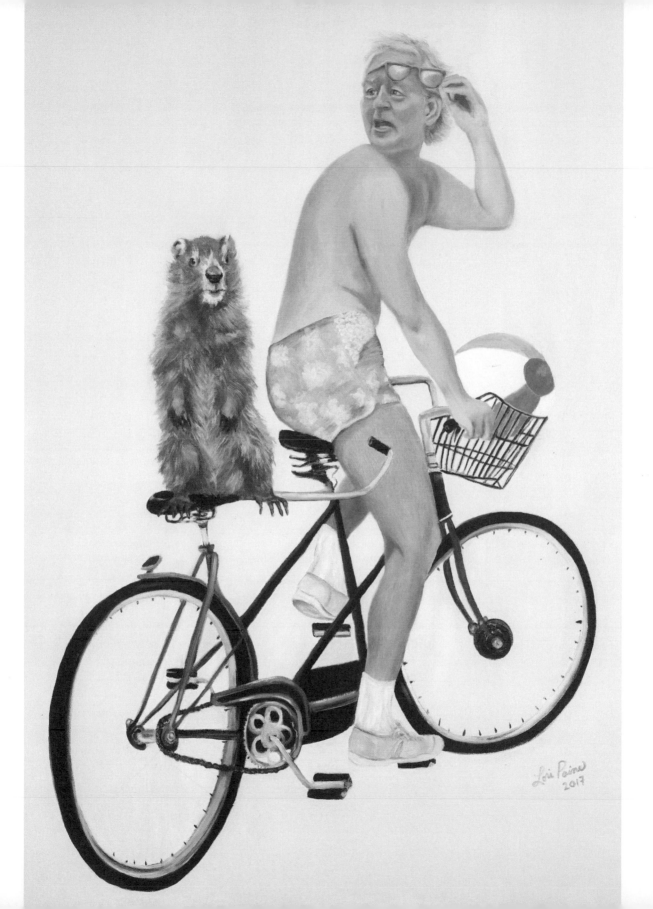

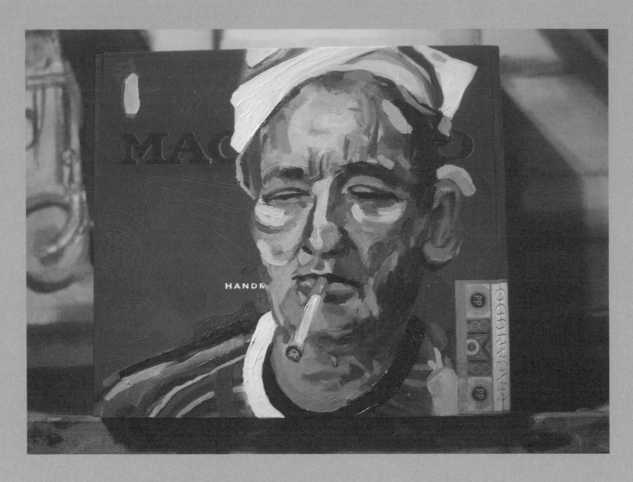

A MURRAY MYSTERY

Bill Murray's *Tootsie* contract stipulated that he not be listed in the opening credits because his agent at the time feared audiences would be disappointed this was not a typical Bill Murray movie. (He was also not on the poster, though he was credited at the end of the movie.)

∧ *Caffeine Delirium* by Shane Waller

>> *Crying on the Inside* by Tony Pro

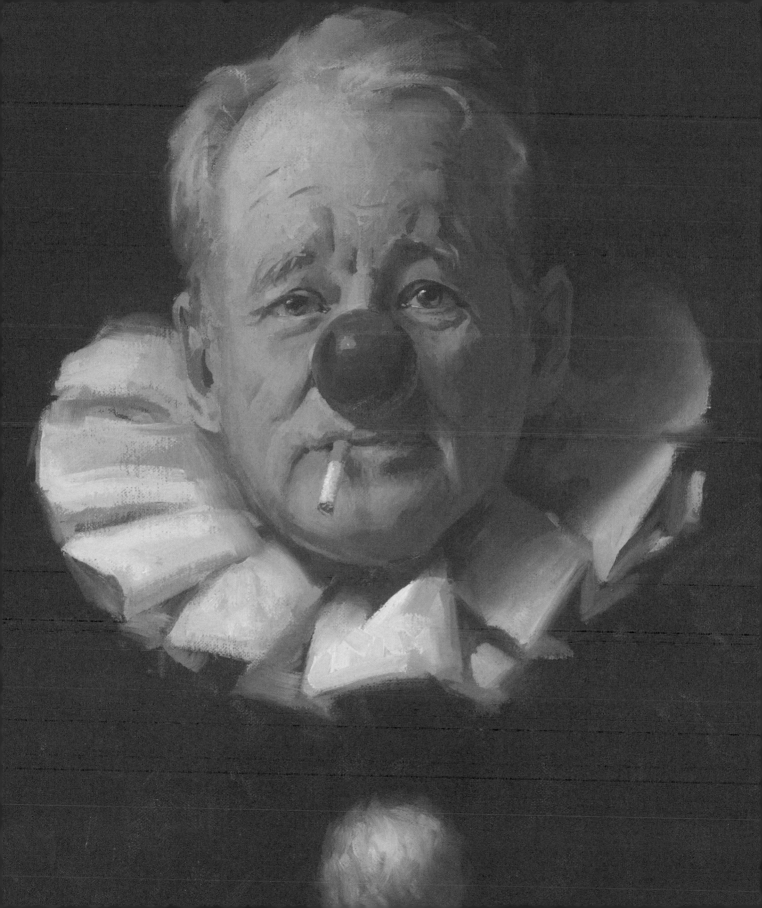

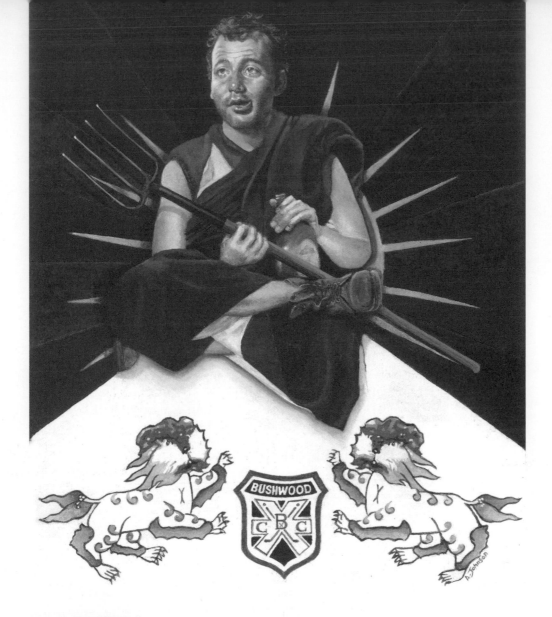

MUR-REALITY

Bill Murray and P.J. Soles (who played Stella) did boot camp for three days with soldiers at Fort Knox while preparing for *Stripes*.

∧ *So I Got That Going for Me* by Aaron Johnson

BEHIND THE SCENES

The original title of the film *Meatballs* was *Summer Camp*, and the first draft was written in a single month.

>> *Barcode Bill* by Benjamin Askevold

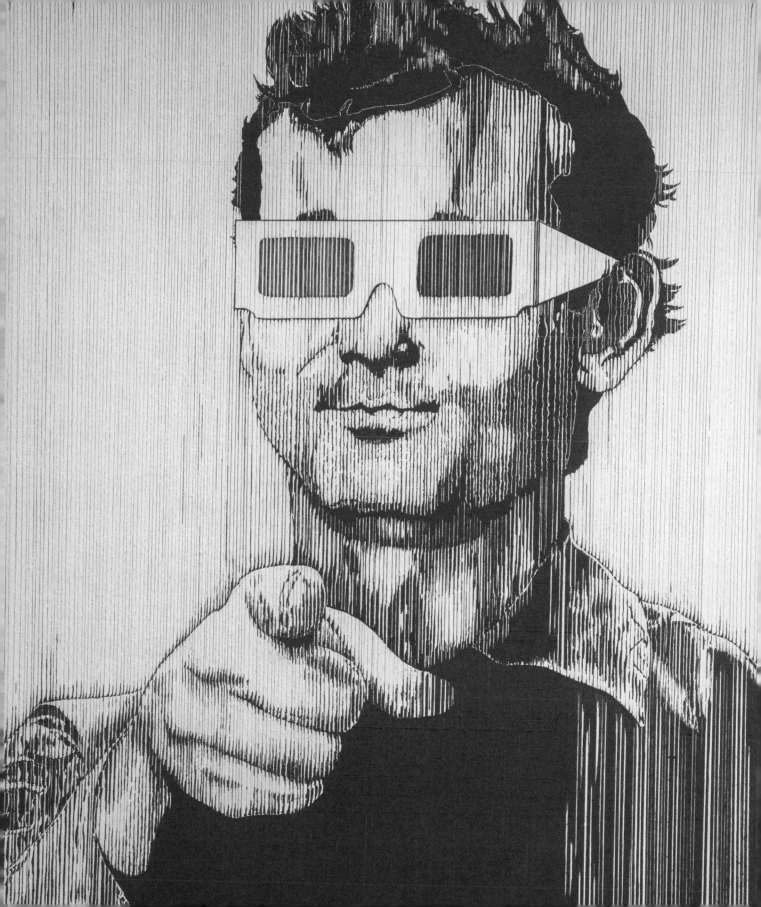

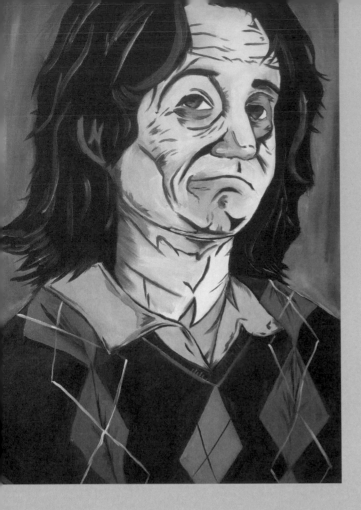

WHERE IN THE WORLD IS BILL MURRAY?

In order to get Bill Murray to read the script for *Zombieland*, the writers revealed they had to send it to a New York FedEx Kinkos since Bill didn't have an email address.

< *Zombie Bill* by Juan Duran

v *Smokin' Murray* by Sheldon Allan

>> *I Dream of Murray* by Jolene Russell

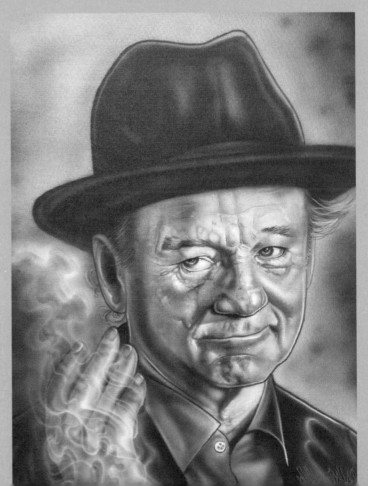

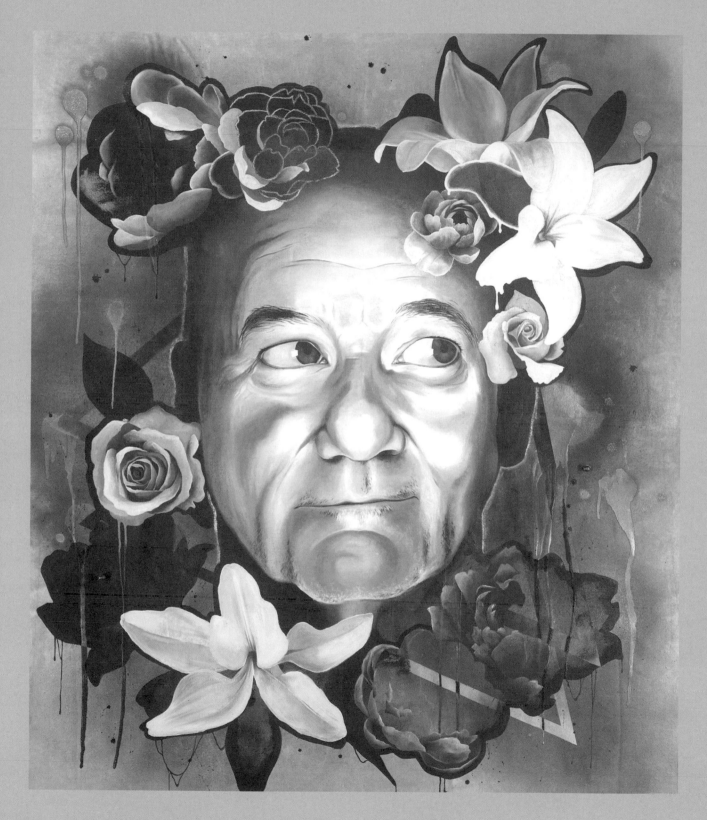

"CARL SPACKLER"

Caddyshack

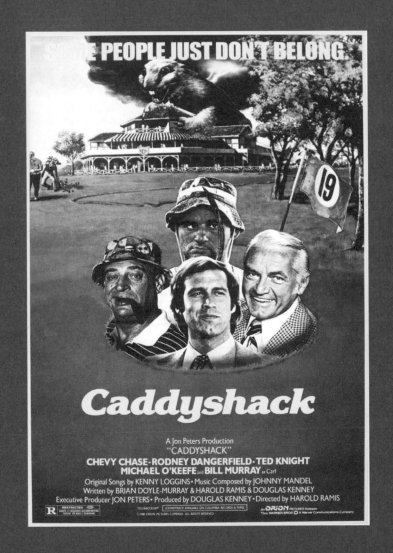

SOME PEOPLE JUST DON'T BELONG.

Caddyshack

A Jon Peters Production
"CADDYSHACK"
CHEVY CHASE · RODNEY DANGERFIELD · TED KNIGHT
MICHAEL O'KEEFE and BILL MURRAY as Carl
Original Songs by KENNY LOGGINS · Music Composed by JOHNNY MANDEL
Written by BRIAN DOYLE-MURRAY & HAROLD RAMIS & DOUGLAS KENNEY
Executive Producer JON PETERS · Produced by DOUGLAS KENNEY · Directed by HAROLD RAMIS

The role of a groundskeeper hasn't been so pivotal to a plot since *Lady Chatterley's Lover* – until Murray came along, tending his homegrown hybrid lawn of Kentucky bluegrass, featherbed bent, and California sinsemilla at the Bushwood Country Club. As the quirky Carl Spackler, Murray stands out among this strong ensemble as a loser loner who talks to himself and fantasizes out loud about everything from geriatric sex to war crimes. He's a lovable lout whose nemesis is the gopher thwarting his greatest goal of becoming head greenskeeper. Carl's weirdly affected stutter and petulant lip quiver indicate that he's especially odd, even among this crazed country club of pretentious posers, duffers, arrivistes, and nymphomaniacs, played to full effect by Chevy Chase, Ted Knight, Rodney Dangerfield, and Cindy Morgan. (Two of Murray's brothers also make an appearance in minor roles that they have transformed into a thriving golfing gear business.) Murray's best scene is set in his janky living quarters with his *Saturday Night Live* collaborator Chase; watching them ad-libbing, toking, and riffing in the moment is the purest expression of their comic gifts. The plot meanders around the youthful caddy Danny Noonan's quest for a club-sponsored college scholarship, and the characters who stymie and sink his search. There's a preggo scare with the nice Irish waitress, a tumble with a sex-starved heiress, pitiable encounters with random golfing geriatrics, and a scatological swimming pool scene that floats the film along. While the humor hits a few sand traps, it plays through the final tournament—and the final exit for Murray's nemesis gopher—a subpar puppet that presages the groundhog by a decade. While a few scenes have their handicaps, *Caddyshack* managed to be Murray's biggest hit yet, a movie that still drives a hole in one. Or maybe a bogey. Or maybe a booger.

BEHIND THE SCENES

Director Harold Ramis thought the movie was so funny, he didn't want to cut any of it—the director's cut of the film is over four and a half hours long. In fact, Murray's legendary "Cinderella" scene originally clocked in at over thirty minutes!

"JEFF SLATER"

Tootsie

What do you get when you cross a hopelessly straight, starving actor with a dynamite red sequined dress?

You get America's hottest new actress.

DUSTIN HOFFMAN
Tootsie

COLUMBIA PICTURES Presents A MIRAGE/PUNCH Production A SYDNEY POLLACK Film
DUSTIN HOFFMAN JESSICA LANGE TERI GARR "TOOTSIE"
DABNEY COLEMAN CHARLES DURNING Music by DAVE GRUSIN Original Songs/Lyrics by ALAN & MARILYN BERGMAN Executive Producer CHARLES EVANS
Story by DON McGUIRE and LARRY GELBART Screenplay by LARRY GELBART and MURRAY SCHISGAL Produced by SYDNEY POLLACK and DICK RICHARDS
Directed by SYDNEY POLLACK

This Christmas everyone will know
that she's Dustin Hoffman and he's Tootsie.

The idea of a known actor playing a woman was a cause célèbre back in 1982—to the extent that Dustin Hoffman had two cast credits, one for Michael Dorsey and one for Dorothy Michaels. A petulant method actor with a talent for rejection, Hoffman's Michael Dorsey is eager to star in a dramatic role written by his equally underemployed roommate, Jeff, played to charming effect by Murray. Jeff needs Michael's funds to produce his play about the Love Canal toxic waste dump. Michael puts on a dress for a television soap opera and becomes a runaway star. In a succession of hilarious, Shakespearean confusions, Michael falls for Julie, his fetching female costar (played by Jessica Lange) while he simultaneously becomes the object of affection for Julie's father (played by Charles Durning), leads on his female friend-with-benefits, and causes a cavalcade of cross-dressing confusion, with a dramatic denouement on live television. Murray plays the literally straight sidekick with aplomb, using dialogue that sounds utterly realistic because it was largely ad-libbed. The producers even convinced Murray to forgo an opening credit so audiences wouldn't miss the broad humor of a "Bill Murray" movie. As a supporting character, Murray hits a balance of wry and mordant humor that moves him past his early slapstick roles and foreshadows the layered Wes Anderson characters to come. Hoffman is clearly the star of *Tootsie*, but Murray's spot-on support helps give this film a timeless, sequined glow.

BEHIND THE SCENES

The name *Tootsie* was inspired by Dustin Hoffman's own mother, who called him "Tootsie Wootsie" as a child.

"LARRY DARRELL"

The Razor's Edge

This roughly exquisite ramble represents Murray's wish to break type in a complex, serious role. His passion for this sprawling period drama about an American soldier's search for enlightenment after WWI was fervent, and presages the timeworn sensitivity of his later characters by a decade. Based on the W. Somerset Maugham novel of the same name, *The Razor's Edge* sees Murray playing Larry Darrell, an idealistic Midwesterner who leaves his fiancée, Isabel, to drive an ambulance in Spain. The horrors of trench warfare hit him hard, particularly the death of the cynical battalion chief named Piedmont, played by his real-life brother Brian Doyle-Murray. (Murray's heartfelt eulogy for Piedmont's character is an homage to his spiritual sibling John Belushi, who also died too soon.) Chastened, Larry rejects the illusion of his formerly predictable life for impoverished, Bohemian Paris. He begins a hardscrabble existence in a cold-water flat, scraping by on manual labor, drink, and philosophy. While Isabel marries and settles into a stifling life of comfort, Larry continues to seek his greater purpose. His studies lead him to a Himalayan monastery in India that offers the epigraph of the film, "The edge of a razor is difficult to pass over; thus the wise say the path to salvation is hard." When Isabel and Larry meet in Paris, she pursues him with fervor. Larry rejects her superficiality for his childhood sweetheart, Sophie, now scarred by her own tragic loss. Larry and Sophie forge their own version of compromised happiness, but Isabel's jealousy wreaks havoc. Larry loses his chance at a meaningful life, and returns to America a broken man.

Much like the character of Larry, Murray said the experience of finding support for this project was deeply disillusioning. Wildly in demand for his comedic roles, he could not find a single studio to produce *The Razor's Edge*, for which he also cowrote the screenplay. Columbia Pictures produced this film in informal exchange for his starring in *Ghostbusters*; he began filming in New York literally the day after he wrapped *The Razor's Edge* in India. Released after the meteoric *Ghostbusters*, *The Razor's Edge* sank like a fishing pole in the Ganges. Disappointed and disjointed from the juxtaposition, Murray moved to Paris to study philosophy and mysticism, attempting to pass over the razor's edge with a four-year hiatus from the movies.

BEHIND THE SCENES

Cheers! In the scene where Larry and Isabel get together for one more night in Paris before she returns to Chicago to get married, they are drinking real champagne.

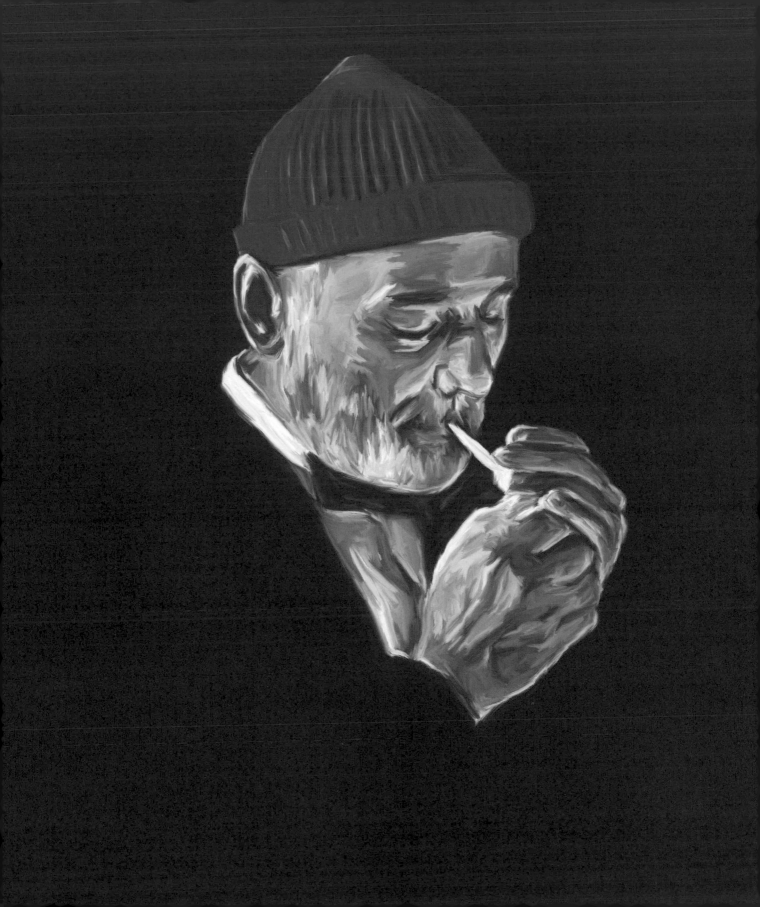

The Thinker

· ·

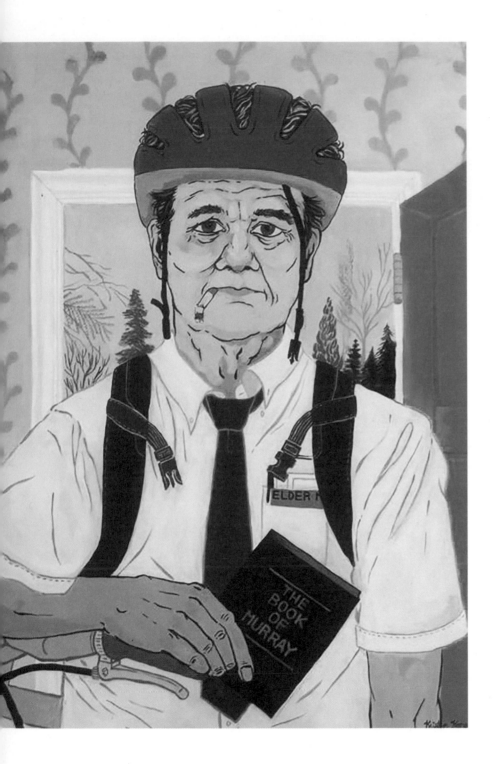

MAD FOR MURRAY

Bill Murray's character wears the same suit throughout *Rushmore*. He just changes the shirt and tie, which are always the same color as each other.

< *Out for a Ride* by Kristen Kong

>> *Bill Murray* by Michael Garfoot

Previous spread: *Shine a Light* by Thorsten Schmitt

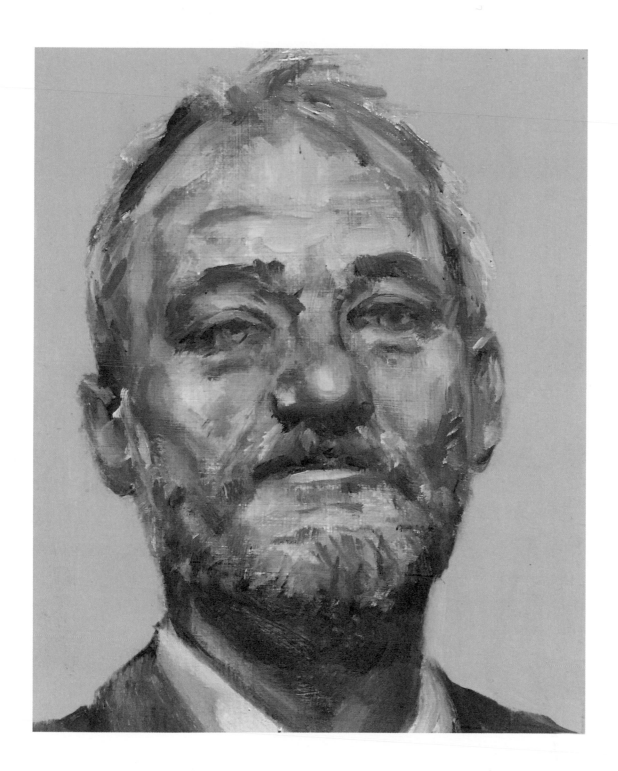

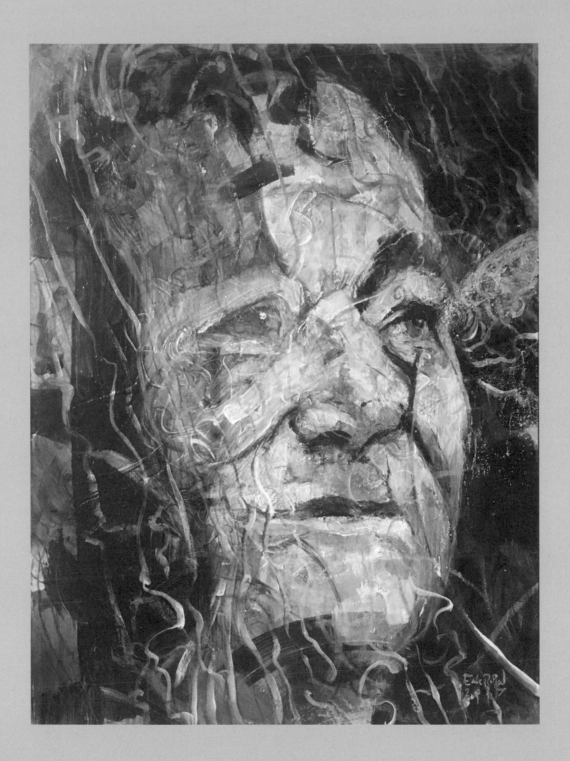

MUSICAL MURRAY

Bill Murray can't read music, but he learned how to play Rachmaninoff on the piano by ear for *Groundhog Day*.

> *The Sailor* by Emily Wood

<< *Murray's Yearning* by Eddie Rifkind

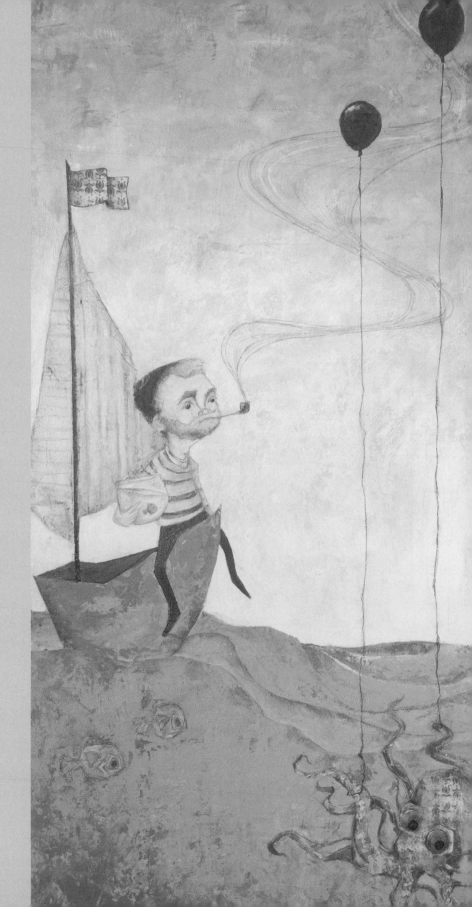

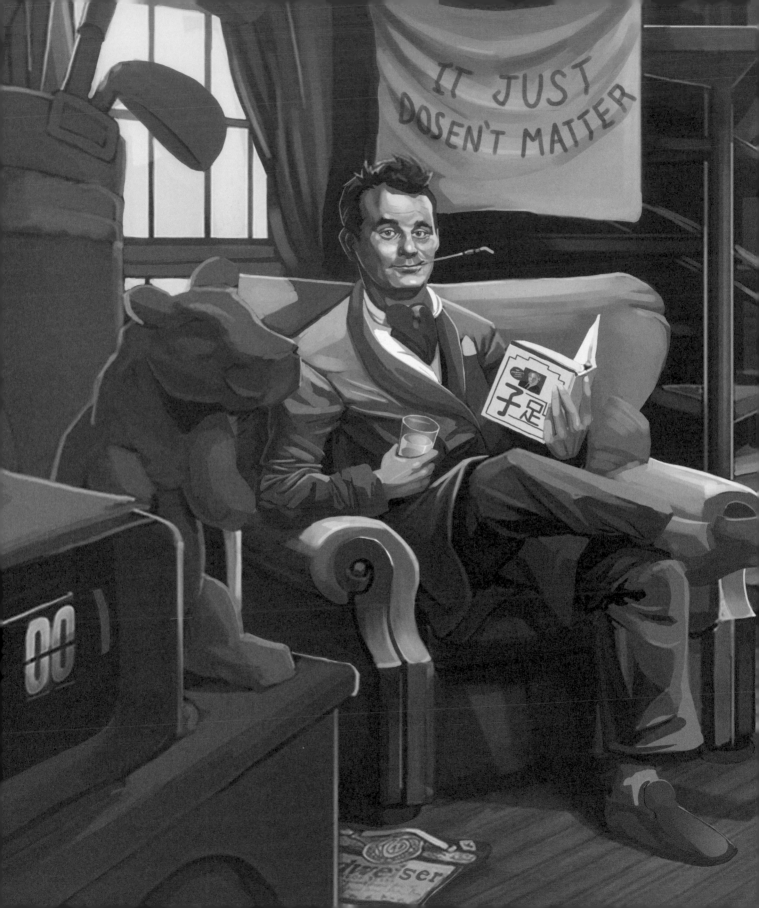

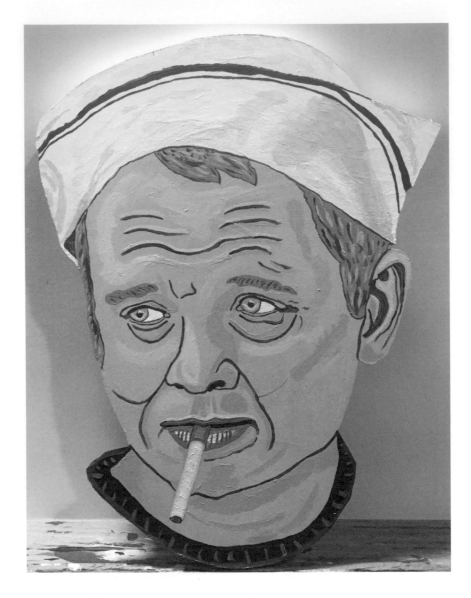

∧ *Serious Delirium* by Kent Grosswiler

>> *Bill* by Linda Fried

Previous spread: *The Tao of Murray* by Frank Harmon

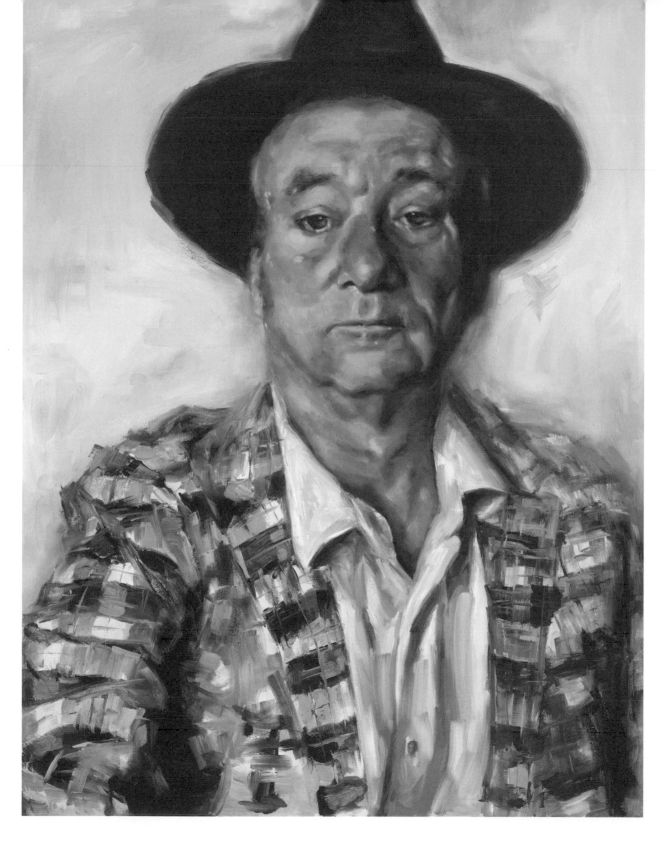

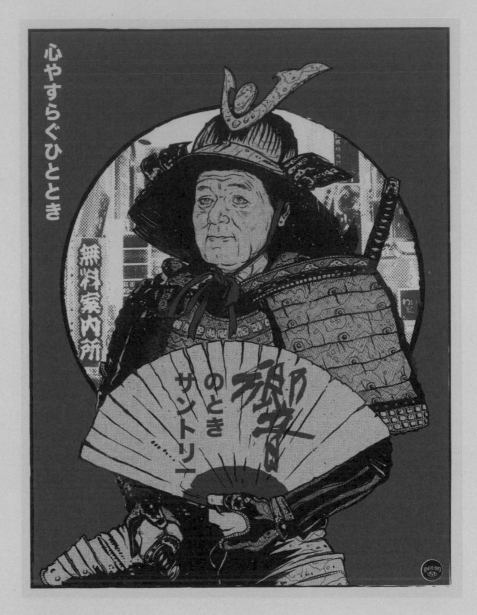

心やすらぐひととき

BETTER BE BILL

Sofia Coppola wrote the lead role in *Lost in Translation* specifically for Bill Murray, and later said if Murray turned it down, she wouldn't have done the movie.

∧ *Suntory Time* **by André Greppi**

>> *Keep Your Five Dollars* **by Lesley Fontanilla**

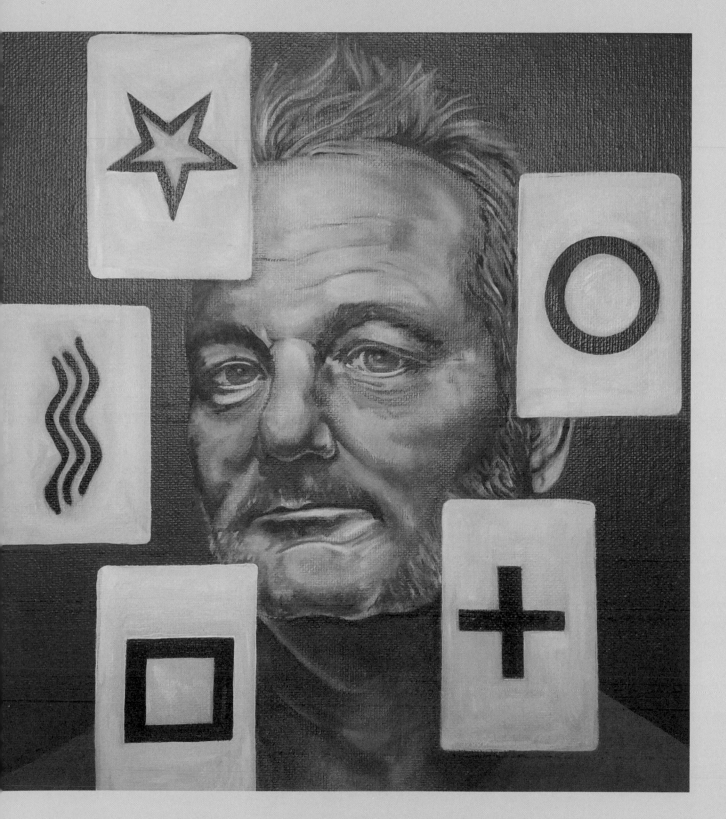

Ghostbusters

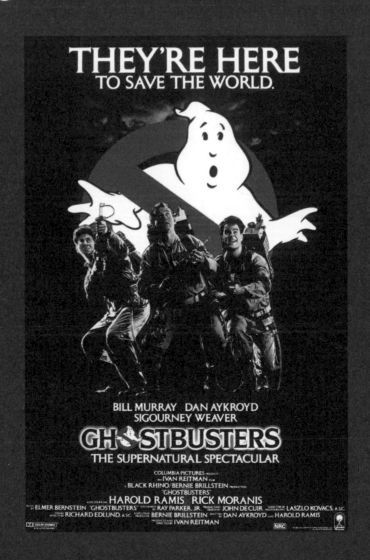

This is the blockbuster of them all, the film that propelled Murray into the big thrill, what *Vanity Fair* called, "The Perfect Comedy." Murray steals the show as the snarky-smart Dr. Peter Venkman, one of three earnest scientists who measure paranormal activity, trap ghosts, and save New York City. Easy, right? With red-hot TV stars Murray and Dan Aykroyd, the first computer graphic ghosts with a sense of humor, and an exquisitely chiseled Sigourney Weaver as Dana, the haughty cellist-turned-priestess, this goofy comic thriller was the highest-grossing film of all time for six years after its summer release in 1984. Originally penned by Aykroyd and Harold Ramis (*Meatballs, Stripes*) to include *SNL* alums Aykroyd and John Belushi, along with John Candy, the script was reconfigured for Murray, who ad-libbed many of the film's favorite lines: "This chick is toast!" "He slimed me!" "Human sacrifice! Dogs and cats living together! Mass hysteria!" (Belushi was memorialized as the green Slimer ghost). Aykroyd, who developed the concept from his family's fascination with séances, is the perfectly awkward Dr. Raymond Stantz, and Ramis is the shy brainiac, Dr. Egon Spengler.

Murray leads as the suave scientist Dr. Peter Venkman, equally intent on scoring dates and paranormal captures. Murray plays Venkman as smooth as the slime the ghosts leave behind, oozing charisma. Romantic rejection only makes him more insistent, and confronting the ghosts more confident. Murray's character is loose and louche, the perfect foil for his earnest costars Stantz and Spengler, whom Aykroyd referred to as "the Scarecrow, the Lion, and the Tin Man." The premise was that specters from an ancient Sumerian society were arriving through Dana's refrigerator, leaving a trail of fear and ectoplasmic slime for the Ghostbusters to clean up. Loading their nuclear proton pack equipment into their repurposed ambulance/hearse with a snazzy roof rack, the Ghostbusters become the default fumigators of fright. When all hell breaks loose out of Dana's refrigerator, statues become rabid dogs, the city gets marshmallow creamed, and the garrulous Ghostbusters save Gotham from earthquakes, white foam, and eternal damnation.

BEHIND THE SCENES

The original title of the movie was *Ghost Smashers* because *The Ghost Busters* was the title of a 1970s TV series for children. The studio eventually got permission to use the name, of course.

"FRANK CROSS"

Scrooged

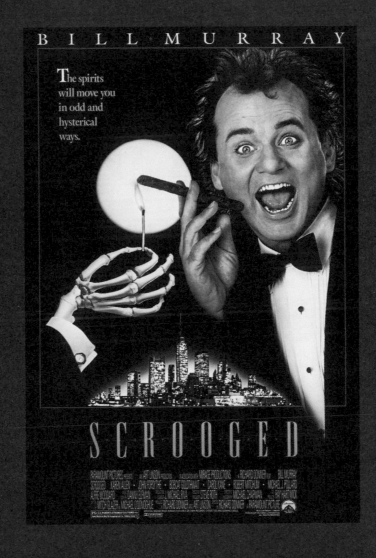

In this devilish retelling of *A Christmas Carol,* Bill Murray plays the most comically humbug Scrooge to ever hit the silver screen. Murray is pitch-perfect as the ruthless television executive Frank Cross, producing a live broadcast *A Christmas Carol*, jam-packed with deliciously miscast '70s and '80s TV stars camping it up. The opening "previews" of Frank's ratings-building holiday shows are a hilarious romp for a generation weaned on outlandish action shows. "That thing looked like the Manson Family Christmas Special, Frank!"

Murray's Cross succeeds with ruthless, provocative television—and behavior. As Cross, he pushes his irreverence over the line into cruelty so extreme it becomes ironically funny, and you know Murray is having a field day with the role. His version of Scrooge is recognizable and relevant to the present day, a point underscored by the hilariously Brooklyn accent of Buddy Hackett as ye olde Victorian Scrooge, with pixie gymnast Mary Lou Retton as an un-crippled Tiny Tim. Even though we know the story by heart, when Cross is haunted by Marley and the wacky ghosts of Christmas Past, Present, and Future, we delight in watching the reluctant rehabilitation of Murray's aptly named Cross.

Equally amusing is watching this faux-fierce Murray interact with a cast chockablock with familiar faces, including all three of Bill's brothers, John, Joel, and Brian Doyle-Murray. When he scowls at the street musicians playing "We Three Kings," played by jazz greats David Sanborn, Larry Carlton, and Miles Davis, and *David Letterman*'s Paul Shaffer, we get the inherent comedy. There are dozens of in-joke Easter eggs throughout. Director Frank Donner calls this the movie "where Murray became an actor." The risk of doing a comic version of *A Christmas Carol* was courageous, and this gambit pays off like the Dickens: as we watch Murray's Cross gradually morph from cruelly calculating to compassionate and even charming, it truly feels like a Christmas miracle.

BEHIND THE SCENES
Scrooged was Murray's triumphant return to film after a voluntary four-year hiatus following his production of *The Razor's Edge*.

"GRIMM"
Quick Change

The bank robbery was easy.
But getting out of New York was a nightmare.

BILL MURRAY
GEENA DAVIS
RANDY QUAID
JASON ROBARDS

Quick
CHANGE

A major metropolitan comedy

WARNER BROS. presents a DEVOTED PRODUCTION BILL MURRAY · GEENA DAVIS · RANDY QUAID · JASON ROBARDS · QUICK CHANGE
EDITED BY ALAN HEIM A.C.E. PHOTOGRAPHED BY MICHAEL CHAPMAN MUSIC BY RANDY EDELMAN EXECUTIVE PRODUCER FREDERIC GOLCHAN BASED ON THE NOVEL BY JAY CRONLEY
SCREENPLAY BY HOWARD FRANKLIN PRODUCED BY ROBERT GREENHUT and BILL MURRAY DIRECTED BY HOWARD FRANKLIN and BILL MURRAY

Bill Murray gets his one and only director's credit for this tragicomic heist film in which he also stars as a wisecracking bank robber dressed as a clown. Metaphor much? Murray portrays the perfectly named Grimm in this cautionary fairy tale, which begins in the heart of Manhattan, and gradually sweats down into the armpit of Brooklyn and the nether regions of Queens. The marvelous opening credits let us accompany Grimm in full clown regalia into the subway, where we enter the everyday-crazy New York of the '90s universe where the story unfolds. If *Manhattan* is Woody Allen's love letter to New York, this is Bill Murray's "Dear John" version, about a man whom the Big Apple thwarts at every turn. The delicious bank robbery scene is Murray at the top of his game, smart and snarky, outwitting his ideal nemesis, Police Chief Rotzinger, ably played by Jason Robards. Grimm is joined in the heist by his conflicted girlfriend, Phyllis Potter (Geena Davis), and his truly compromised childhood friend Loomis, dramatically overplayed by Randy Quaid. While we never really understand the reason Potter loves Grimm or vice versa, and we certainly don't understand why either of them continues to allow the incapable Loomis to screw the caper, the plot requires us to suspend disbelief to lurch forward. And lurch it does. Turns out robbing a bank is the easy part—it's the getaway that twists and turns into New York's Heart of Darkness, introducing the everyday insults that New Yorkers have to deal with on a regular basis: cab drivers who don't know the language or the way, persnickety bus drivers demanding exact change, impossible landlords, apathetic construction workers, antagonistic neighbors, snail's pace grocery checkers, mourning madonnas. The film and the getaway slow as each situation beats them down, until the increasingly desperate trio happens into a mafioso den; Murray gives us his *Godfather* moment, and it's a goodie, which sets a new storm in motion and ultimately proves to be our hero's salvation on the wings of a jet. While Murray was technically the codirector with screenwriter Howard Franklin, his sensibility is splashed all over the film like a muddy puddle kicked up by a passing bus. It's his own take on *Ghostbusters*, but here, the dark forces are attributed to the cumulative minor insults that comprise and compromise every New York minute. Not a hit at the box office, *Quick Change* has become a beloved cult film among New Yorkers who recognize that Murray has perfectly captured the quirks of a city that never really changes, at least not quickly.

BEHIND THE SCENES

The watch used to bribe Bill Murray in the bank robbery scene was an expensive Swiss Audemars Piguet watch and was Bill's actual watch. He jokingly had asked the director to write it into the script because he had to pay $150 to get it wound by the Audemars Piguet store every time he didn't wear it for a while.

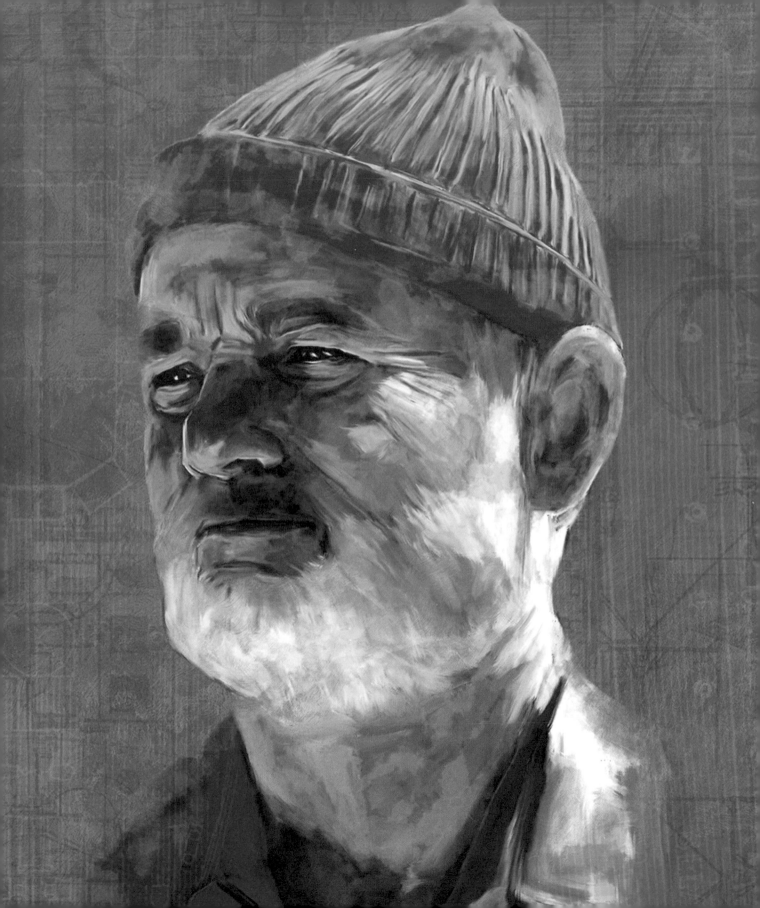

The Intense

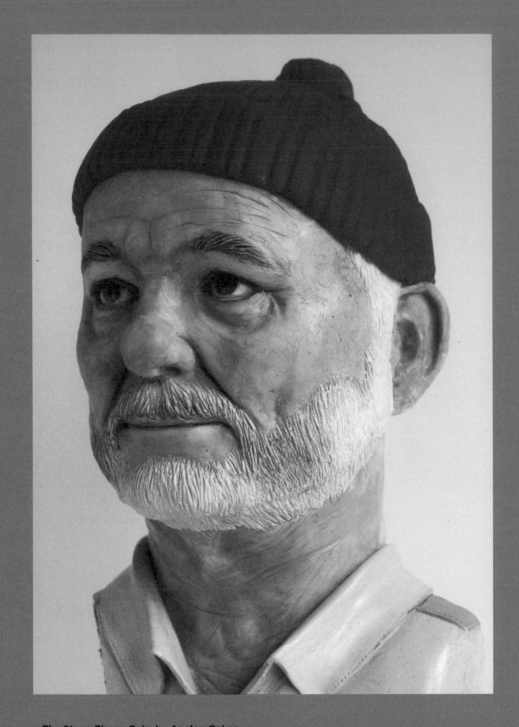

∧ *The Steve Zissou Cake* by Avalon Cakes

Previous spread: *Zissou* by Thorsten Schmitt

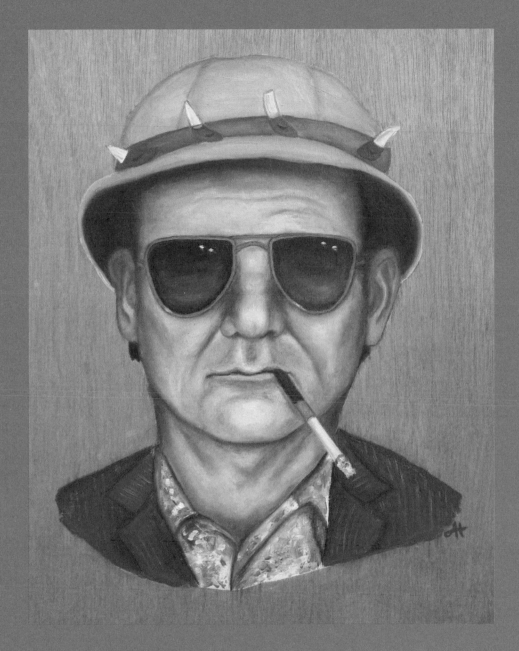

MUSICAL MURRAY

Hunter Thompson recommended folk artist John Prine to Bill Murray when he was going through a depressed slump at one point, and Bill acknowledges that the song "Linda Goes to Mars" helped him get his humor back.

∧ *Where the Bill Murray Roam* by Andrea Hooge

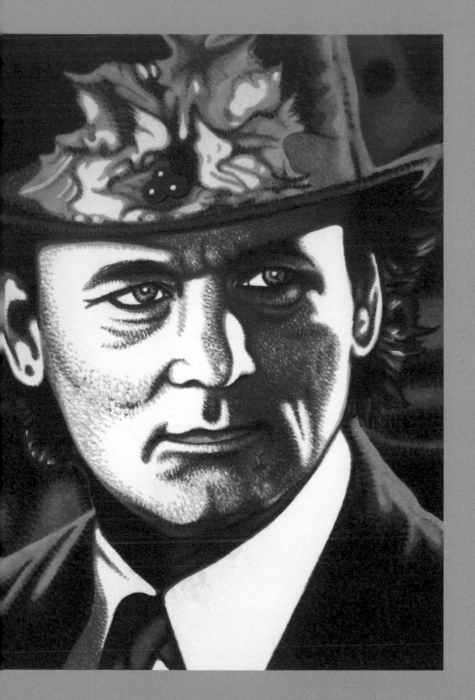

OUCH!

The Ghost of Christmas Present—
played by Carol Kane in *Scrooged*—
accidentally injured Bill Murray during
filming when she grabbed his lip and
tore it, but he admitted it was his idea
for the ghost to be so physical.

< *Holiday Bill* by Justin McAllister

FOR THE LOVE OF MURRAY

The character of Steve Zissou was
written specifically for Bill Murray by
Wes Anderson and Noah Baumbach.

>> **The Murray by Sonia McNally**

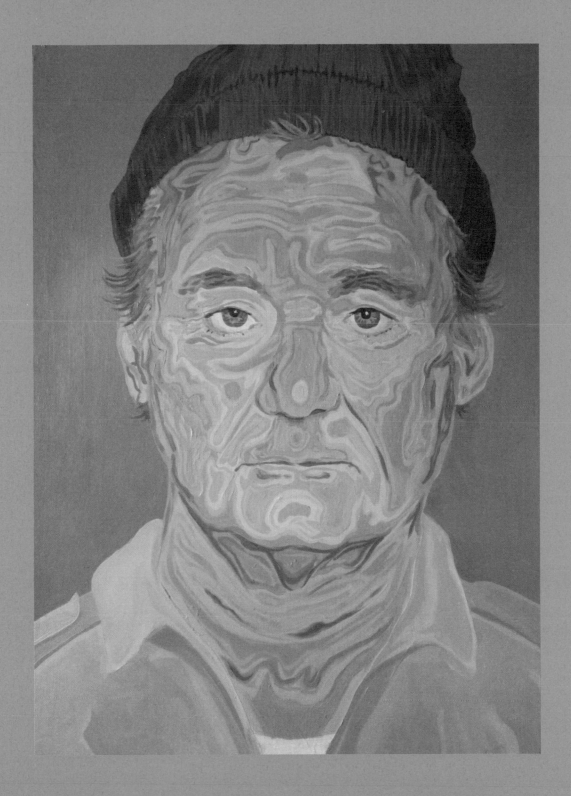

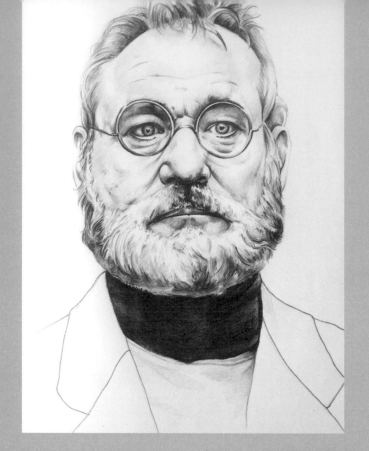

MUR-REALITY

The Murray brothers started a line of golf wear and apparel called William Murray Golf in 2017. One of the best sellers? A shirt designed by Bill with highball glasses on them. Fore!

< *Well, I Want to Die* by Phil Galloway

v *Bill Murray in Oil* by Jennifer Gennari

>> *Bill Murray* by Lori Paine

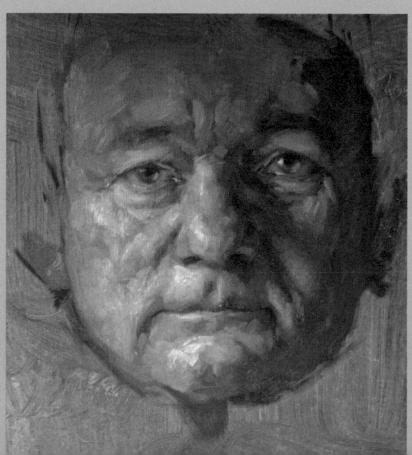

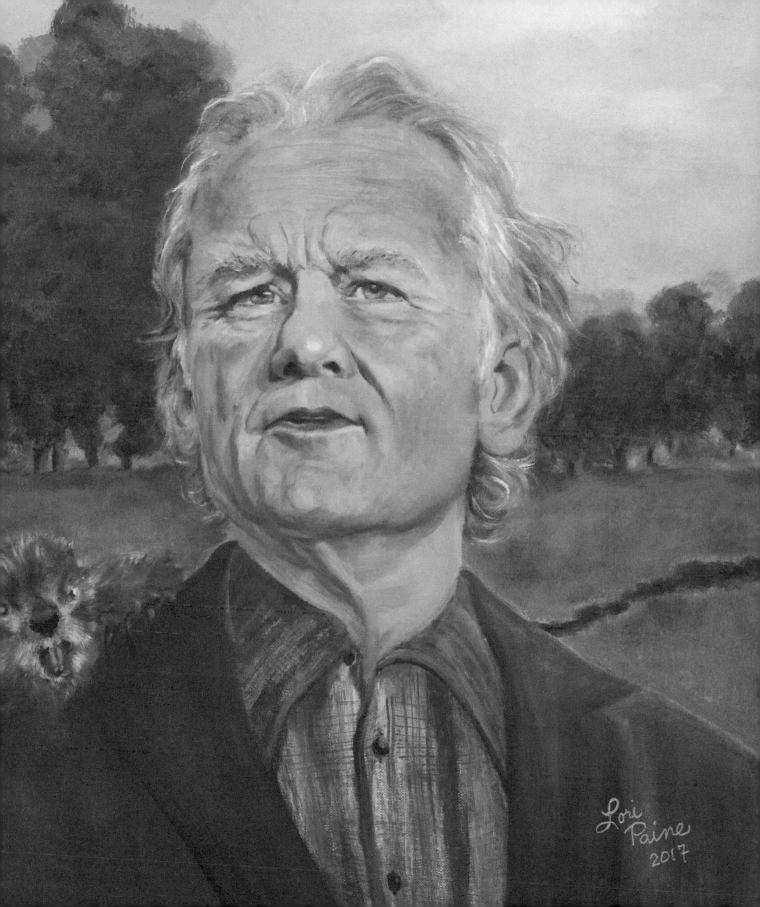

Lori
Paine
2017

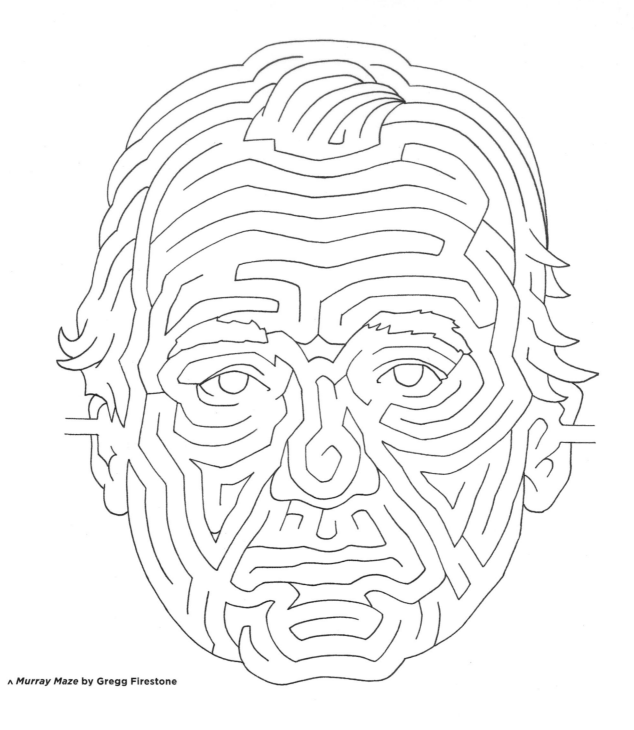

∧ *Murray Maze* by Gregg Firestone

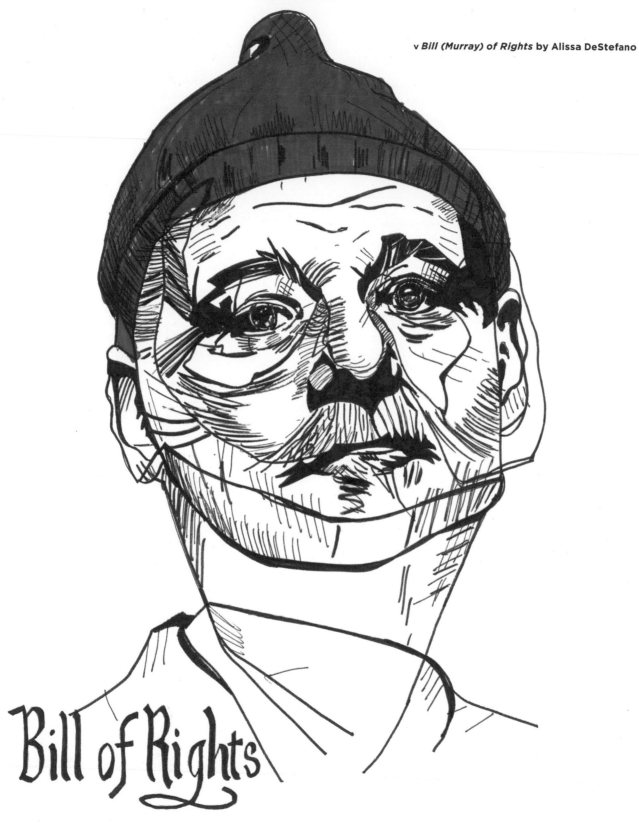

Bill of Rights

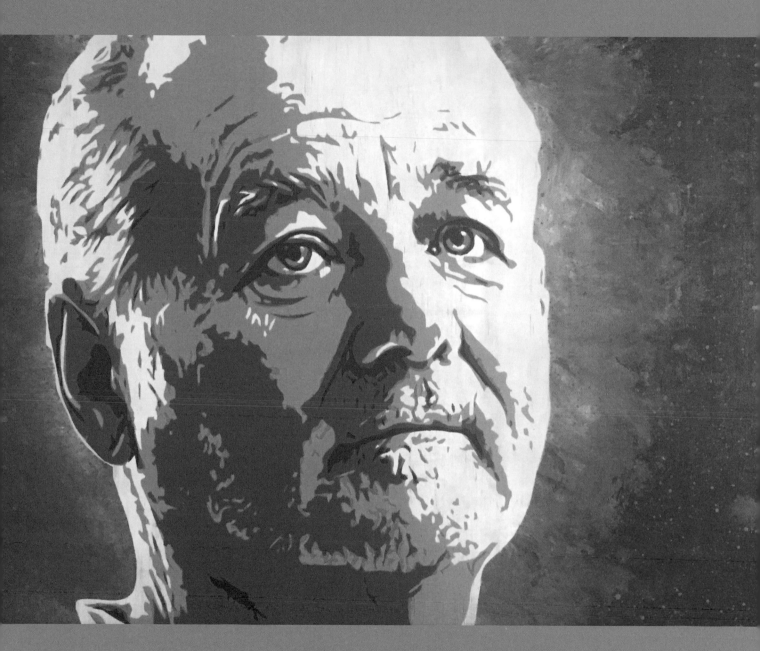

BILL'S THRILLS

Murray admits to liking the "sloppy roles" in a 2014
Today Show interview about the film *St. Vincent*.

∧ *Acid Invents a Sunny Vent* by Ryan Borella

<< *The Bitch Hit Me with a Toaster* by Christine Delorenzo

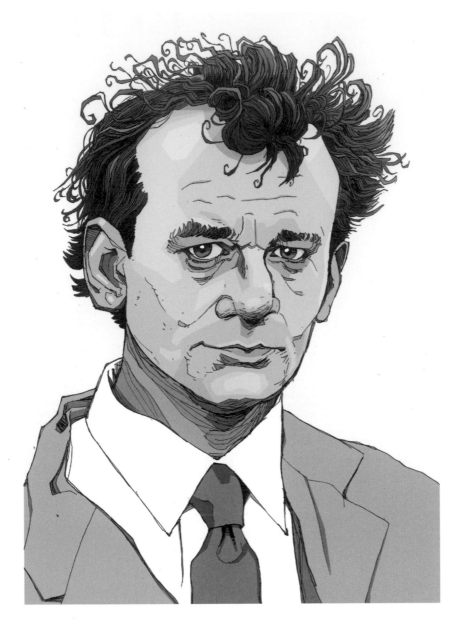

BOOZE WITH BILL

In 2016, Bill Murray bartended at his son's bistro, 21 Greenpoint in Brooklyn. In addition to a two-hour shift, Murray also named a new cocktail—the Depth-Finder— which contained Slovenia Vodka and Amaro liqueur.

< *Venkman* by Ryan Gajda

>> *Seedy Bill Murray* by Kristin Smith

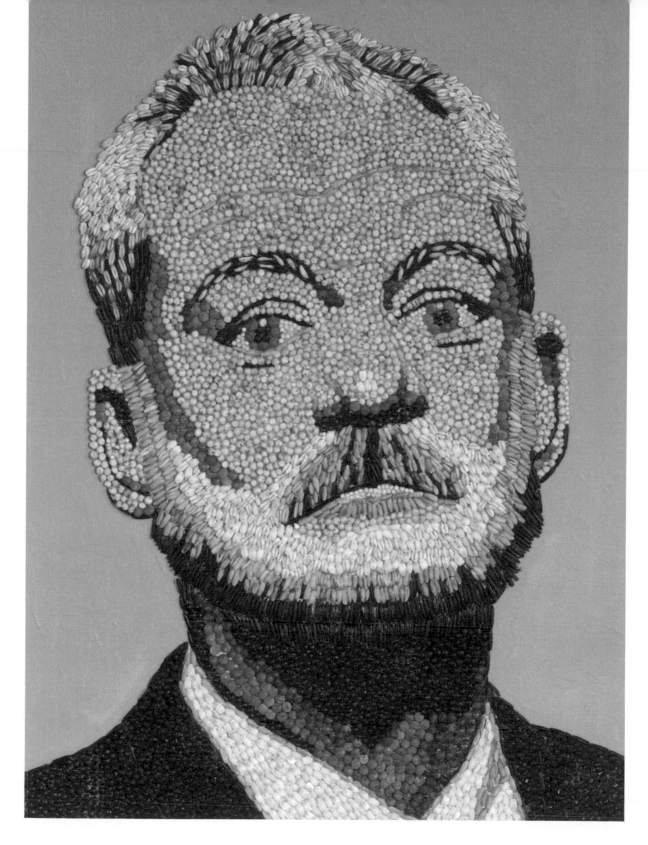

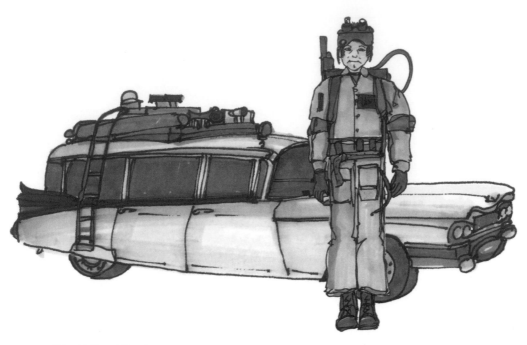

∧ *Ecto Bill* **by Melissa Wood**

∨ *The Jacqueline and Bill* **by Melissa Wood**

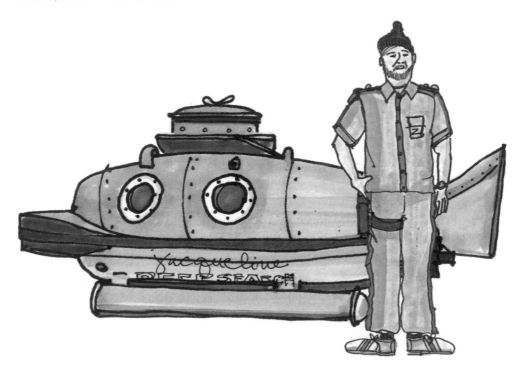

MURRAY GOES MOBILE

In real life, Murray's favorite automobile is a vintage Maserati sports car.

∧ *Chrysler LeBaron with Wood Paneling and Bill* by Melissa Wood

> *Bill's Golf Cart* by Melissa Wood

"BOB WILEY"

What About Bob?

BILL MURRAY RICHARD DREYFUSS

Bob's a special kind of friend.
The kind that drives you crazy.

Lauded New York psychotherapist Dr. Leo Marvin (Richard Dreyfuss) is an insufferable know-it-all, and chronic neurotic Bob Wiley (Bill Murray) is an endearingly anxious master manipulator—what could possibly go wrong? When barely functional Bob meets Dr. Marvin, the doctor diagnoses, "multi-phobic personality characterized by acute separation anxiety and extreme need for family connections."

To overcome his new patient's neuoses, Dr. Marvin prescribes a regime from his bestselling book, *Baby Steps*. As soon as Dr. Marvin leaves for a family vacation in New Hampshire, an increasingly desperate-for-therapy Bob applies Marvin's methodology to board a bus and follow him there. The canny Bob realizes his best chance to connect is to ingratiate himself with the doctor's family, which he does with enthusiasm and a hint of guile. The family welcomes Bob as a diversion in a "Don't hassle me I'm local" T-shirt, a harmless eccentric rather than an intrusive threat, preferring loopy Bob to domineering Marvin. As Bob forces himself to overcome his phobias through baby steps, he validates Marvin's process even while driving him crazy. The roles reverse when Bob's intrusion drives Marvin to a psychological break, and Bob is rewarded by literally becoming the less-crazy uncle of the family.

While Dreyfuss plays bombastic bluster to perfection—a doctor who cannot take his own medicine—he quickly loses our sympathy. Meanwhile, as Murray sheds his fears and phobias, we continue to cheer on his progress—Murray makes sure we always care about Bob. Murray and Dreyfuss are well matched, even as it is clear their characters never come to like one another—and neither, apparently, did the actors, as Dreyfuss revealed in an interview. Despite their differences, though, Dreyfuss admits, "I've got to give it to him: I don't like him, but he makes me laugh even now."

BEHIND THE SCENES
The Los Angeles Times actually reported in 1989 that Bill Murray and Woody Allen were going to be playing patient and doctor in *What About Bob?*.

"PHIL CONNORS"

Groundhog Day

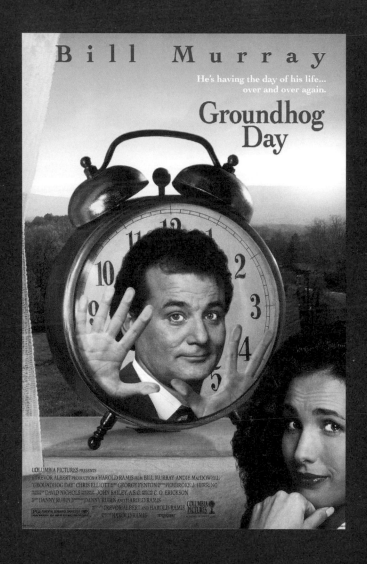

What if you had to repeat your worst day ever? What if you had to repeat your worst day ever? What if you had to . . . well, that's the premise behind this sweetly redemptive tale of an unhappy weatherman, Phil (Bill Murray), who inexplicably must relive the same twenty-four-hour period until he can ultimately right his life. At first cold and cynical, Phil is dispatched to Punxsutawney, Pennsylvania, to cover the annual ceremony where a groundhog named Phil predicts if there will be six more weeks of winter.

Human Phil is accompanied by chipper producer Rita (Andie MacDowell) and browbeaten cameraman Larry (Chris Elliott), who tolerate Phil's insults to get on with their job. When an unpredictable storm hits, they can't get out of town, so they retreat back to Punxsutawney for the night, and the same day begins anew. Trouble is, only weatherman Phil seems to notice that it's déjà vu – everyone else goes about his or her day like it's the first time. It builds as it repeats, and we share Phil's enervation at hearing the same quips, meeting the same small-town archetypes, stepping in the same icy puddles day after cold, relentlessly quotidian day.

This is where Murray's brilliance as an actor comes in to play—he brings us along as Phil subtly adjusts his emotions from anger to incredulity to despair as his predicament sinks in. He attempts different approaches to move the day forward: first recklessness, then lawlessness, then existential despair. It takes a while for him to realize that learning from his own responses to the previous same day will improve the same day that follows. Once he accepts this supernatural conundrum as a way to adjust his own behavior and emotions, he starts to enjoy the process, and things begin to turn around. As Phil rises to become his better self, Rita warms to him, and their affection blossoms. Phil's despair turns to hope, and our observance turns to delight. It's a Buddhist reincarnation parable set in small-town Pennsylvania, of all things, but remarkably, charmingly, and effectively, it works, it works, it works.

BEHIND THE SCENES
There is a plaque in Woodstock, Illinois, in the exact spot where Bill Murray kept stepping into the puddle during the Ned Anderson scene in *Groundhog Day*. The plaque appropriately reads "Bill Murray Stepped Here."

"ERNIE McCRACKEN"

Kingpin

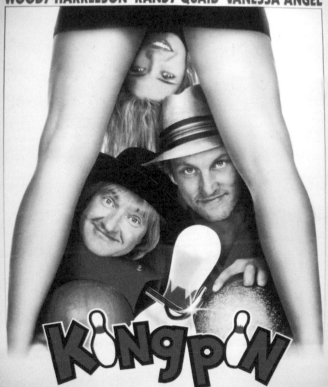

Leave it to the Farrelly Brothers (behind classics like *Dumb and Dumber* and *There's Something About Mary*) to find the goofy humor in a road trip movie about a failed bowling prodigy/scam artist Roy Munson (Woody Harrelson) who uses a naive Amish farming rube Ishmael (Randy Quaid) to stage a comeback, get the girl Claudia (Vanessa Angel,) and triumph over his darker instincts. He is also trying to triumph delicious villain Ernie McCracken (Bill Murray), an outsized parody of a smooth-talking bowling champion who dresses well and behaves badly.

Murray plays it to the hilt as a cynical, selfish womanizer who treats life and bowling as an intensely competitive win-or-lose sport. Early in the film, we see him in action in the 1970s sporting a flashy double-knit leisure suit and blond afro, the supposedly wiser mentor to Harrelson's idealistic Munson. McCracken thinks nothing of coldheartedly throwing Munson to the wolves, destroying Munson's bowling hand and nascent career before it starts. Munson's downward spiral is extreme, a seventeen-year bender that the Farrelly's manage to make squeamishly comic and increasingly desperate. When Munson encounters man-child Ishmael, a devout Amish naif with a secret bowling habit, Munson cynically repeats the McCracken cynicism by setting Ishmael up. They embark on an uncomfortable road trip to the world bowling championships in Reno, Nevada, the city and the event both washed-up parodies of former glory.

While the arc of narrative runs as flat as the road West, the outrageous dialogue propels them to their next encounter with an older, slicker McMaster, whose bowling success is only exceeded by his flashy wardrobe and cantilevered comb-over. Murray pulls out all the stops as the attention-hoarding champion who takes whatever he wants; it is outsize sports figure parody at its best, particularly in a "public service" commercial where Murray captures the essence of disingenuous smarm. When Munson and McMaster finally face off in the bowling lanes, Murray plays the character as big and brash as possible; he is having so much fun inhabiting this persona that you cannot help but marvel as he whispers to his custom-made bowling ball and overinflates the fan frenzy. He is an embellished cartoon and buffoon with plenty of moxie. That leaves the poignancy to Harrelson, Quaid and Angel, who manage to redeem themselves with modest humanity and round out the film on a feel-good note. As people and protagonists, those are the humans we want to win. But we save our guiltiest delight for Murray's McMaster, a slick trickster who bowls us right over with his bravura. He's the kingpin we hate to love, the one who strikes his way into the heart of the film and leaves us with the last laugh.

BEHIND THE SCENES
Bill Murray actually bowled the three tournament-winning strikes at the culmination of the film.

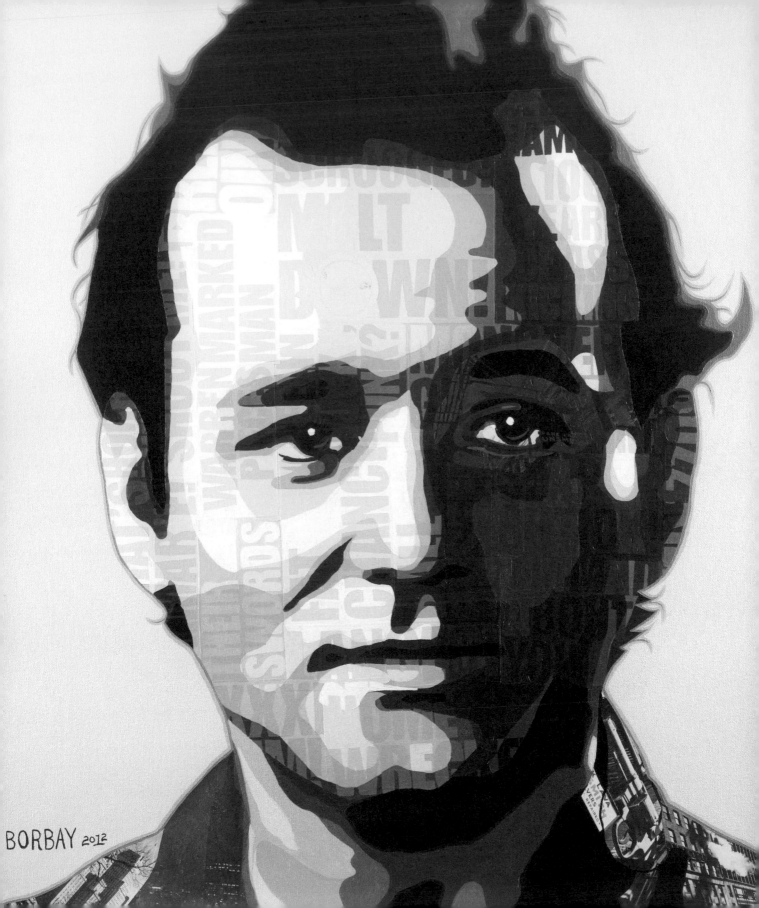

BORBAY 2012

The Charming

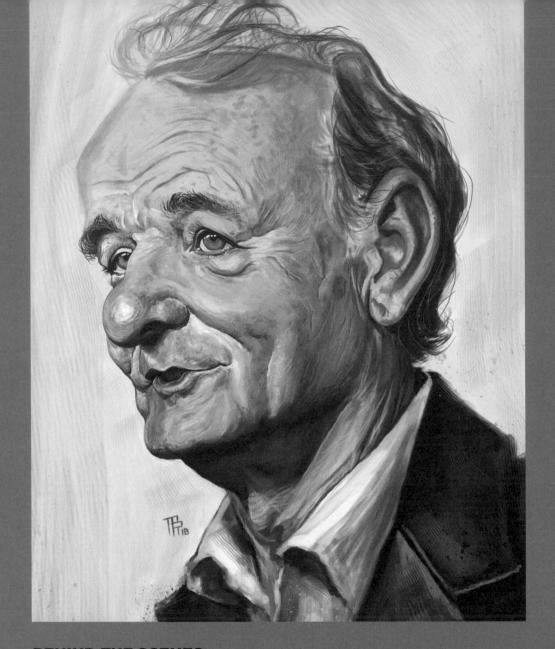

BEHIND THE SCENES

The studio initially didn't want Harold Ramis to play a role in *Stripes*, but Murray refused to do the film unless Ramis played Russell.

∧ *Bill Murray* by Mike Robinson

>> *Mosaic Murray* by Warren McCabe-Smith

Previous spread: *Dr. Bill Venkman* by Borbay

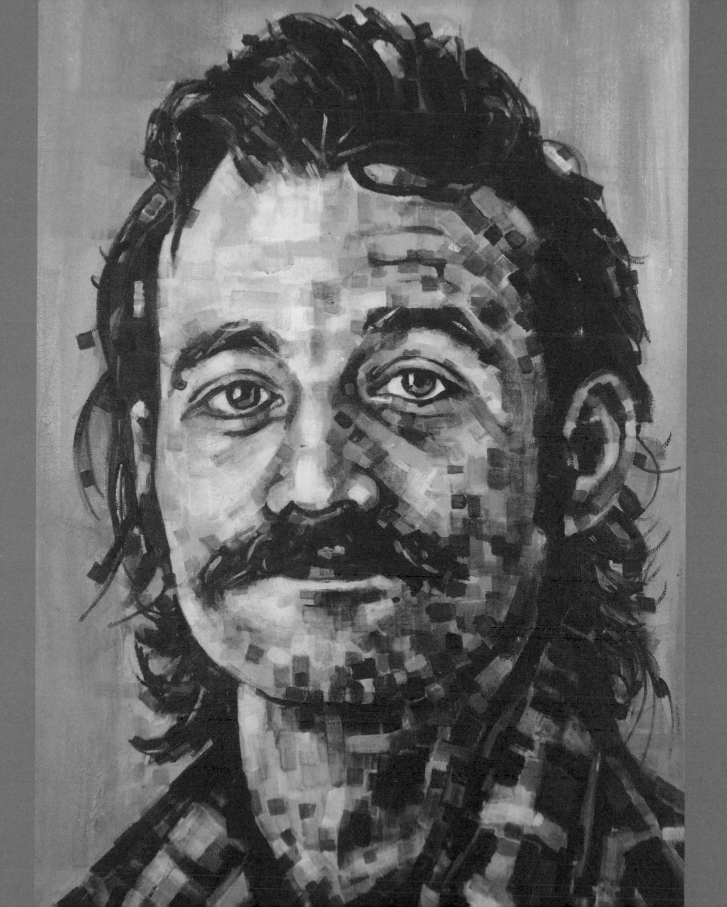

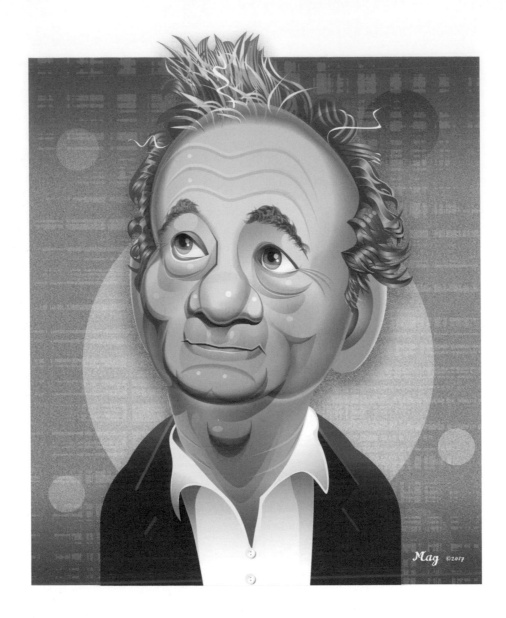

BEHIND THE SCENES

The inspiration for Murray's character in *Lost in Translation* to do a Suntory whisky commercial was partly inspired by the fact that Sofia Coppola's father, Francis Ford Coppola, made a real Suntory commercial in the 1970s.

∧ *Just Bill* by Robert Magliari

>> *Ghostbusters* by Armando Mesías

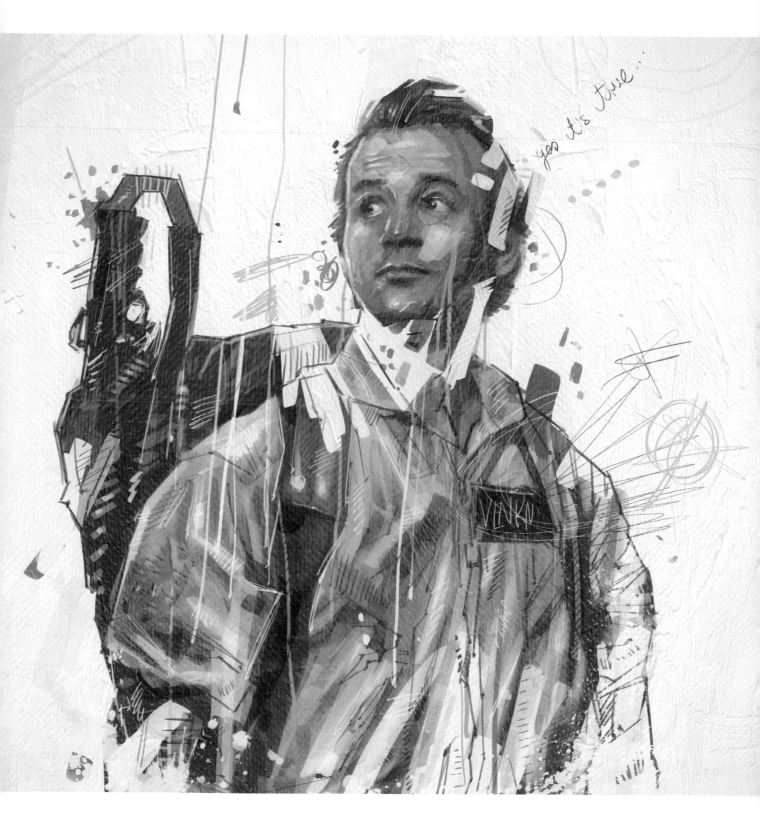

yes it's true...

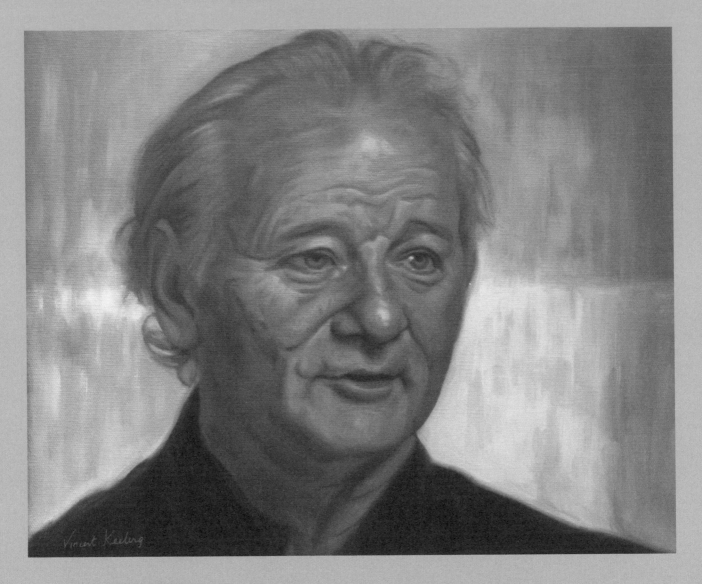

A MURRAY MYSTERY

Bill Murray wasn't told what the director was saying to him during *Lost in Translation*'s commercial shoot scene in order to make his confusion more real.

∧ *Bill Murray* by Vincent Keeling

>> *Blue Murray* by Lauren Fitzgerald

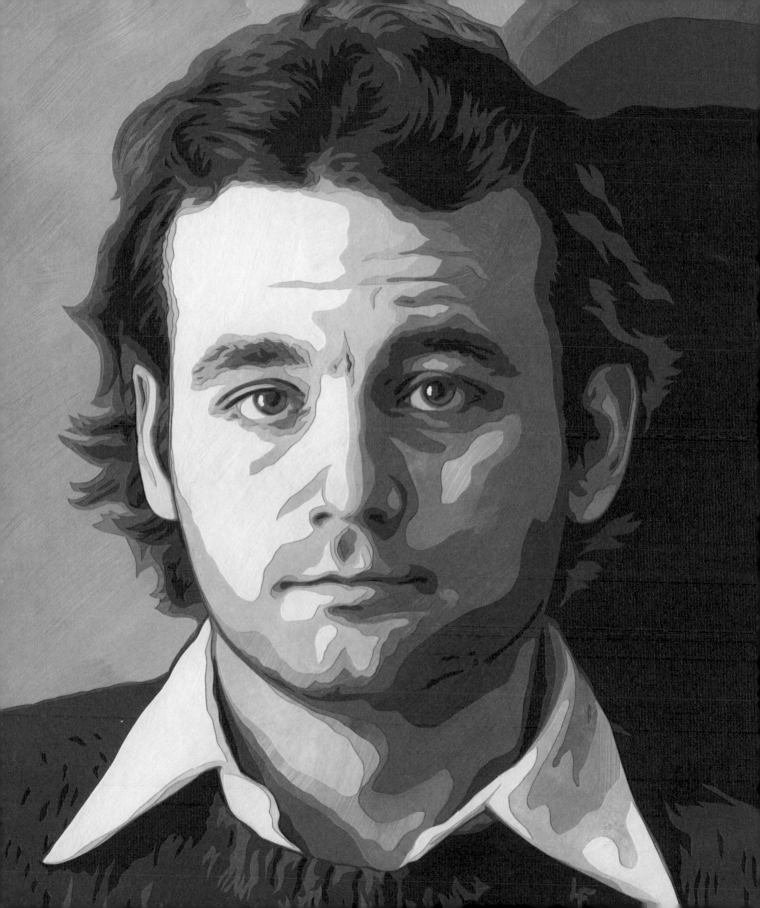

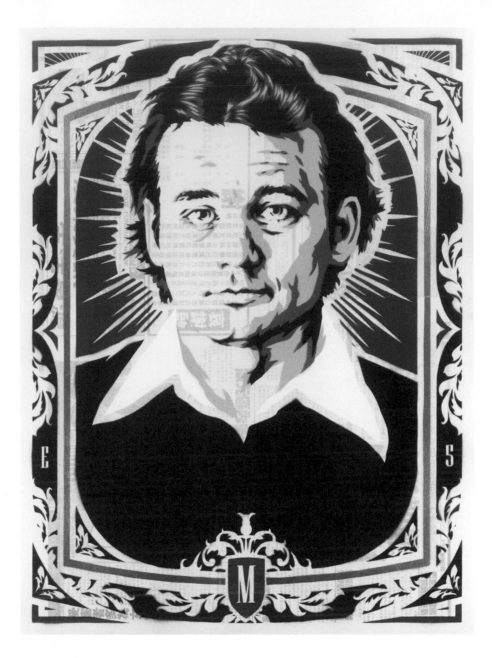

BEHIND THE SCENES

The *Ghostbusters* cast admitted to "stealing shots" in New York City, meaning they shot scenes for the film without obtaining the needed permits. Miraculously, they weren't caught!

∧ *It Just Doesn't Matter* by Epyon5

≫ *Bill Murray* by Jessa McClintick

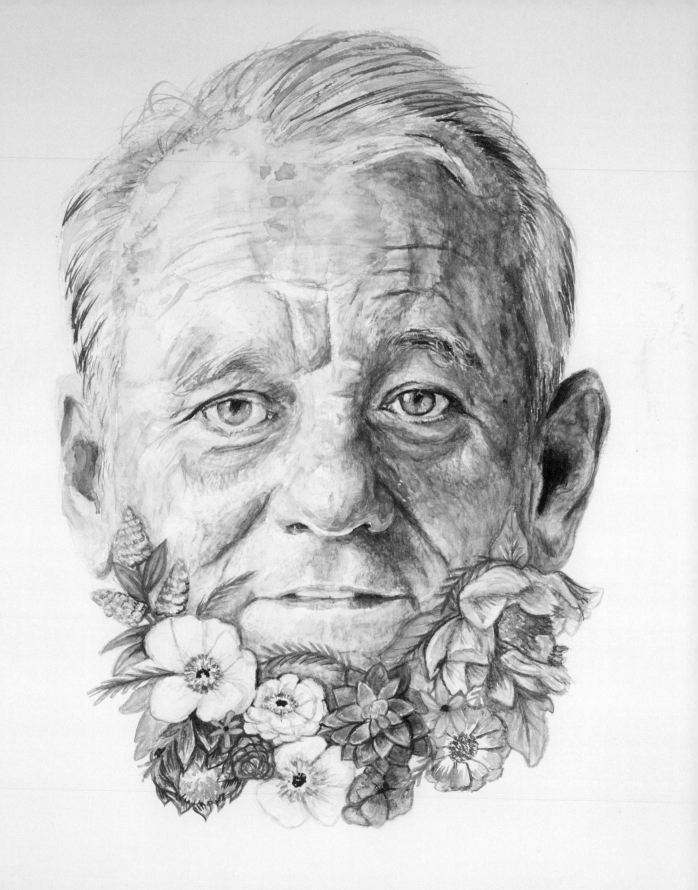

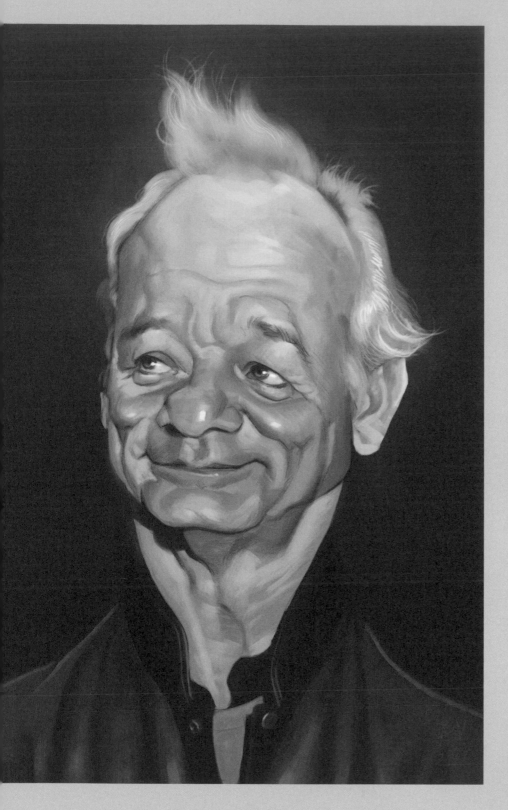

BETTER BE BILL

Bill Murray's role in *Ghostbusters* was originally intended for John Belushi, who passed away suddenly in 1982. Belushi is forever immortalized, however, in the character of party-loving Slimer.

< *Stretch* by Dylan Vermeul

>> *Is It 5:00 Yet?* by Todd Spence

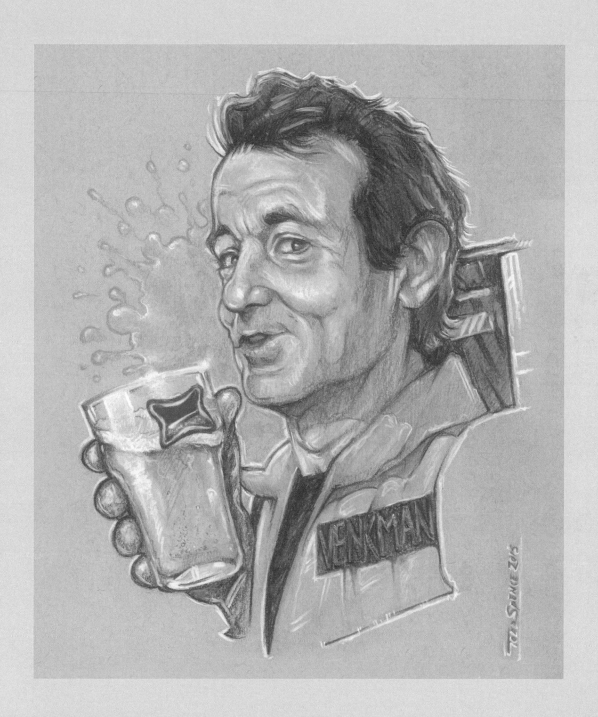

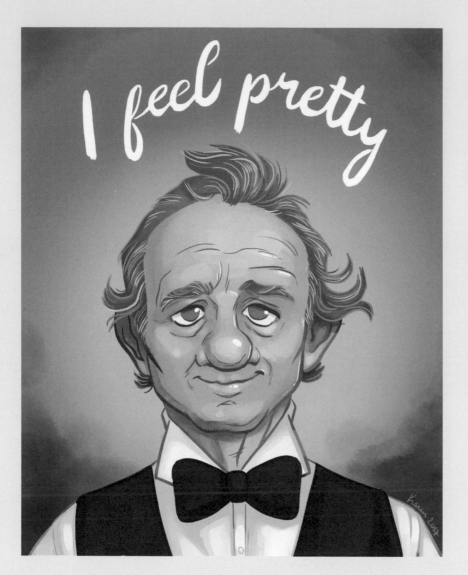

WHERE IN THE WORLD IS BILL MURRAY?

In the middle of a *David Letterman* interview in 2014, Bill Murray announced he was training for the NYC marathon. He applied Ben-Gay and left mid-interview to train . . . all while dressed in a tuxedo.

< *I Feel Pretty* by Karen Krajenbrink

>> *Murray Seal of Approval* by Gregg Firestone

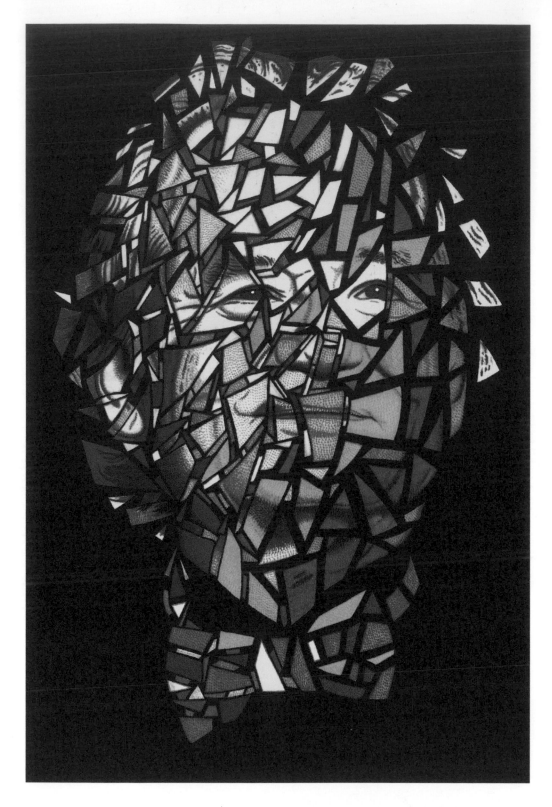

BILL'S SKILLS

During the scene in the sushi bar in *Lost in Translation*, Murray was only told to make Scarlett Johanssen's character laugh. He improvised the entire scene.

> *Suntory Smile* by Jess Kristin

<< *Murray Mosaic* by Justin McAllister

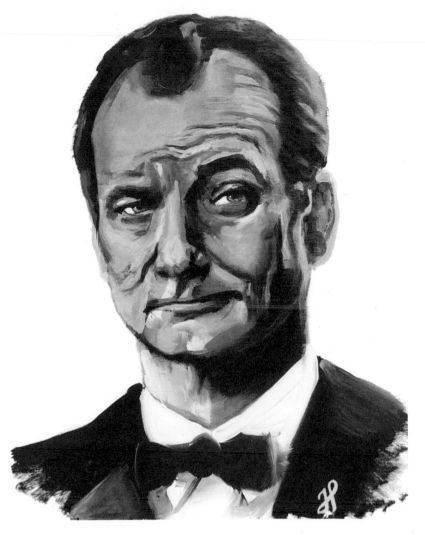

HAH! EVEN IF WE WIN! EVEN IF WE PLAY SO FAR ABOVE OUR HEADS THAT OUR
EVEN IF EVERY MAN WOMAN AND CHILD HELD HANDS TOGETHER AND PRAY
MOHAWK BECAUSE THEY'VE GOT ALL THE MONEY! IT JUST DOESN'T MATTER IF
WE CAN'T SHOOT FOR SHIT. " WHAT'S THE MATTER? YOU'RE PACING LIKE AN EXP
AND THE FISH AND GAME COMMISSION HAS RAISED THE LEGAL KILL LIMIT ON C
HAWK BASKETBALL GAME LEAVING IN 15 MINUTES, AND THERE IS A VERY FAT PA
COULDN'T INVENT SOMEONE LIKE CARL LAZLO. HE WAS A... HE WAS ONE OF A
SPIT OUT THE OTHER SIDE COVERED WITH LIME AND CHALK AND LOOK GOOD
WORKED. " YES SIR, THANK YOU SIR. I PLAYED IN COLLEGE, AND THEY'RE GONNA
ONE AND A HALF OF THE STATE SENATE OF UTAH ARE SCREWHEADS. YOU KNOW
HESE GODDAM SCREWHEADS, THEY TERRIFY ME. AND THE POOR DOOMED, TH
Y ELSE'S MEAL. THEY'RE LIKE PIGS IN THE WILDERNESS. " YOU! WHAT ARE YOU DO
O JOCK, AND WHO DO YOU THINK THEY GIVE ME? THE DALAI LAMA, HIMSELF.
ER. HE HAULS OFF AND WHACKS ONE - BIG HITTER, THE LAMA - LONG, INTO A
GA, GUNGA-LAGUNGA. SO WE FINISH THE EIGHTEENTH AND HE'S GONNA STIF
HERE WON'T BE ANY MONEY, BUT WHEN YOU DIE, ON YOUR DEATHBED, YOU WIL
ENSKEEPER, NOW, ABOUT TO BECOME THE MASTERS CHAMPION. IT LOOKS LIKE
G IS DEAD VARMINT POONTANG, I THINK. " BARK LIKE A DOG. " LICENSE TO KI
MY, AND IN THIS CASE MY ENEMY IS A VARMINT. AND A VARMINT WILL NEVER G
OWER. AND THAT'S ALL SHE WROTE. " NOBODY CRIED WHEN OLD YELLER GO
COW. IT'S CZECHOSLOVAKIA. IT'S LIKE GOING INTO WISCONSIN. " MA'AM, I'M S
ND THAT YOU'RE GOING TO BURN IN HELL FOR ALL THIS " I DON'T LIKE IT WHE
D. " YOU KNOW, I LIKE IT WHEN PEOPLE COME UP TO ME THE NEXT DAY, OR A WE
IONS. " IT SOUNDS LIKE YOU'VE GOT AT LEAST TWO OR THREE PEOPLE IN THERE,
LAID, WE WON'T HAVE ANY TROUBLE! " WE CAME, WE SAW, WE KICKED ITS AS
T, I'M GONNA TURN OVER THE NEXT CARD. CONCENTRATE... I WANT YOU TO TE
CC'S OF THORAZAINE... SHE'S GONNA TAKE A LITTLE NAP NOW. " YOU'RE DAMN
OBLEM. LET'S GO GET HIM! " WHEN PIEDMONT DIED, I HAD TO PAY HIM BACK F
TRYING TO LIVE A GOOD LIFE. UH UH. THERE IS NO PAYOFF - NOT NOW. " IT'S EAS
Y NEED A LONG, SLOW ROOT CANAL " IT'S CHRISTMAS EVE! IT'S... IT'S THE ONE
E. FOR A COUPLE OF HOURS OUT OF THE WHOLE YEAR, WE ARE THE PEOPLE TH
R OWN BODY, STOP THE DAMN HAMMERING? " I NEVER LIKED A GIRL WELL ENC
A SCHMUCK! " 105 YEARS OLD, HE HUNG IN THERE, DIDN'T HE? " OH, NO! I HA
WHO YOU GONNA CALL? " I BET THOSE SCIENCE CHICKS REALLY DIG THAT LAR
LAN WOULD COME BACK TO LIFE NOW AND CHOOSE NEW YORK! TASTY PICK,
HERN CALIFORNIA'S BEAUTIFUL SAN FERNANDO VALLEY! " YOU KNOW, I'M A V
WE CAN DO THIS TOMORROW? " I HAVE MORE THAN TWO GRADES OF LAUNDR
TWENTY MINUTES... IT'S PERFECTLY FINE. " THE MAN IS AN ANIMAL! RIPPING OUT
IT'S THERE. " OH, YOU MUST BE FROM AROUND HERE. " THERE MUST BE ALOT O
SOME SKIS OUT OF LOST LUGGAGE TO COVER YOUR LIMP. " IS THIS SOME RADIC
PARKS THAT WE GET ONE-ON-ONE, WE JUST GOTTA FIGURE OUT A WAY TO WOR
AND SUNDAY? " THERE ARE TWO TYPES OF PEOPLE IN THIS WORLD: THOSE WHO
OZAC THE RIGHT CHOICE? " I FEEL GOOD, I FEEL GREAT, I FEEL WONDERFUL...
LARGE FRIES, TWO CHOCOLATE SHAKES AND ONE LARGE COKE. " I WAS IN TH
T A PREDICTION ABOUT THE WEATHER, YOU'RE ASKING THE WRONG PHIL. I'LL G
THE SAME THING YOUR WHOLE LIFE: "CLEAN UP YOUR ROOM, STAND UP STRAIG
RAILROAD TRACK." " THERE IS NO WAY THAT THIS WINTER IS EVER GOING TO END
OP HIM. " COME ON, ALL THE LONG DISTANCE LINES ARE DOWN? WHAT ABOU
BRITIES? I'M BOTH. I'M A CELEBRITY IN AN EMERGENCY. " WHEN CHEKHOV SAW
CYCLE OF LIFE. BUT STANDING HERE AMONG THE PEOPLE OF PUNXSUTAWNEY
ER. " YOU LIKE BOATS, BUT NOT THE OCEAN. YOU GO TO A LAKE IN THE SUMMEI
F, AND A PLACE YOU USED TO CRAWL UNDERNEATH TO BE ALONE. YOU'RE A S
STAND IN THE SNOW YOU LOOK LIKE AN ANGEL. " SOMEBODY ASKED ME TOD,
NEVADA, OUR NATION'S HIGH AT 79 TODAY." OUT IN CALIFORNIA, THEY'RE GO
, AS YOU CAN SEE, THEY'RE GONNA HAVE SOME VERY, VERY TALL TREES. " I'M F
ANYMORE. " I MAKE THE WEATHER! ALL THIS MOISTURE COMING UP OUT OF TH
HER WITH SOUP. " OH AND INCIDENTLY, I DON'T KNOW WHAT YOU ARE TALKING
ASELVES. " I SHOULD DO SOME SIT-UPS. " YOU ALWAYS GET SOMEONE TO FIGHT
ALL YOUR FRIENDS TO GET BAPTIZED JUST SO YOU CAN MAKE A MONSTER MOV
GHTMARE. WE GOT INTO A CAR ACCIDENT... HE WAS KILLED. OUR LUGGAGE... W
MUNSON, A MAN-CHILD, WITH A DREAM TO TOPPLE BOWLING GIANT ERNIE MC
OKER. BELIEVE ME, AS A BOWLER, I KNOW THAT RIGHT ABOUT NOW, YOUR BLADI
ING OUT LOUD? WAS I? SORRY. GOOD LUCK " YOU'RE ON A GRAVY TRAIN WIT
PERFUME BEFORE YOU COME BACK TO OUR TABLE? " ONE MORE TIME, SWEET
KNOW, THEY SAY AN ELEPHANT NEVER FORGETS. BUT WHAT THEY DON'T TELL Y
OVE. I JUST LIED ABOUT MY SIGN. " OKAY I'VE GOT SOME GOOD NEWS AND SO
E, ISN'T IT? " LARRY'S NOT WHITE. LARRY'S CLEAR. " PRODUCER'S A FRIEND OF N
S BACK THERE. WE WEREN'T IN ANY EMOTIONAL STATE TO PUTT. " SORRY I GET N
REAL NAME. IT DESTROYS THE REALITY I'M TRYING TO CREATE. " STAY AWAY FROM
E'S A DOWN SIDE. " WAS THAT A TEAR? HOW DO YOU PEOPLE DO IT? DO YOU
O YOU ENJOY BEING A GUEST OF THE STATE? " YOU GUYS HAVE IT REAL EASY. I N
COUNTRY: RUSHMORE. NOW, FOR SOME OF YOU IT DOESN'T MATTER. YOU WERE
IN THE CROSSHAIRS AND TAKE THEM DOWN. JUST REMEMBER, THEY CAN BUY
ETTY FIGURED OUT. " MMM, I'M A LITTLE BIT LONELY THESE DAYS. " SO YOU'VE C
E. " COME WORK FOR ME. " I'LL TAKE PUNCTUALITY. " INDEFINITELY. I'M BEING SU
VED THAT WITH DEVOTIONS PIOUS WE DO SUGAR O'ER THE DEVIL HIMSELF. " TH
LY LONG TALK WITH A SQUIRREL ONE TIME. LONGER IN FACT THAN I ON

LEED FOR A WEEK TO TEN DAYS; EVEN IF GOD IN HEAVEN ABOVE COMES DOWN AND POINTS HIS HAND AT OUR SIDE O
US TO WIN, IT JUST WOULDN'T MATTER BECAUSE ALL THE REALLY GOOD LOOKING GIRLS WOULD STILL GO OUT WITH THE G
N OR WE LOSE, IT JUST DOESN'T MATTER! " OK, THE ZONE'S NOT WORKING. THEY'RE A LITTLE TOO BIG TO PLAY MAN-TO-M
FATHER WITH THE CLAP. " IMPORTANT ANNOUNCEMENT - SOME HUNTERS HAVE BEEN SEEN IN THE WOODS NEAR PINEY R
S TO THREE. SO, IF YOU'RE HIKING TODAY, PLEASE WEAR SOMETHING BRIGHT AND KEEP LOW. " ATTENTION. BUS FOR THE C
NTS HANGING ON THE FLAGPOLE THIS MORNING. " BUT, YOU KNOW... SOMEBODY'S GOT TO DRAW THE LINE SOMEWHE
E WAS A MUTANT. A REAL HEAVYWEIGHT WATER BUFFALO TYPE... WHO COULD CHEW HIS WAY THROUGH A CONCRETE
G IT. " IN MY CASE, YOU KNOW, I HATE TO ADVOCATE DRUGS OR LIQUOR, VIOLENCE, INSANITY TO ANYONE. BUT IN MY
OUR DAUGHTER TOO SIR. I'VE HEARD THEIR RALLIES, THEY LIKE JULIE BUT TRICIA... AND THEY REALLY HATE YOU SIR. YOU KI
NEVER REALLY FRIGHTENED BY THE BOPHEADS AND THE POTHEADS WITH THEIR SILLINESS NEVER REALLY FRIGHTENED ME EI
G, AND THE SILLY, THE HONEST, THE WEAK, THE ITALIANS... THEY'RE DOOMED, THEY'RE LOST, THEY'RE HELPLESS, THEY'RE SO
THAT IS FIRE, ASSHOLE! " HEY! NOT FUCKING BAD! " A LOOPER, YOU KNOW, A CADDY, A LOOPER, A JOCK. SO, I TELL THEN
H SON OF THE LAMA. THE FLOWING ROBES, THE GRACE, BALD... STRIKING. SO, I'M ON THE FIRST TEE WITH HIM. I GIVE HIM
OUSAND FOOT CREVASSE, RIGHT AT THE BASE OF THIS GLACIER. DO YOU KNOW WHAT THE LAMA SAYS? GUNGA GALUN
ND I SAY, "HEY, LAMA, HEY, HOW ABOUT A LITTLE SOMETHING, YOU KNOW, FOR THE EFFORT, YOU KNOW." AND HE SAYS,
VE TOTAL CONSCIOUSNESS." SO I GOT THAT GOIN' FOR ME, WHICH IS NICE. " CINDERELLA STORY, OUTTA NOWHERE. A FOR
... IT'S IN THE HOLE! IT'S IN THE HOLE! IT'S IN THE HOLE! " I SMELL VARMINT POONTANG. AND THE ONLY GOOD VARMINT PO
HERS BY THE GOVERNMENT OF THE UNITED NATIONS. MAN, FREE TO KILL GOPHERS AT WILL. TO KILL, YOU MUST KNOW
ER. THEY'RE LIKE THE VIET CONG - VARMINT CONG. SO YOU HAVE TO FALL BACK ON SUPERIOR INTELLIGENCE AND SUPE
? I'M SURE. " C'MON, IT'S CZECHOSLOVAKIA. WE ZIP IN, WE PICK 'EM UP, WE ZIP RIGHT OUT AGAIN. WE'RE NOT GOIN
ERE ARE A LOT OF WAYS I'VE GONE THAT YOU HAVEN'T. " I DON'T THINK I'VE EVER BEEN THIS HAPPY. " OH, MY BALLS! " I'M
E COME UP TO ME AFTER MY PLAYS AND SAY, "I REALLY DUG YOUR MESSAGE, MAN." OR, "I REALLY DUG YOUR PLAY, M
R, AND THEY SAY, "I SAW YOUR PLAY. WHAT HAPPENED?" " YOU SLUT. " THIS CITY IS HEADED FOR A DISASTER OF BIBLICAL
Y. " WE'VE BEEN GOING ABOUT THIS ALL WRONG. THIS MR. STAY PUFT'S OKAY! HE'S A SAILOR, HE'S IN NEW YORK; WE GET
SHE'S A DOG... " I DON'T HAVE TO TAKE THIS ABUSE FROM YOU, I'VE GOT HUNDREDS OF PEOPLE DYING TO ABUSE ME.
WHAT YOU THINK IT IS. " I THINK WE CAN GET HER A GUEST SHOT ON "WILD KINGDOM." I JUST WHACKED HER UP WITH A
NG, NOTHING LASTS FOREVER! " YOU GO ON AHEAD. I'M GONNA SAY MY PRAYER. " IT'S THAT KID! I KNEW HE WAS GONN
LIFE. I FOUND OUT THERE'S ANOTHER DEBT TO PAY - FOR THE PRIVILEGE OF BEING ALIVE. I THOUGHT SOPHIE WAS MY REW
A HOLY MAN ON TOP OF A MOUNTAIN. " IT'S VERY EASY TO LOVE SOMEONE LIKE YOU. " I THINK I NEED A ROOT CANAL. "
OF THE YEAR WHEN WE ALL ACT A LITTLE NICER, WE... WE... WE SMILE A LITTLE EASIER, WE... W-W-WE... WE... WE CHEER A L
LWAYS HOPED WE WOULD BE! " I MAY BE INVISIBLE, BUT I AM NOT DEAF! " WOULD YOU PLEASE, FOR THE LOVE OF GOD,
O GIVE HER TWELVE SHARP KNIVES. " THE JEWS TAUGHT ME THIS GREAT WORD: SCHMUCK. I WAS A SCHMUCK. AND NOW
NEW CHEAP MOVES. " KITTEN, I THINK WHAT I'M SAYING, IS THAT SOMETIMES, SHIT HAPPENS, SOMEONE HAS TO DEAL WI
NIUM OF YOURS, HUH? " YOU KNOW, I HAVE MET SOME DUMB BLONDES IN MY LIFE, BUT YOU TAKE THE TACO, PAL! ONLY A G
HEAD! IF YOU HAD BRAIN ONE IN THAT HUGE MELON ON TOP OF YOUR NECK, YOU WOULD BE LIVING THE SWEET LIFE O
REN'T YOU SUPPOSED TO LIE TO ME AND KISS MY BUTT? " BOYS, BOYS, YOU'RE SCARING THE STRAIGHTS, OKAY? IS THERE
Y? THERE'S NOT JUST CLEAN AND DIRTY. THERE ARE MANY SUBTLE LEVELS. OKAY? SEE? YOU HANG THIS OUTSIDE THE WIND
S, URINATING ON DESKS... YOU SEE WHAT HE DID TO MS. COCHRAN'S SHIRT? THERE'S A SCRATCH HERE, I MEAN, IT'S NOT L
PETITION FOR THAT CORNER. " THANK YOU ROY. GOD! ALRIGHT, ROY'S GOING TO GET US THE DUGGLE BAG, A WHEELC
THERAPY? " IT WAS AN INTERESTING MORNING, FRUITFUL. BUT IT LACKED THE INTENSITY THAT YOU AND I GENERATE TOGE
ND YOUR SCHEDULE. COULD WE WORK AFTERNOONS? TWO TO FOUR? THREE TO FIVE? MONDAY, WEDNESDAY, FRIDAY, SA
EIL DIAMOND, AND THOSE WHO DON'T. MY EX-WIFE LOVES HIM. " EXCUSE ME, PHIL, BUT WITH THESE PARTICULAR SYMPTO
GOOD, I FEEL GREAT, I FEEL WONDERFUL... I FEEL GOOD, I FEEL GREAT, I FEEL WONDERFUL... " YEAH, THREE CHEESEBURG
N ISLANDS ONCE. I MET A GIRL. WE ATE LOBSTER, DRANK PINA COLADAS. AT SUNSET, WE MADE LOVE LIKE SEA OTTERS. "
J A WINTER PREDICTION: IT'S GONNA BE COLD, IT'S GONNA BE GREY, AND IT'S GONNA LAST YOU FOR THE REST OF YOUR
K UP YOUR FEET. TAKE IT LIKE A MAN. BE NICE TO YOUR SISTER. DON'T MIX BEER AND WINE, EVER." OH YEAH: "DON'T DRIV
G AS THIS GROUNDHOG KEEPS SEEING HIS SHADOW. I DON'T SEE ANY OTHER WAY OUT. HE'S GOT TO BE STOPPED. AND I H
ATELLITE? IS IT SNOWING IN SPACE? DON'T YOU HAVE SOME KIND OF A LINE THAT YOU KEEP OPEN FOR EMERGENCIES OR
NG WINTER, HE SAW A WINTER BLEAK AND DARK AND BEREFT OF HOPE. YET WE KNOW THAT WINTER IS JUST ANOTHER ST
SKING IN THE WARMTH OF THEIR HEARTHS AND HEARTS. I COULDN'T IMAGINE A BETTER FATE THAN A LONG AND LUSTR
YOUR FAMILY UP IN THE MOUNTAINS. THERE'S A LONG WOODEN DOCK AND A BOATHOUSE WITH BOARDS MISSING FROM
FOR FRENCH POETRY AND RHINESTONES. YOU'RE VERY GENEROUS. YOU'RE KIND TO STRANGERS AND CHILDREN, AND W
L, IF YOU COULD BE ANYWHERE IN THE WORLD, WHERE WOULD YOU LIKE TO BE?" AND I SAID TO HIM, "PROB'LY RIGHT H
VE SOME WARM WEATHER TOMORROW, GANG WARS, AND SOME VERY OVERPRICED REAL ESTATE. UP IN THE PACIFIC NO
G THE SAME DAY OVER AND OVER. " IT JUST TAKES AN AWFUL LOT OF WORK. " I KILLED MYSELF SO MANY TIMES I DON'T E
WILL PUSH OFF TO THE EAST AND HIT ALTOONA. " YOU LOVE HER? I OWN HER! " DO YOU KNOW WHAT BOTULISM IS? WE
A GUY IN A GARBAGE PAIL... BUT UH, MOST OF THE PEOPLE I KNOW WHO DON'T DIE IN BED... THEY USUALLY WIND UP KIL
GHTS FOR YOU? " WHO AM I TO TALK? YOU ALRIGHT HAROLD? " RAVE OF THE CENTURY. " HOW DO YOU DO IT? HOW DO
T'S HEAR YOU CALL BORIS KARLOFF A COCKSUCKER. " OH, WHAT DOES THAT OLD QUEEN KNOW? " OH, THAT. MEXICO W
LEN, THE SURGEON... TURNED OUT TO BE... A QUACK. IF IT HADN'T BEEN FOR THESE MEN... " IT ALL COMES DOWN TO THIS R
EN. IF HE STRIKES, HE'S THE 1979 ODOR-EATERS CHAMPION. HE'S GOT ONE FOOT IN THE FRYING PAN AND ONE IN THE PRES
LS LIKE AN OVERSTUFFED VACUUM CLEANER BAG AND YOUR BUTT IS KINDA LIKE AN ABOUT-TO-EXPLODE BRATWURST. " V
IT WHEELS. " KEEP 'EM COMIN', SWEETS, I GOT A LONG DRIVE. DO ME A FAVOR, WILL YOU? WOULD YOU MIND WASHING
I'LL SAY. PROBABLY A YEAR FOR EVERY TOPPING ON THE TABLE. I HEARD A HORRIBLE RUMOR... " THAT'S STILL VERY GOO
HAT YOU NEVER FORGET AN ELEPHANT. " FINALLY, I GOT OVER IT. " I'M A MOTIVATOR, NOT A PHYSICAL THERAPIST. " I MU
NEWS. THE GOOD NEWS IS IT'S ALL DOWNHILL FROM HERE. THE BAD NEWS IS YOU'RE GOING TO CARRY ME. " IT'S 'CAUS
E SENT A TEAMSTER TO DROP ME OFF. " IT IS ALIVE! " LARRY, THAT COULD HAVE BEEN ME. " LARRY, I'M GONNA GIVE US
BIT INSENSITIVE, BUT I'M A HITMAN! " TIME OUT! TIME OUT! I GOT SOMETHING IN MY EYE, JAGOFF! " PLEASE DON'T CALL M
PHONE! " YOU MATEY, YOU JUST STABBED ME WITH YOUR PEN. " THEY PAY ALL YOUR EXPENSES, YOU'RE LICENSED TO KILL
OURSELF IN THE EYE? OR ARE YOU THINKING RIGHT NOW "MY DOG IS DEAD"? " KELLY VAN RYAN? AS IN SANDRA VAN R
HAD IT LIKE THIS WHERE I GREW UP. BUT I SEND MY KIDS HERE BECAUSE THE FACT IS YOU GO TO ONE OF THE BEST SCHOO
RICH AND YOU'RE GOING TO STAY RICH. BUT HERE'S MY ADVICE TO THE REST OF YOU: TAKE DEAD AIM ON THE RICH BOYS
NG BUT THEY CAN'T BUY BACKBONE. DON'T LET THEM FORGET IT. THANK YOU. " ANNA TOMBACZ " YEAH, YOU SEEM TO
D YOUR MIND AND YOU WANT THE JOB. " NEVER IN MY WILDEST IMAGINATION DID I EVER DREAM I WOULD HAVE SON
DIVORCE. " IF YOU GUYS ARE GOING TO KILL MY JOKE AT LEAST KILL IT RIGHT. " WE ARE OFT TO BLAME IN THIS, TIS TOO M
FUNNY. A FRIEND OF MINE TOOK A FIGHTING MUFFIN IN THE CHEST; THEY SENT HIM HOME IN FOUR ZIPLOC BAGS. " AND
PEOPLE. " 99 KINDS OF WINGS! 128 DIFFERENT DIPPING SAUCES! YOU LOVE MATH, CRUNCH THE NUMBERS ON THAT. ANI

"HERMAN BLUME"

Rushmore

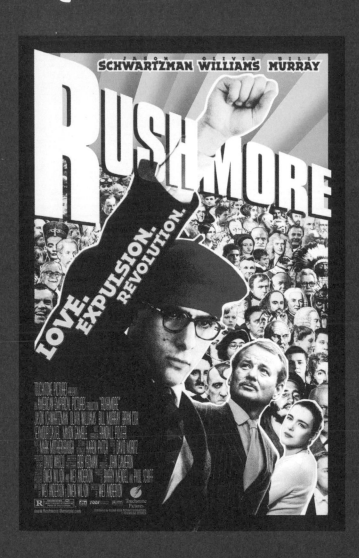

This pithy triangle between widowed first-grade teacher Rosemary Cross (Olivia Williams), striving high schooler Max Fischer (Jason Schwartzman), and wealthy businessman Herman Blume (Bill Murray), stands on its own as a charming paean to the mysteries of love. It's also the first time we see Murray in a Wes Anderson film, and that is love at first sight. Anderson's deliberately stilted dialogue, visual puns, and nearly natural characters lie somewhere between interior monologue and wishful thinking for how we live our lives; he gives Murray an entirely new universe and vernacular to explore, and Murray thrives in Anderson's meticulously manicured worlds.

Murray's Blume is focused and decisive in business, but wistful and hopeful in his friendship with Max and his love of Olivia. It's a kinder, gentler Murray, one who seems to surprise even himself with its subtlety and humanity. At first, he's lonely and surprised by Max's friendship and Olivia's attention. Then he's angered by Max's competitive possession of Olivia, and her reluctance to continue an affair with him. Eventually, he comes to understand them, and himself, as flawed and lonely humans just trying to connect.

The dichotomies of Murray's Blume are well matched in Schwartzman's film debut as Max Fischer. Fischer is the precocious adolescent whose ruthless pursuit of extracurricular activities at the elite Rushmore School becomes supplanted by his pursuit of the fetching teacher. He is an iconoclastic dynamo who fills the sadness in his heart with achievement; Max is in an awkward child-man phase that seems familiar, if exaggerated; he makes us wonder if that's how Blume was before he conquered business, too. When Blume realizes he loves Cross, he regresses to a man-child, matching Fischer's level of adolescent one-upmanship and palpable yearning. It would be painful to watch if it wasn't so well done, and so heartfelt. When the characters do get a hold of themselves, they are wiser and more forgiving of themselves and one another. Rushmore Academy ultimately offers them a privileged education of the heart.

BEHIND THE SCENES

Murray loved the script for *Rushmore* so much that he immediately signed on and ended up working on the film at scale, which Anderson estimated at about $9,000.

"POLONIUS"

Hamlet

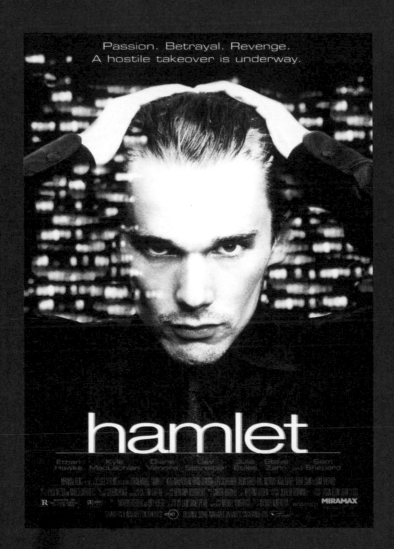

Bill Murray finally found a scriptwriter he cannot ad-lib—that other awesome Bill, Shakespeare. In this achingly updated Y2K version, he is perfectly cast as the solicitous courtier Polonius, advisor to kings and father to Hamlet's love interest, Ophelia, a waiflike Julia Stiles. Ethan Hawke plays the disaffected trustafarian Prince Hamlet, coolly observing the hostile takeover of Denmark "Corporation" by his uncle, King Claudius, played by a slick Kyle MacLachlan, who holds forth from the Trump Tower-esque high-rise, Elsinore Hotel. It's the year 2000 in Manhattan, and everything, including power, is for sale. Cultural references abound, with endless bottles of Danish Carlsberg beer being downed in front of televisions that show earlier film versions of *Hamlet*, reminding us of its relevance to each generation.

As advisor to King Claudius and Queen Gertrude, Murray's Polonius manages upward with unctuous flair—his language is flowery, his reasoning is elaborate, his behavior is obsequious. Freed from the expectation of comedy, Murray uses intonation and gesture to convince us to value Polonius, who is struggling to keep his position as the corporate shakedown makes his role even more precarious. When lecturing his son, Laertes (Liev Schrieber), and daughter, Ophelia, he is less guarded and more direct, but equally strategic; he wants them to play the game to maintain their position and power as he does. In his "To thine own self be true" speech, one of the greatest litanies of parental advice ever given, he outlines the behavior he believes kept him on as advisor to successive chief executives. But there's a disconnect; we don't see Polonius following his own recommendations. He becomes Shakespeare's favorite trope, a wise fool who cannot see how foolish he actually is. In playing the part, Murray does what only Murray can—he uses delivery and inflection to make us listen anew to a speech we have heard many times before. It may be one of his finest monologues ever.

But Polonius can't hear or help himself. Secretly meeting with Queen Gertrude in her bedroom to convince her that her son, Hamlet, is mad, he is also trying to convince her that he is necessary to her and the organization. When Hamlet unexpectedly turns up, Polonius hides in the Queen's dressing room to eavesdrop unseen. Hamlet hears something stirring and blindly shoots, mortally wounding Polonius in one eye. Half-blinded literally and figuratively, Polonius' dying glance to Hamlet and Gertrude is a macabre tour de force; his knowing, wordless look tells us he finally realizes the folly of this advisory role. Having taken his own advice to "give every man thy ear, but few thy voice," he dies the opposite of how he lived, a silent and hapless victim. A mournful Hamlet says, "Thou wretched, rash, intruding fool, fare thee well. I took thee for thy better." He is genuinely sorry to see Polonius go, and surprisingly, so are we.

BEHIND THE SCENES

Years before his role in *Hamlet*, Bill Murray took workshops with esteemed vocal coach Kristin Linklater, and it shows in his flawless delivery of Shakespeare.

"RALEIGH ST. CLAIR"

The Royal Tenenbaums

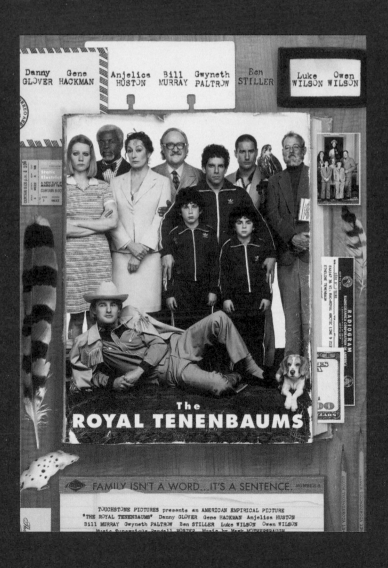

Writer-director Wes Anderson provides a curiously exaggerated tale of the brilliant but fractured Tenenbaum family in an ensemble tour de force. Gene Hackman plays Royal Tenenbaum, the estranged husband of long-suffering archaeologist Eveline (Anjelica Huston) and father of their three grown children: the widowed financial wizard and overprotective father, Chas (Ben Stiller); the pensive, lovesick, retired tennis pro, Richie (Luke Wilson); and the moody, adopted playwright daughter, Margot (Gwyneth Paltrow).

As patriarch Royal Tenenbaum reenters their lives to make amends for a lifetime of bad behavior, he disrupts the status quo of each of their lives, forcing each of them to examine themselves. Moody, headstrong Margo is unhappily married to neurologist Raleigh St. Clair (Bill Murray), a character loosely based on the real-life British neurologist Oliver Sacks, bushy beard and all. St. Clair is proud of Margot's accomplishments, doting and eager to please her; alas, she does not return his ardor. Murray's portrayal of the resigned husband is a wry parody of psychiatric gravitas; he's self-important but sad, maintaining his calming shrink persona as he ruefully watches Margot slip away, first in favor of novelist Eli Cash (cowriter Owen Wilson) and then her adoptive brother Richie.

Margot's distinctive kohl-eyed, mink-and-Izod-clad siren remains the silent center of attention for her three suitors. Wry intellectualism and narcissism have clouded their world like the cigarettes Margo furtively chain-smokes, but, ultimately, they find a way to get along. As the characters work out a lifetime of affronts and misunderstandings, they approach revelation and acceptance, if not happiness. It's all absurdly self-referential in a charmingly stilted way. Like so many royal families, the Tenenbaums carry their struggles individually, but manage to intertwine their lives as part of a messy but enveloping tapestry of support, understanding, and love.

BEHIND THE SCENES

Richie's hawk, Mordecai, was actually kidnapped and held for ransom while they were filming *The Royal Tenenbaums.* He was never found, and they needed to use a different bird for the remainder of the film.

"BOB HARRIS"

Lost in Translation

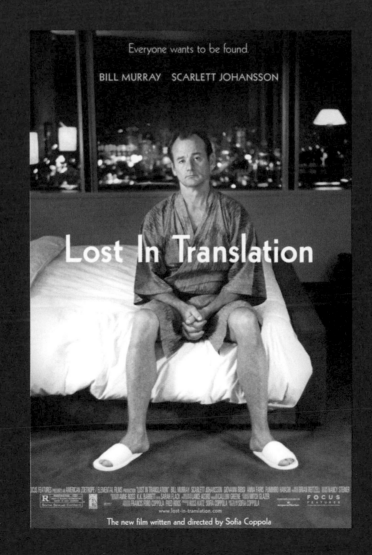

Everyone wants to be found.

BILL MURRAY SCARLETT JOHANSSON

Lost In Translation

The new film written and directed by Sofia Coppola

The film where nothing happens is everything. Director Sofia Coppola wrote this role for Bill Murray—if he hadn't agreed to it, she says the film would not have happened, and it is certainly among his finest performances. His character, Bob Harris, is a world-weary, jet-lagged, middle-aged Murrayesque actor sequestered fifty-two stories above Tokyo in the Park Hyatt hotel. His trip is reluctant but lucrative—he is there to film a Suntory whisky commercial for $2 million, shepherded by a phalanx of corporate functionaries and translators, and confused by a director he cannot understand in any language.

Back at the hotel, Harris spies sweet-faced twentysomething ingénue Charlotte (Scarlett Johansson) in the elevator and later in the loungy hotel bar; she is aimlessly whiling her days, waiting for her narcissistic photographer husband on assignment. Bob and Charlotte agree to hang out, revealing the empty spots of their lives to one another, even as they resist the romantic tension that builds as slowly as a tea ceremony. He is trapped in a haranguing marriage that he avoids, which generates more harangues. She is biding time and seeking her life's purpose, her recent Yale degree in philosophy hanging over her head like the glaring neon signs in Shibuya, blinking "what next?" They feel for one another, and for the loneliness in themselves, but they know the prospect of a fleeting romance is ill-advised. So they brood, and emote, and platonically share the impossibly layered culture of Japan. They invite us into their dark and familiar place of boredom, and ennui, and anxiety about how to have the glittering, shiny life that outsiders think they should have as movie stars and comely intellectuals. They speak with their eyes, and their silences, and their absences from one another, resisting the temptation to do the obvious in lieu of treasuring the exquisite dance of possibility. At one point, an aimless Charlotte wanders into an Ikebana flower-arranging class, an exercise in beauty and restraint, her controlled action reinforcing the intention of this surprisingly human film.

When Bob and Charlotte leave one another in the hotel lobby, the sadness of lost opportunity, and the relief of ill-fated romantic potential is palpable; nothing has happened between them, except the experiences of Japan and one another. And then, trapped in his taxi to the airport, Bob spies Charlotte on the street, and rushes to see her again. They kiss passionately for the first and last time—perhaps the best unscripted Murray moment ever—and suddenly it all makes sense between them. Like a Shinto prayer, they live inside a glorious, fully realized instant. They may be lost in Tokyo, and in their lives, but they are finally able to share the same language of the heart without remorse, or tension, or translation.

BEHIND THE SCENES

Sofia Coppola wasn't sure if Bill Murray was actually going to appear in Tokyo for filming, having only received a verbal confirmation that he would do the part.

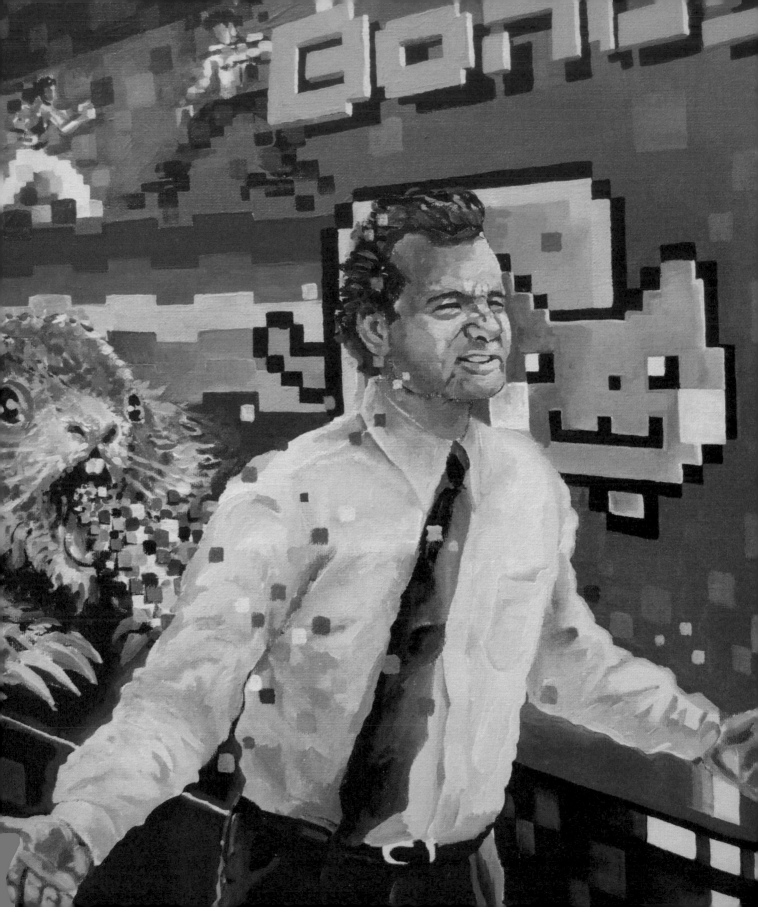

The Exasperated

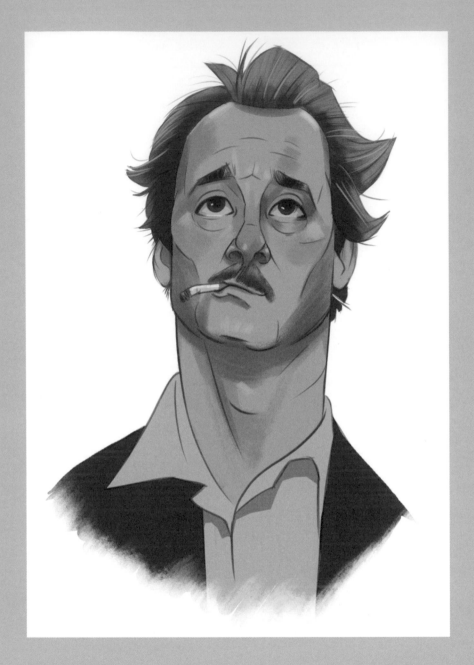

BILL'S SKILLS

Bill Murray read the script for the Amish bowling comedy *Kingpin*, but ended up rejecting the mediocre dialogue in the script and made up most of his lines.

∧ *Bill Murray* **by Peter Slattery**

>> *Groundhog Day* **by Post Typography**

Previous spread: *Bill-M* **by Stephen Schisler**

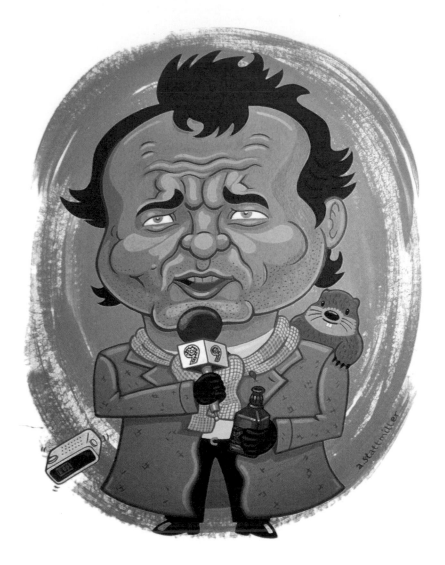

OUCH!

It turns out groundhogs aren't very friendly. Murray was bitten by Scooter, the groundhog, twice during shooting and had to get rabies shots.

∧ *Groundhog Day* by Andy Stattmiller

>> *Groundhog Day* by Graham Corcoran

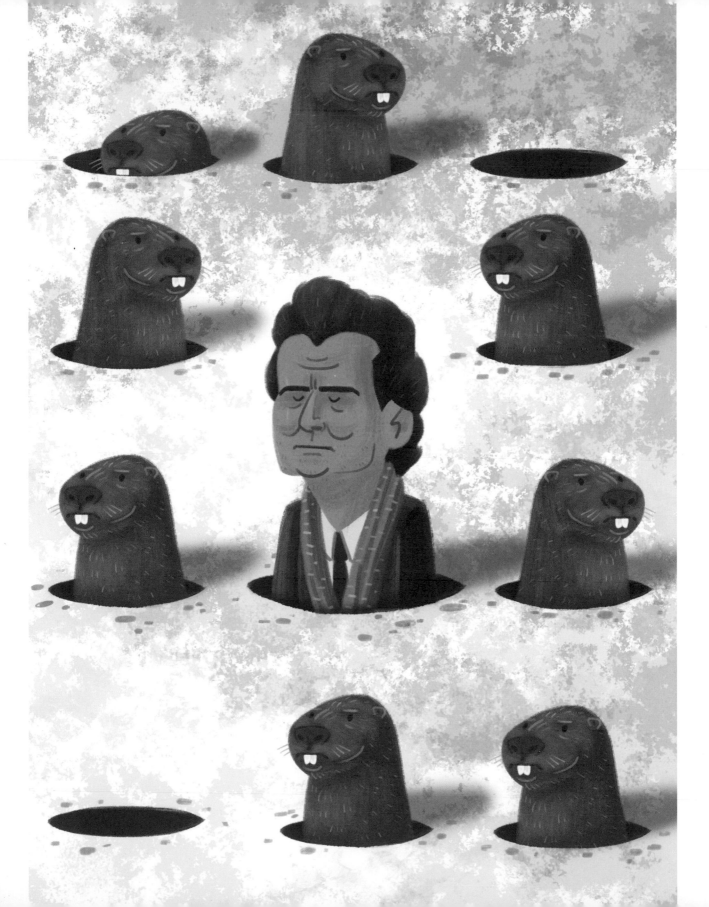

BETTER BE BILL

Before Bill Murray nailed the part, producers considered
Tom Hanks, Michael Keaton, and John Travolta for the role
of Phil Connors in *Groundhog Day*!

∧ *Bill* by Angelina Gemuend

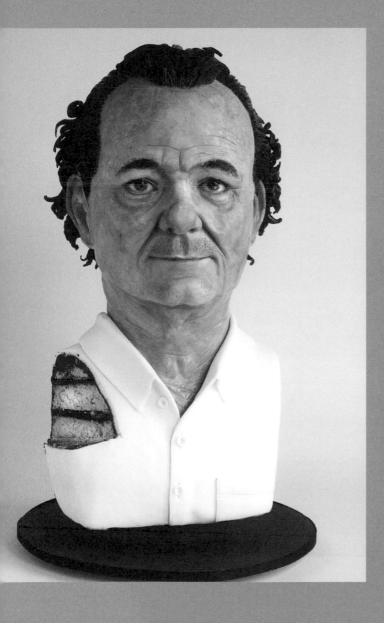

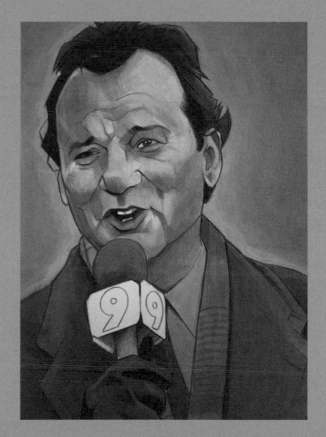

BILL'S THRILLS

Murray admitted he drove Richard Dreyfuss nuts during filming of *What About Bob?*, but felt it ultimately worked for the movie.

< *What About Bob Cake* by Avalon Cakes

∧ *Phil Connors* by Ryan Gajda

"STEVE ZISSOU"

The Life Aquatic with Steve Zissou

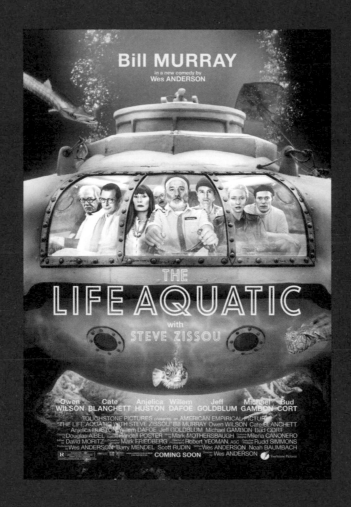

What do you do after falling in love on the fifty-second floor of a Tokyo hotel? You get lost in your own translation, underwater. Indie director Wes Anderson gives Murray the title role and the helm as Steve Zissou, a literally washed-up television oceanographer with a failing marriage, a sinking viewership, and a ship of intern fools. Murray plays Zissou somewhere between Captain Ahab and Captain Nemo, with the barest touch of Captain Cousteau: determined, dismissive, and disaffected. But Murray makes it clear that Zissou's disregard is a by-product of his depression that life has not turned out as planned—he is a partly sympathetic sailor whose moments of honor and generosity may or may not be self-serving.

The crew of characters is equally Anderson-absurd: a Kentucky airline pilot who might be his son (Owen Wilson), a jealously mutinous mate (Willem Dafoe), a coolly caustic wife (Angelica Huston), a narcissistic nemesis (Jeff Goldblum), and an alluring investigative journalist sporting a (real!) baby bump (Cate Blanchett). When you put them aboard a revenge voyage in search of the killer jaguar shark and insert a feral pack of Filipino pirates, you need a sextant just to parse the plot. The film teems with sly Andersonian homage—Zissou's ship is called the Belafonte, the ship is docked on Port-au-Patois, and the ship's safety officer, Pele, regularly serenades with Bowie songs sung in Portuguese. Every delicious detail seems to have something to say to or about Zissou: the monogrammed matchy-matchy uniforms, the individuated red watch caps, the humiliating intern tees. At the time of release, the resulting film was not well received: too complex, too stilted, too self-indulgent—much like the criticism directed at Murray's acting. But like so many voyages seen in hindsight, the depth charge is imperceptible—this is a film, and a performance, that reveals itself through a periscope rather than cinemascope. As it dives deeper and deeper into Zissou's life aquatic, it reveals a man of quiet majesty who leaves the choppy current far above and genuinely revels in the kaleidoscope of characters swimming smoothly below.

BEHIND THE SCENES

While filming *The Life Aquatic with Steve Zissou*, Bill Murray became a certified diver, logging over 40 hours.

"DON JOHNSTON"
Broken Flowers

WINNER · Grand Prix

2005 CANNES FILM FESTIVAL

BILL MURRAY

JEFFREY WRIGHT

SHARON STONE

FRANCES CONROY

JESSICA LANGE

TILDA SWINTON

JULIE DELPY

BROKEN FLOWERS

a new film by JIM JARMUSCH

Bill Murray plays Don Johnston, a financially successful middle-aged loner whose beautiful, exasperated girlfriend (Julie Delpy) has just walked out on him. On the same day, he receives a mysterious unsigned pink note from a former flame who says a long-ago liaison created a nineteen-year-old son "who may come looking for you."

Johnston is discomfited—the mother could be one of five women he was dating around that time, none of whom have remained in his life. His beloved Ethiopian neighbor, Winston (Jeffrey Wright), an amateur sleuth and extroverted family man, encourages Johnston to go visit each of them to learn more, and Johnston reluctantly, anxiously agrees. Winston coaches him to bring pink flowers to each encounter, and to be on the lookout for indications of a son.

When Johnston visits lonely widowed Laura (Sharon Stone), and her aptly named daughter, Lolita, and then stilted, anxious Dora (Frances Conroy) and her doting husband, Ron, he comes no closer to knowing about them, and realizes how little he knows about himself. His next encounter, with lawyer-turned-animal-behaviorist Dr. Carmen Markowski (Jessica Lange), is brief and tense; she wants nothing of this past in her present, even having her assistant return his flowers. His visit to angry biker chick Penny (Tilda Swinton) is explosive from the start; she vents her anger at the pain of their breakup, and her current boyfriend leaves Johnston with a black eye and broken flowers. His final pilgrimage is to the gravesite of a girlfriend who died a few years before; he leaves a bouquet of pink flowers, and gains the realization of how short life truly can be. Dejectedly returning home, Johnston engages a young man who dresses like he does and claims he is on a journey of sorts—is this his son? He conjectures out loud, and the young man bolts before he can find out. Don Johnston is left unknowing.

This exquisitely wrought meditation almost caused Bill Murray to retire—because he felt this film elicited the best performance of his life. Murray gives the subtlest of bravura renditions of the melancholy Johnston. He has more telling facial expressions than spoken lines; he reveals everything we need to know through his eyes. There is no slapstick, no snark, no winning us over with his witty charm. Murray's Johnston is leading his life like all of us do, accumulating his share of success and sadness, and realizing the pain we feel and cause in others. Writer-director Jim Jarmusch lingers on the discomfort, emphasizing the awkward pauses and the unsaid affirmations, allowing us to put ourselves into the what-ifs of Johnston's middle age. He gives Murray permission to be Everyman instead of Murray's usual Exceptional Man. The result is a painful, perfect depiction of a compromised human who is as broken and beautiful as his flowers.

BEHIND THE SCENES

Bill Murray's real-life son, Homer Murray, has a cameo in *Broken Flowers*. He is in a passing car at the end of the film, and he looks into the camera as he passes.

"BILL FUCKING MURRAY"

Zombieland

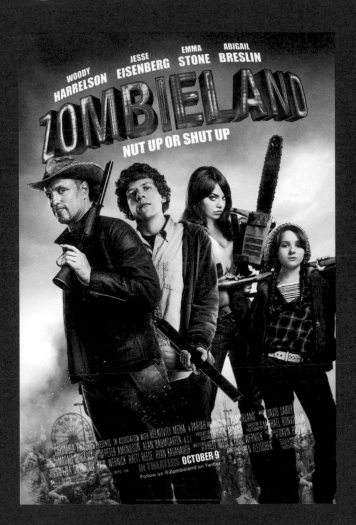

This comic horror movie imagines a dystopian America where nearly everyone is consumed by zombies, former humans who have been converted into insatiable flesh-eating monsters. Among the few humans left, nerdy college student Jesse Eisenberg plays Columbus, a loner on a futile journey to find his family back in Ohio. His survival guidelines are thirty-two comic rules that pop up on the screen—video-game style—and are tested throughout the narrative.

Along his journey he encounters the fearless, faithless Tallahassee (Woody Harrelson), who seems to have little purpose but to kill zombies and sniff out Twinkies moldering at abandoned convenience stores along the way. Fiercely protective sisters Little Rock (Abigail Breslin) and Wichita (Emma Stone) eventually join on as a pair, outwitting the men enough to earn their reluctant trust.

The unlikely quartet ends up in Hollywood, where they use a map of stars' homes to guide them to the mansion of Tallahassee's idol, the actor Bill Murray. Murray may or may not be a zombie living in a palatial estate with more fake rococo than Mar-a-Lago. Murray plays himself to perfection in a sequence that is exactly what you'd expect of Murray in a zombie dystopia: funny, mordant, wistful, like catching up with your high school best friend on the eve of the apocalypse. The self-referential humor is complete when we watch Murray in full zombie makeup acting out a scene from *Ghostbusters*. Then the situation turns dark (no spoilers) and Columbus, Tallahassee, Wichita, and Little Rock head out to Pacific Playland, an amusement park where there are supposedly no zombies. Wrong again. The whole thing is over-the-top humorous, ironic, and a bloody good time. The action-packed cliffhanger ending at Playland hearkens back to Orson Welles's *The Lady from Shanghai*. As we watch in the uneasy space between humor and horror, Playland transforms into Zombieland, a park once designed for its visitors' amusement—and now, namely, for ours.

BEHIND THE SCENES

Patrick Swayze was originally going to be cast as the celebrity zombie. He was going to parody his classic roles in *Ghost* and *Dirty Dancing*, including a "lift" scene with Woody Harrelson. When Swayze became ill, Woody Harrelson offered to contact Bill Murray to replace him.

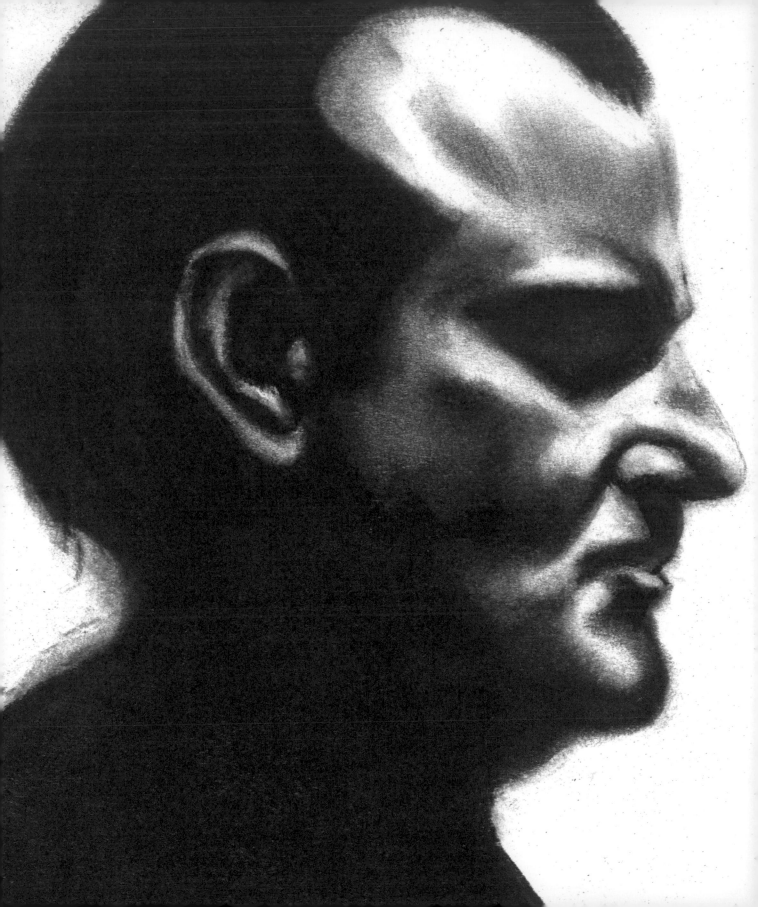

The Melancholy

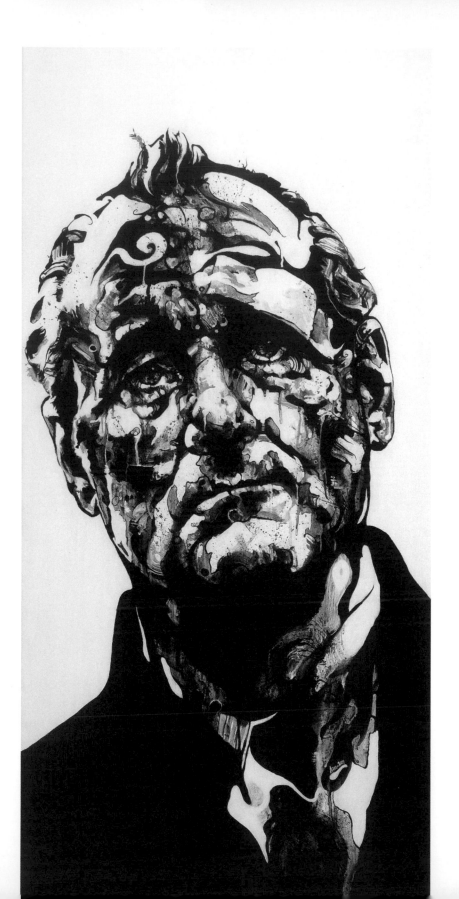

WHERE IN THE WORLD IS BILL MURRAY?

Director Ted Melfi left multiple voicemails, letters, and scripts to random PO boxes hoping to convince Bill Murray to take the role in *St. Vincent*.

< *Too Little* by Aaron Reichert

>> *Bill Murray Can Have This Painting* by Tracy Piper

Previous spread: *Bill in Profile* by Angela Meyers

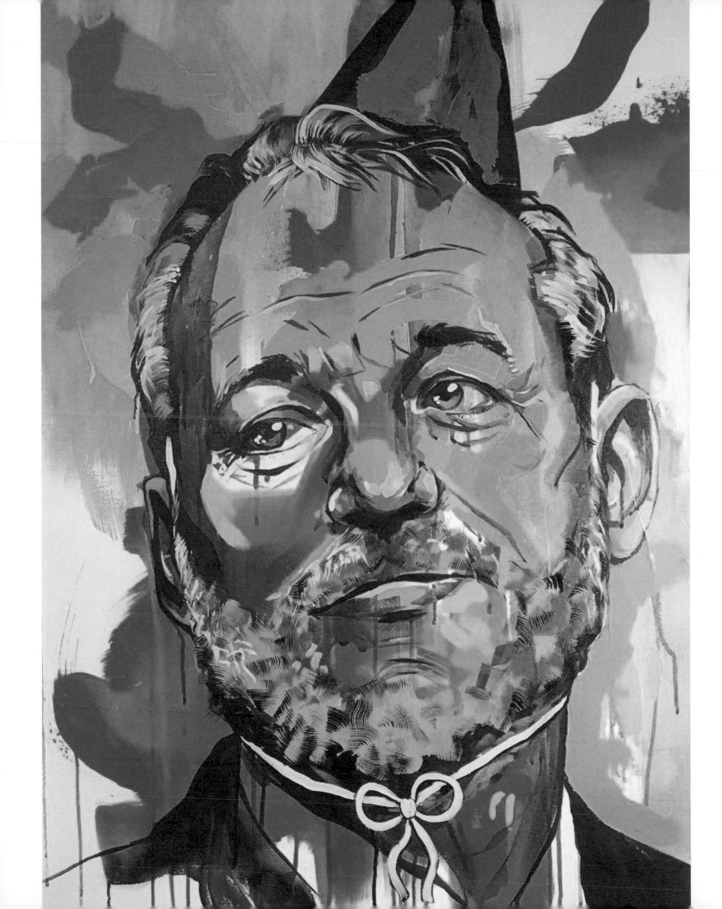

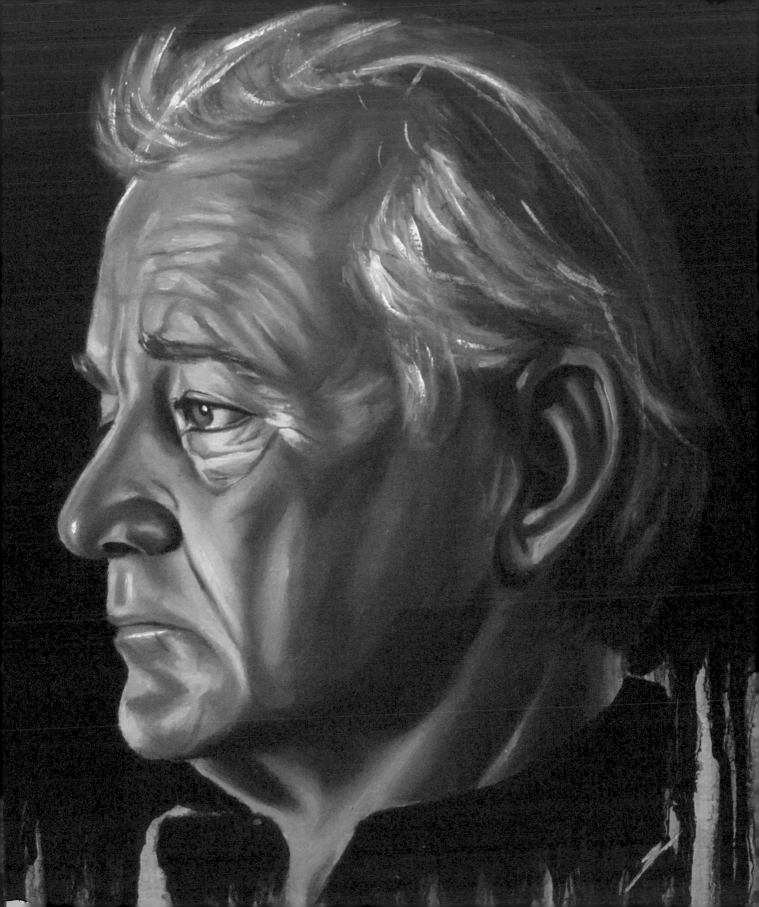

MUSICAL MURRAY

Bill Murray chose to sing Bob Dylan's "Shelter from the Storm" at the end of *St. Vincent*.

> *Bill Murray Undone* by Ryan Gajda

<< *Bill Murray* by Luis Tinoco

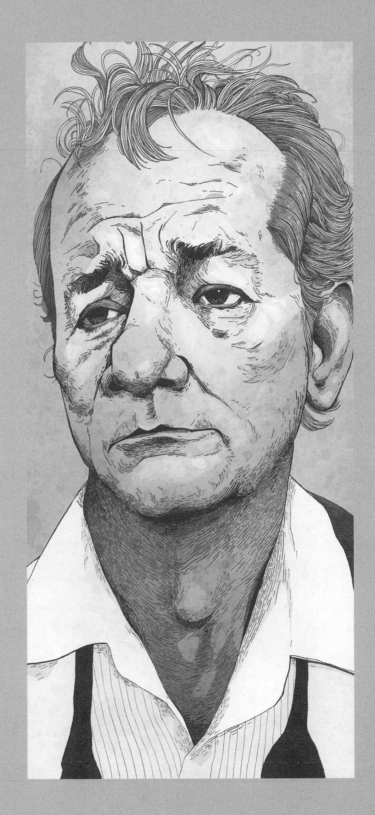

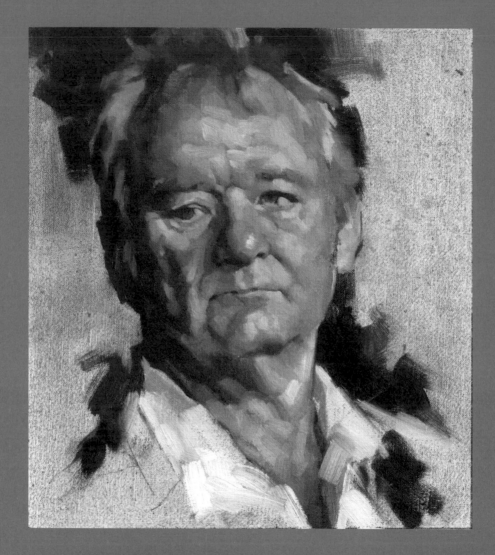

WHERE IN THE WORLD IS BILL MURRAY?

While filming The *Life Aquatic with Steve Zissou*, Bill Murray had to temporarily leave production to fly to Los Angeles to accept a Golden Globe for *Lost in Translation*.

∧ *Bill Murray* by Adam Carlson

>> *Bill Murray* by Giacomo Agnello Modica

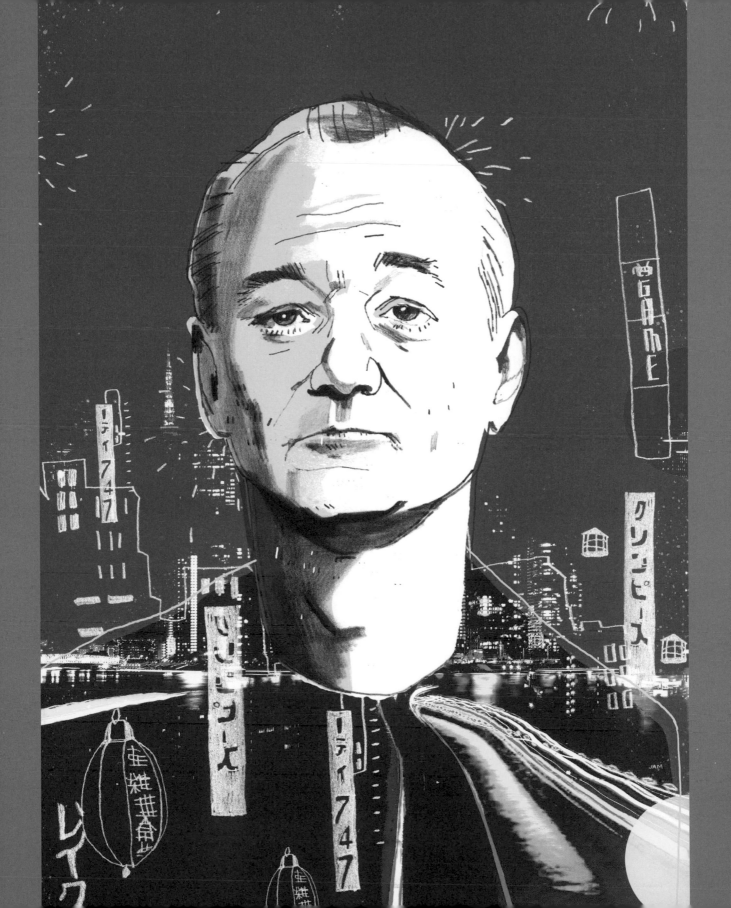

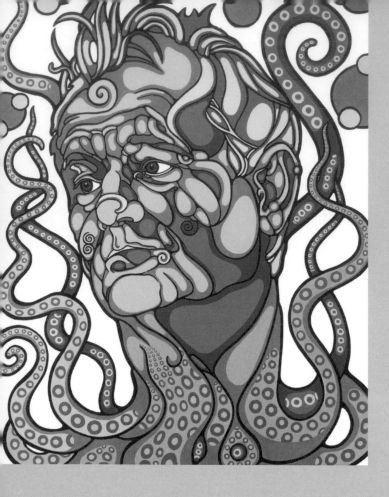

LIFE AQUATIC WITH BILL MURRAY

For *Saturday Night Live*'s 40th Anniversary, Bill Murray reprised his infamous role as Nick Ocean, the lounge singer, by singing the theme song to *Jaws*.

< *Bill Murray* by Tabitha Lahr

v *Team Zissou* by Ryan Gajda

>> *Natural Habitat* by Holly Highfield

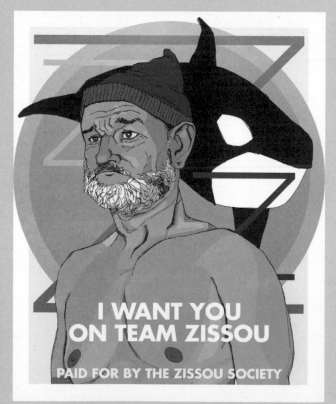

I WANT YOU ON TEAM ZISSOU

PAID FOR BY THE ZISSOU SOCIETY

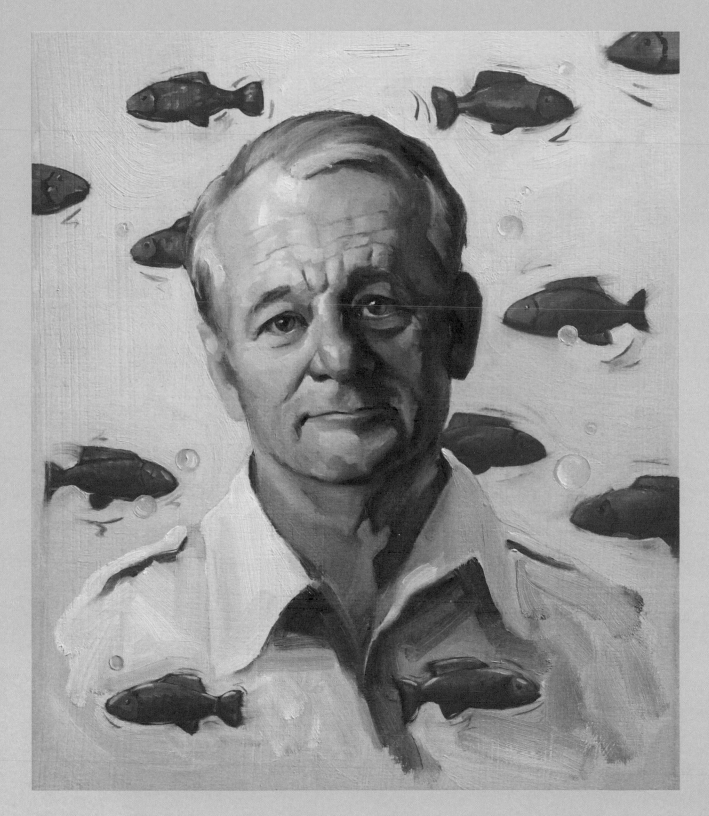

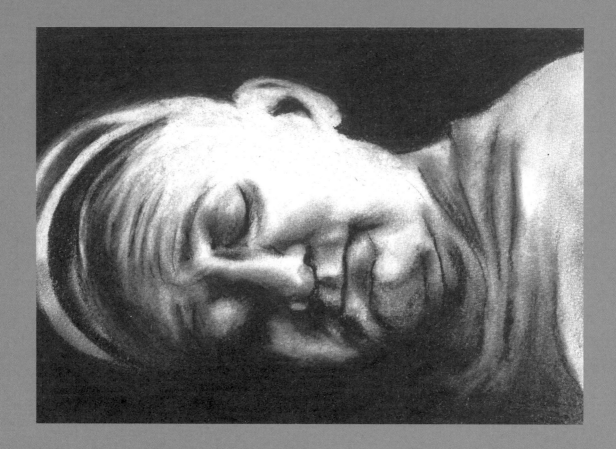

A MURRAY MOMENT

Bill Murray made his debut on *The Late Show with Stephen Colbert* in 2016 by falling asleep in the front row of the audience and getting scolded for it by Colbert during his opening monologue.

∧ *Murray Dreaming* by Angela Meyers

>> *Golf Clap* by Harrison Larsen

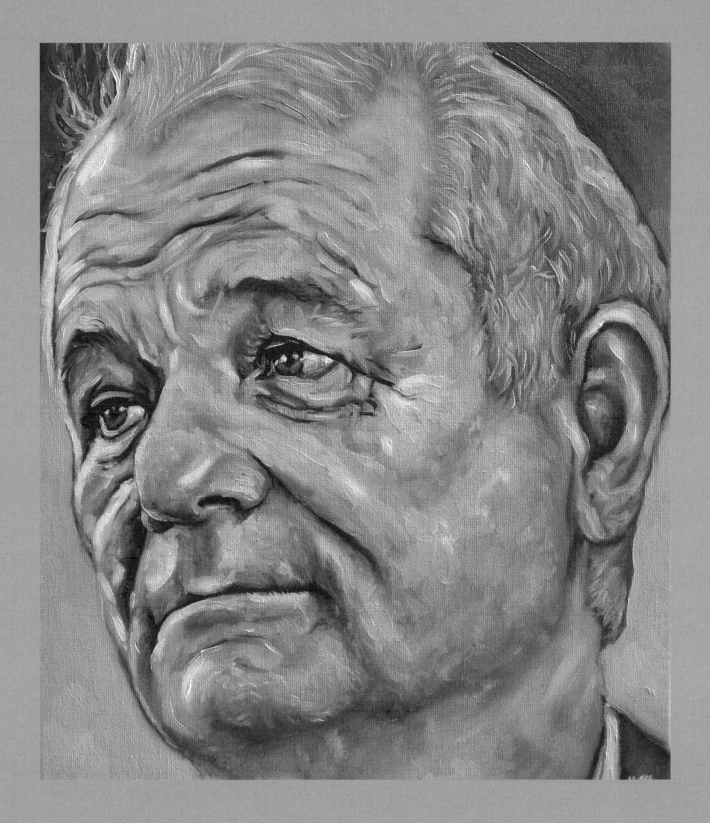

"PRESIDENT FRANKLIN D. ROOSEVELT"

Hyde Park on Hudson

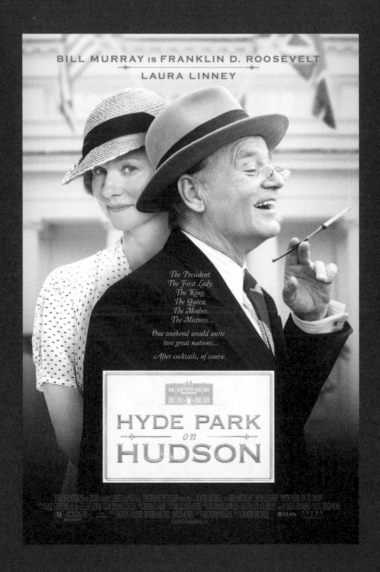

BILL MURRAY IS FRANKLIN D. ROOSEVELT

LAURA LINNEY

The President.
The First Lady.
The King.
The Queen.
The Mother.
The Mistress...

One weekend would unite
two great nations...

After cocktails, of course.

HYDE PARK
ON
HUDSON

Bill Murray as President Franklin D. Roosevelt might seem like an unusual casting choice, but like a New Deal mural project, it becomes something artistic and quite lovely as it is shaded and colored. A period-perfect costume drama that suspends disbelief, Murray deftly slips into the press-protected private life of FDR with surprising ease. The time is 1939, and FDR is on one of his habitual escapes from the tribulations of Washington to sojourn at his grand childhood home in Upstate New York. Even though her son is fifty-seven, his domineering mother, Elizabeth, fusses around her only child, going so far as to procure his attractive, fortysomething cousin, Daisy Suckley, movingly underplayed by Laura Linney, to "cheer him up." Mother is noisily preparing for an historic visit from King George VI and Queen Elizabeth of England, here to ask Roosevelt for support against Hitler. Mother Elizabeth is her own form of queen, sparring with Roosevelt's strong-willed wife, Eleanor, who has learned to turn a blind eye to her husband's female diversions. As Roosevelt, Murray plays the role with uncharacteristic restraint; his seduction of Daisy is gentle but determined, and his affection for her is genuine. The switched-on Murray charm is subdued, and he uses the physical and emotional constraints of the role to great advantage. He deftly captures the characteristic head tilt that holds on his pince-nez spectacles, and the jaunty angle his cigarette tilts in his teeth, reverberating his speech with the familiar FDR lockjaw and intonation. Like the thirty-second president himself, Murray treats FDR's polio as a nuisance, but not a limitation, alternating between a wheelchair and crutches, saving the masterful force of upper-body strength for moments when he wants to incite emotion. It's a winning strategy to get the girl(s), the king, the press, and the viewer on his side, on the Hudson, and on the mark.

BEHIND THE SCENES

Bill Murray was already familiar with the difficulties of living with polio, as his sister had contracted the disease as a child.

"WALT BISHOP"

Moonrise Kingdom

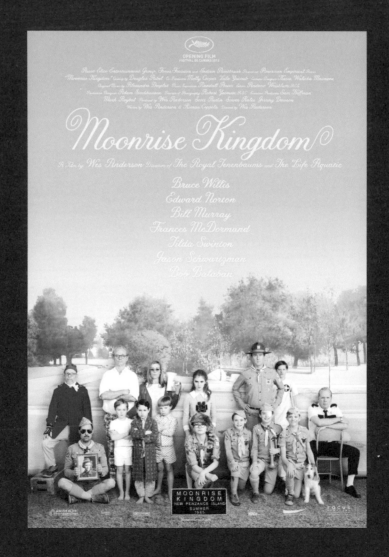

A fervent but gentle romance between twelve-year-old orphan Sam Shakusky and his bookish inamorata Suzy Bishop, lies at the center of this sentimental gem written and directed by Wes Anderson. The story takes place in 1965 on the fictional New England island of New Penzance; a confined geography that is still large enough to contain its own multitudes. All of the supporting ensemble serve to refract or amplify their ardor; the adults mess it up while the kids marvel at it. Bill Murray plays Suzy's father, Walt Bishop, an exasperated but resigned attorney whose own marriage to Suzy's mother and his legal partner, Laura (Frances McDormand), is crumbling. Laura's eye is wandering toward the island's only constable, a dim but earnest Duffy Sharp (Bruce Willis); the contrast between the young people's new love and the adults' entrapped flirtation is stark. Sam absconds under the authority of Khaki Scouts' Camp Ivanhoe and earnest Scoutmaster Edward Norton. Suzy escapes from their family's "Summer's End" home with her cat, her brother's record player, and a suitcase filled with her favorite books. They meet, meander, gingerly make out, and get caught by a search party of scouts, Suzy's parents, and Constable Sharp. As Suzy's father, Murray gives a pitch-perfect performance walking the line between genuine concern for his daughter's well-being, and his own annoyance at both his wife and daughter being irrationally swayed by the love of men other than himself. More separations and reunifications ensue, and the Khaki Scouts and constable collaborate to help Sam and Suzy be together. It's all sweetly Shakespearean, without the tragic ending. Murray's performance is subtle and strong; he never even dominates the scenes he is in, but subsumes his own wishes—and bites his tongue—in order to keep the peace. He's Ward Cleaver's downtrodden cousin; responsible, reliable, and resigned, a true father of his era, the middle-aged monarch of his island kingdom watching the new generation rise.

BEHIND THE SCENES
During filming, Bill Murray reportedly taught Jared Gilman (Sam) how to tie a necktie for the first time.

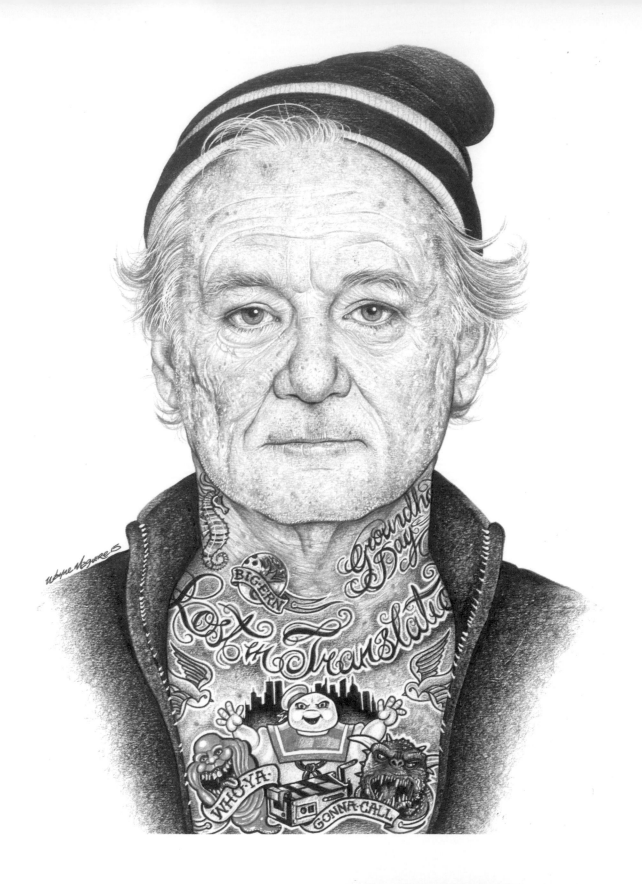

The Complex

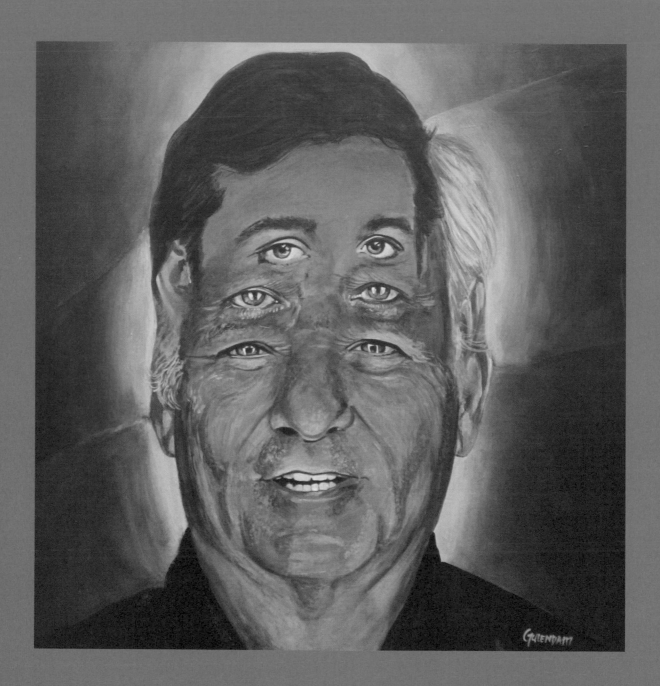

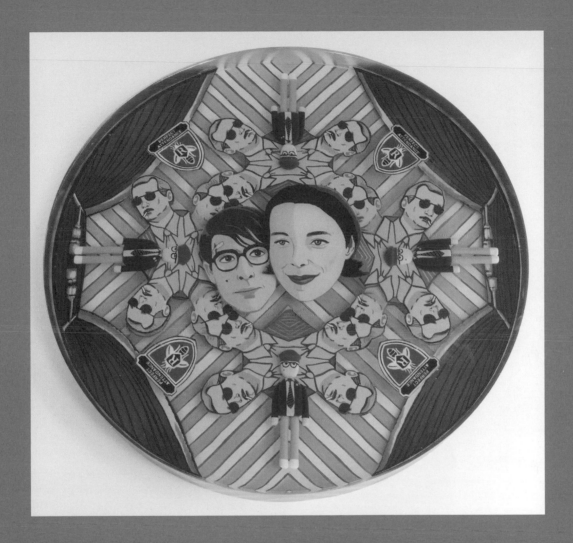

WHERE IN THE WORLD IS BILL MURRAY?

While *Rushmore* was Bill Murray's first Wes Anderson film, Anderson admitted that he tried to get Murray for *Bottle Rocket*, but couldn't reach him!

∧ *Rushmore* by Geoff Trapp

<< *Bill's Blue* by Gulendam Ece Hurmeydan

Previous spread: *OG Murray* by Wayne Maguire

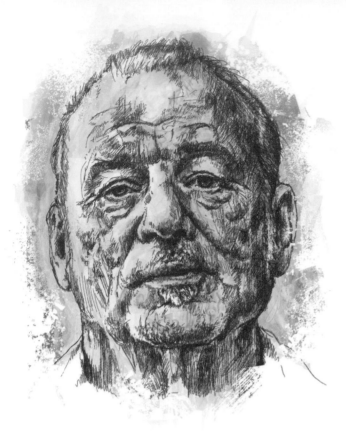

BEHIND THE SCENES

The movie studio had to negotiate with a real-life lawyer named Steve Zissou in order to use his name for the title character.

^ *St. Vincent* **by Chad Lonius**

> *AmalgaMurray Junk Drawer Scavenger Hunt* **by Justin McAllister**

>> *Steve Zissou* **by Joshua Roman**

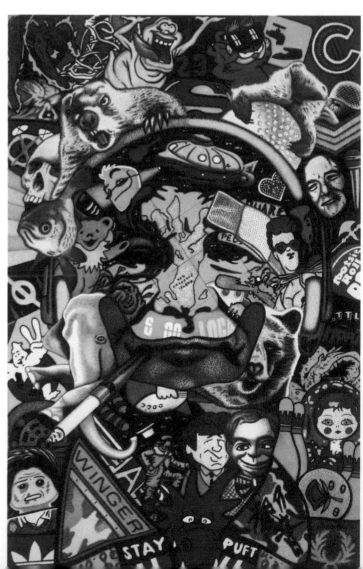

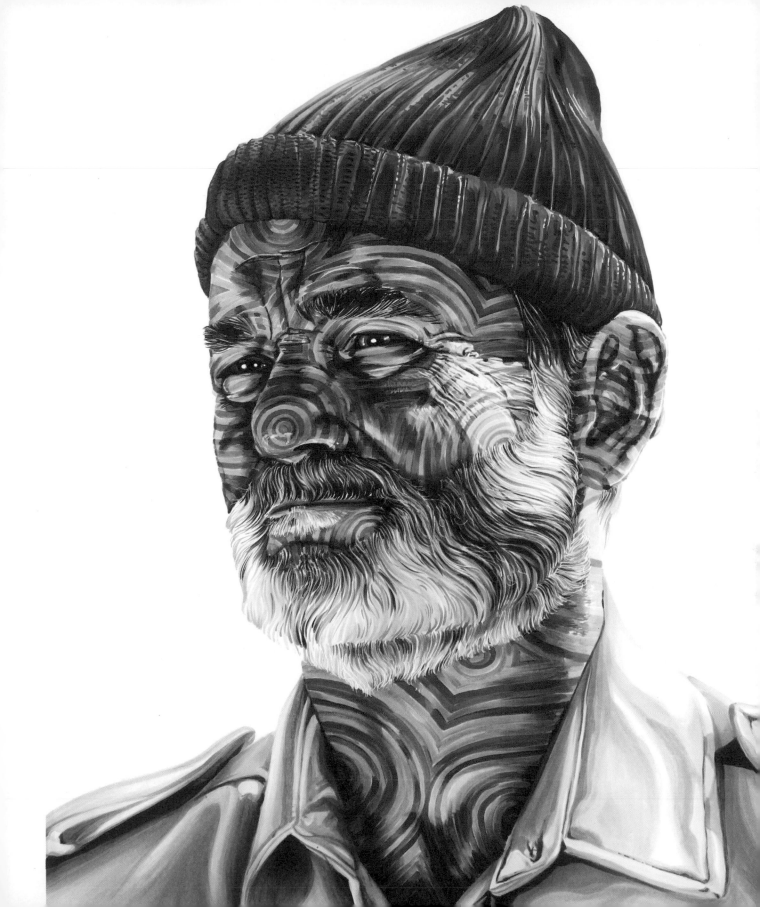

BILL'S BESTIES

Including *Isle of Dogs* in 2018, Bill Murray and Wes Anderson have collaborated on eight feature films beginning with *Rushmore* in 1998.

∧ *Zissou* by Todd Slater

> *Raleigh* by Todd Slater

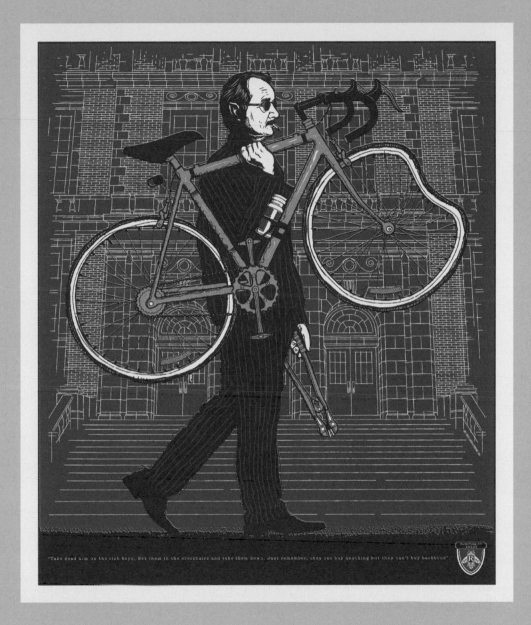

MAD FOR MURRAY

The Toronto International Film Festival honored Bill Murray by officially declaring September 5 to be "Bill Murray Day."

∧ *Rushmore* by Todd Slater

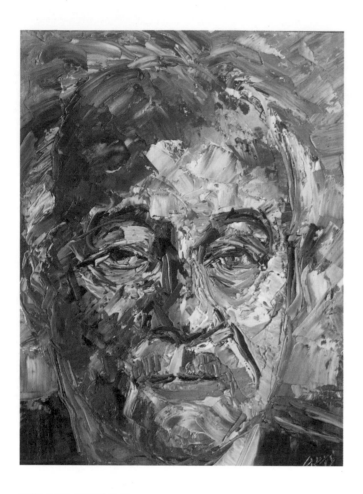

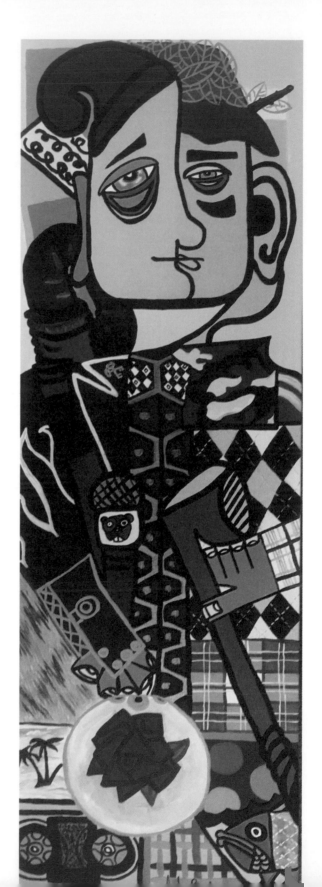

BILL'S SKILLS

In 2007, Murray drove a golf cart through downtown Stockholm and gave people lifts to a local 7-11.

∧ *Bill Murray* by Arturo Espinosa

> *15 Murrays of Fame* by Anita Beshirs

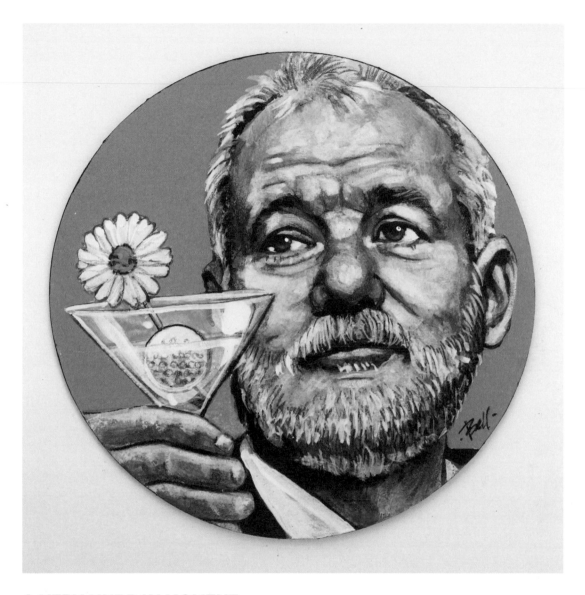

A VERY MURRAY MOMENT

Murray's famous "Cinderella" story scene in *Caddyshack* was almost entirely improvised by Murray with just a few lines of direction from Harold Ramis.

∧ *Bill Fucking Murray* **by Mike Bell**

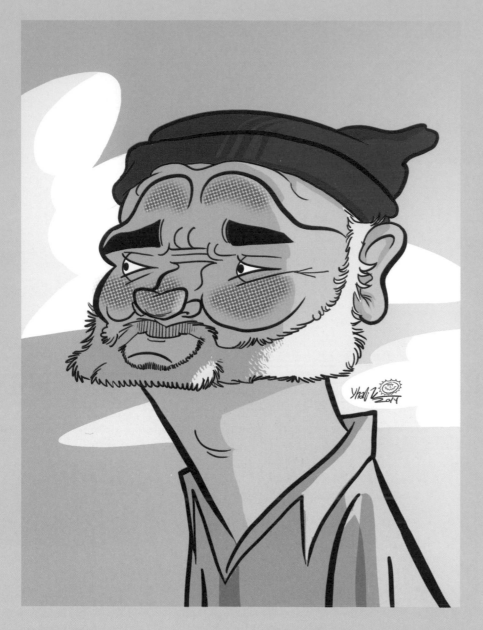

WHERE IN THE WORLD IS BILL MURRAY?

Fans were surprised in 2014 by Bill Murray working as a ticket taker for the Minnesota St. Paul Saints game, a team that Murray co-owns.

< *Staring Out at Sea* by Yhali Ilan

>> *Where the Buffalo Roam* by John Benko

"VINCENT MacKENNA"

St. Vincent

Grumpy curmudgeon Vincent MacKenna (Murray) hardly rolls out the welcome wagon for his new Brooklyn neighbors, struggling single mother Maggie (Melissa McCarthy) and her practical, precocious son Oliver (Jaeden Lieberher). But grouchy Vincent is severely short on cash and harried Melissa has to work late, so she reluctantly agrees to let him babysit Oliver after school. Vincent's version of childcare is letting the boy tag along to dive bars and race tracks. Vincent teaches Oliver how to deal with bullies, how to push a lawnmower, and how "not to annoy me." He introduces Oliver to Daka (Naomi Watts), his brusque sex-worker girlfriend who is struggling with a very visible pregnancy. He also reveals his secret sentimental side, bringing Oliver along to visit the Alzheimer's-afflicted wife who no longer recognizes him. When Vincent and Oliver grow close, their unlikely friendship is disrupted by a custody battle with Maggie's ex-husband, and by Vincent's debilitation due to a stroke. Their parting is painful and abrupt. But Oliver cannot give up on his malcontent mentor. Rifling through the trash, Oliver discovers Vincent's history as a decorated Vietnam war veteran, and profiles his heroism and hidden kind-heartedness at a school assembly honoring "Saints Among Us." Vincent's role is redeemed, and the unlikely chosen family of Melissa, Oliver, Vincent, Daka, and Daka's newborn baby reconstitute themselves as best they can.

Murray revels in the role of cranky, compromised Vincent, whose combination of bad luck and bad judgment has caught up and left him a broken man. His Sheepshead Bay, Brooklyn accent tells us of his working-class origins, and of his predilection for booze and brawls. Left on his own, he is a sad sack whose future looks bleak. His youthful charge provides purpose: he can educate Oliver in the ways of his world, the real world. Murray plays the contradictions of his character with aplomb; he's a baddie, but a not-so-bad influence; a john who actually helps his trick out of a jam more than once. When he closes the film air-guitaring his version of Bob Dylan's "Shelter from the Storm," he brings his character into focus. Sinner or saint, he suggests, what we all need is to give and receive a little shelter from the gusty downpour of everyday life.

BEHIND THE SCENES

Murray worked to master Vincent's particular Sheepshead Bay accent in New York, but there were apparently not many original residents left that could help.

"RICHIE LANZ"

Rock the Kasbah

Washed-up pop talent manager Richie Lanz (Murray) gets to audition wannabe Madonnas in his fleabag motel . . . but he still has the schmooze, and the motivation, to manage a big star like he says he used to. Desperate for a break, he drags his latest discovery (Zooey Deschanel) to Kabul, Afghanistan, to perform for USO shows. Freaked out and strung out, she absconds with Lanz's wallet and passport, enlisting a brittle mercenary (Bruce Willis) to help. A panicked Lanz realizes that survivors in this bombed-out city function on bribery, quick wits, and silver tongues—so the Murray acting arsenal is fully activated. Lanz falls hard for Miss Merci (Kate Hudson), an exceptionally skilled courtesan on her "401(k) tour," who reveals her charms to him in a double-wide ringed with barbed wire for an unmissable dress-up scene. Tricked into smuggling bullets to a remote Pashtun village, Lanz's talent-trained ear zeroes in on the serenade of the chieftain's daughter Salima (Leem Lubany). His skill is useful in smooth-talking his way into or out of life-or-death situations, although machine guns and a poor translator nearly get him lost for good. Lanz uses his moxie to book his new find on the *American Idol*–style *Afghan Star* television show. Hitting perfect notes is left to the luminous Salima, whose soulful rendition of "Peace Train" captures the imagination of a country desperate to get on board. As the talent manager Lanz, a deftly articulate Murray engineers a good Hollywood ending halfway around the globe and worlds away from what he planned. Ironically, Murray himself doesn't use a talent manager—so this may be his homage to the road not taken beyond the Kasbah.

BEHIND THE SCENES

The title is a reference to the song of the same name (but spelled Casbah) by the punk band The Clash. The original song was influenced by Iran's ban on Western music in 1979. The song "Rock the Casbah" doesn't appear in the movie, because the filmmakers were denied the rights to use it.

"BALOO"

The Jungle Book

Bill Murray as a great big benevolent bear in the darkest reaches of India? That's the treat that appears a third of the way into this live animated version of Rudyard Kipling's classic about Mowgli, an orphaned boy raised, befriended, and hunted by jungle animals. Murray endearingly voices the sloth bear Baloo, Mowgli's boon companion and protector. Remarkable computer generation has produced a Baloo who is realistically bear-like while stuffed full of Murrayisms: the fast-talking negotiator, the laconic lotus-eater, the indulgent tutor—and, according to director Jon Favreau, impressive ad-libber. Surprised? Baloo's rationalizations and always-adjusting practicality are the perfect foil for Mowgli's youthful surges of enthusiasm, just as his portly pear shape and bear belly contrast nicely with Mowgli's wiry, tree-hopping frame. Although clearly inspired by the 1967 animated version, this Baloo has much more complexity, contradiction, and charisma; he's the Murray we know and love, just in ursine form—a great big, nap-loving, honey-guzzling goofball with a great big heart, and a tummy to match. His swamp-singing duet with Mowgli is the film's most sentimental moment, but still rings true. And in terms of box office, Murray was no sidekick—he was the film's highest-paid voice actor, with a salary and share of royalties estimated at $48 million. Now, that will cover the "bear" necessities of life, and then some.

BEHIND THE SCENES
Keep it in the family! Bill Murray did the voice of Baloo in this 2016 version, but his brother Brian Doyle-Murray ALSO played the voice of Baloo in the 1998 film!

The Legend

OOPS!

The crew got food poisoning after eating chicken while filming in India on set for *The Razor's Edge*. Director John Byrum lost twenty-five pounds after the incident and had a glucose IV for the remainder of filming.

∧ *Master Murray* by Martin Segobia

>> *Bolder than Bill* by Sayuri Kimbell

Previous spread: *King of Comedy* by Dana Vermette

O CAPTAIN, MY CAPTAIN

Bill Murray is a poetry lover and supporter of the Poets House in New York City. He frequently participates in the annual Poets House walk over the Brooklyn Bridge, stopping at various points to read favorites along the way.

< *Zissou Cruises* by Jason Brueck

>> *Hamlet Murray* by Steve Brackett

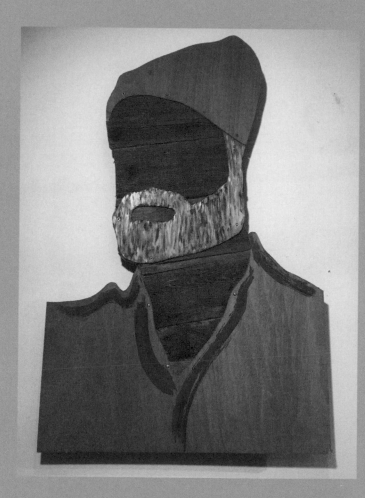

BEHIND THE SCENES

Jacques Cousteau was the inspiration for Bill Murray's character Steve Zissou, and Cate Blanchett's character was modeled after famed primatologist Jane Goodall.

> *Stevesy* by Andrew Rehs

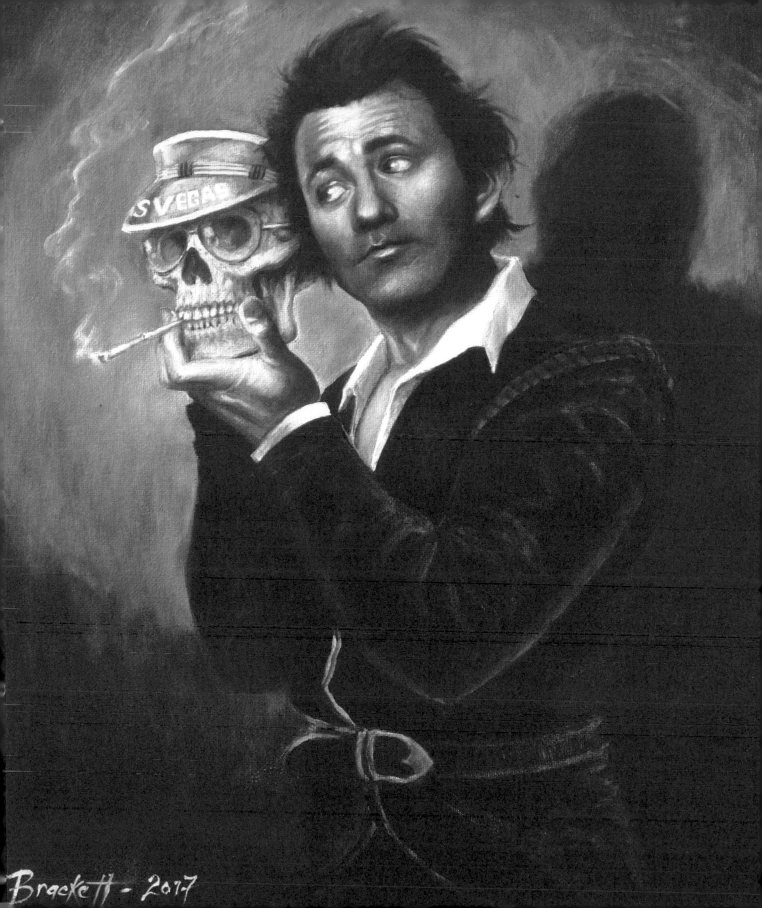

Brackett - 2017

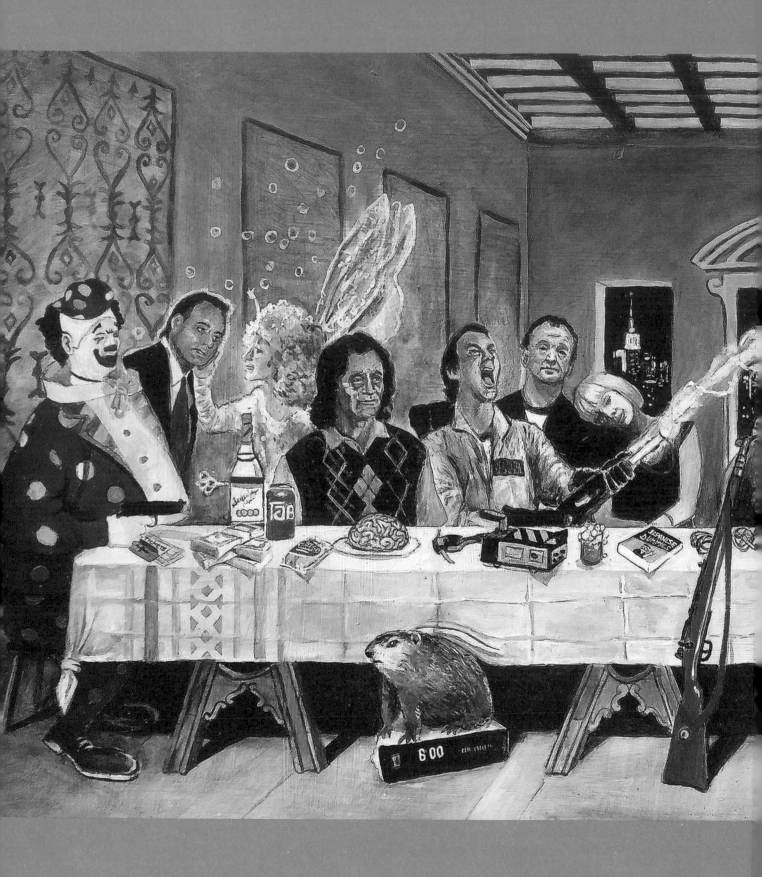

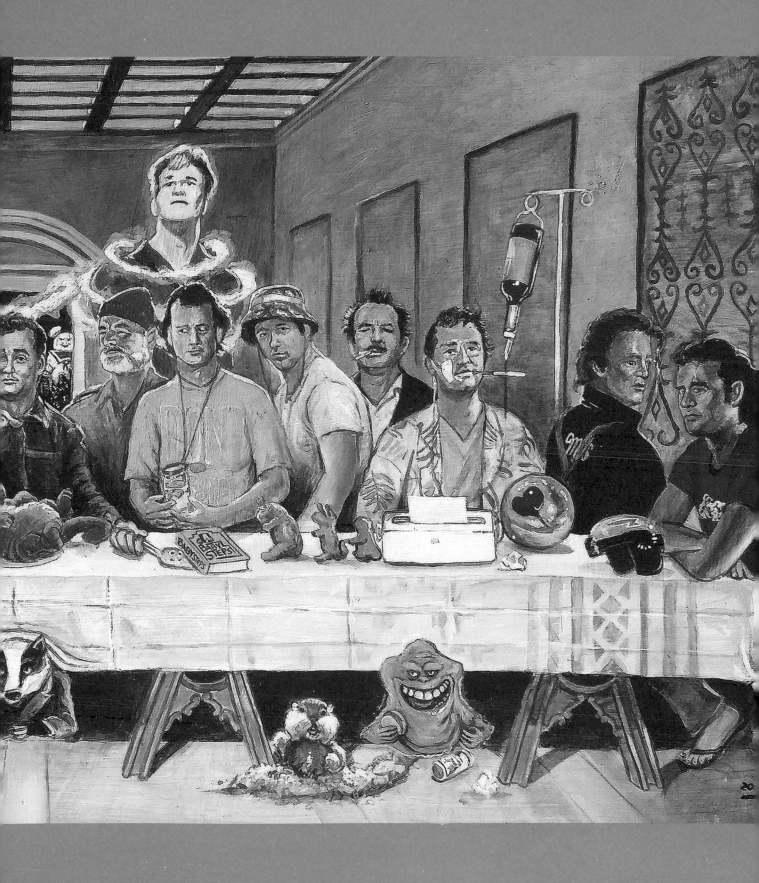

MURRAY, CHICAGO CUBS

BILL'S THRILLS

Murray is very public about his love for the Chicago Cubs. He's been spotted handing out tickets to fans, singing "Take Me Out to the Ballgame" at Wrigley Field, and celebrating the world series win in 2016 with champagne in the Cubs' locker room. He even reportedly had the Cubs logo designed at the bottom of his pool.

< *Bill Murray Tobacco Card* by Joshua Ryals

v *Obey Murray* by Kristy Brucle Jach

Previous spread: *Bill's Last Supper* by Tom Carlton

ALL IN THE FAMILY

Bill has appeared with his brothers in several films, but his sister Nancy has a talent for performance too. An Adrian Dominican nun, Sister Nancy Murray portrays St. Catherine of Sienna in a traveling show across the country.

< v *Murray Monroe* by Pete Hurdle

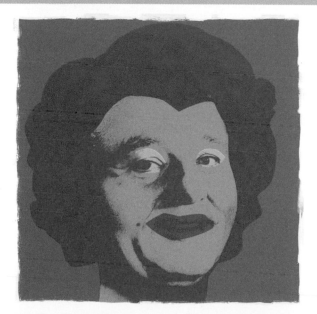

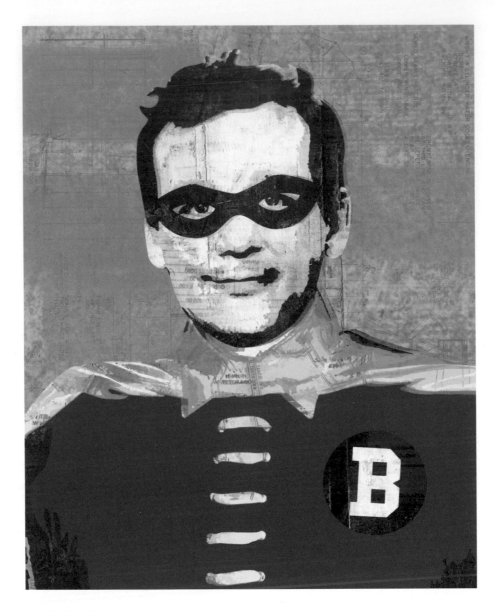

SUPER BILL

Murray portrayed Superman in a 1979 *Saturday Night Live* sketch which also featured Dan Aykroyd as The Flash and John Belushi as the Hulk.

∧ *Bobin* by Pete Hurdle

≫ *Superbill* by Pete Hurdle

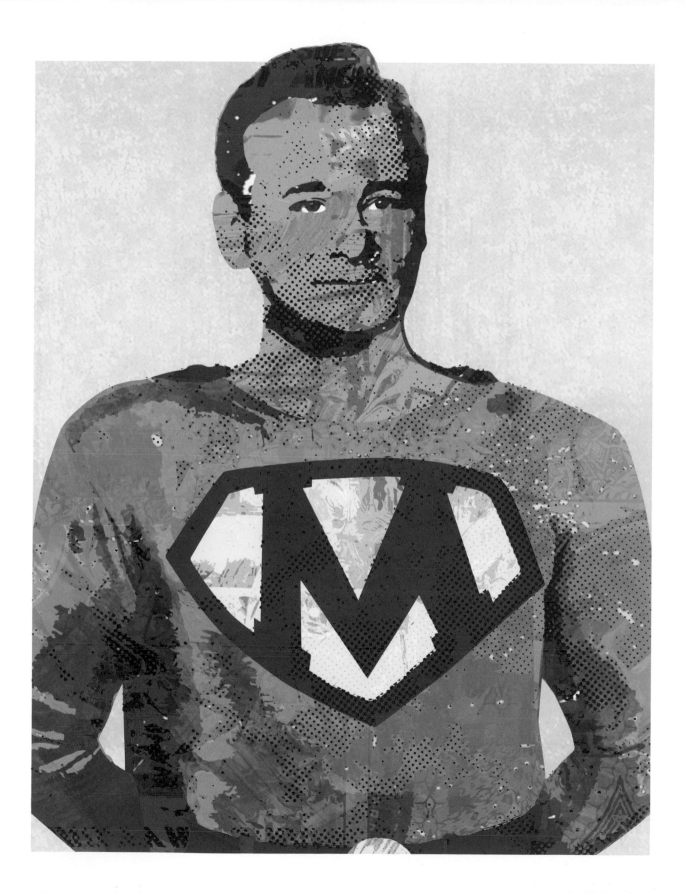

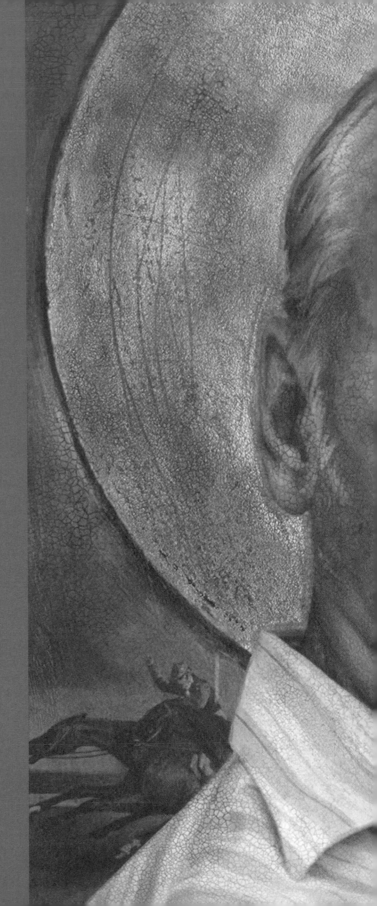

MUR-REALITY

The story of St. Vincent was based on a true story, according to writer-director Ted Melfi.

> *St. Vincent* by Michael Koelsch

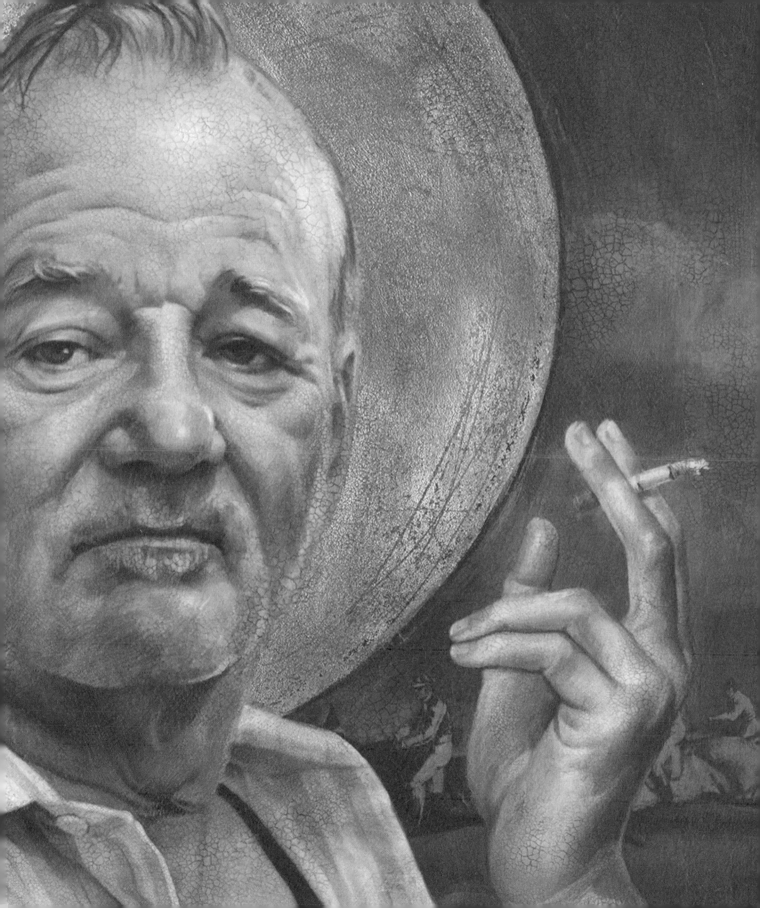

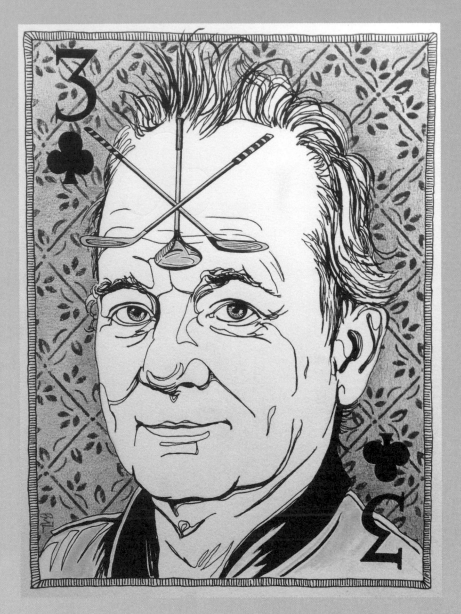

BILL'S BALLS

Murray is one of the best golfers in Hollywood with a remarkable 7 handicap.

< *The Three of Clubs* by Patrushka

GO GREEN

Murray was inducted into the Irish American Hall of Fame in 2017 by Chicago Cubs Chairman Tom Ricketts.

>> *Bill Murray Matches* 1 by Mike Bell
>> *Bill Murray Matches* 2 by Mike Bell
>> *Bill Murray Matches* 3 by Mike Bell
>>> *Astro Murray* by Epyon5

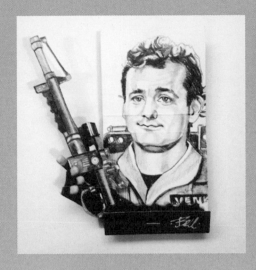

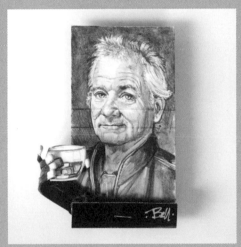

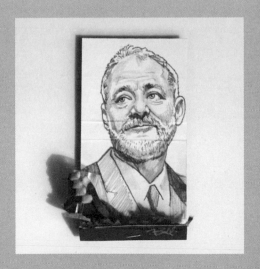

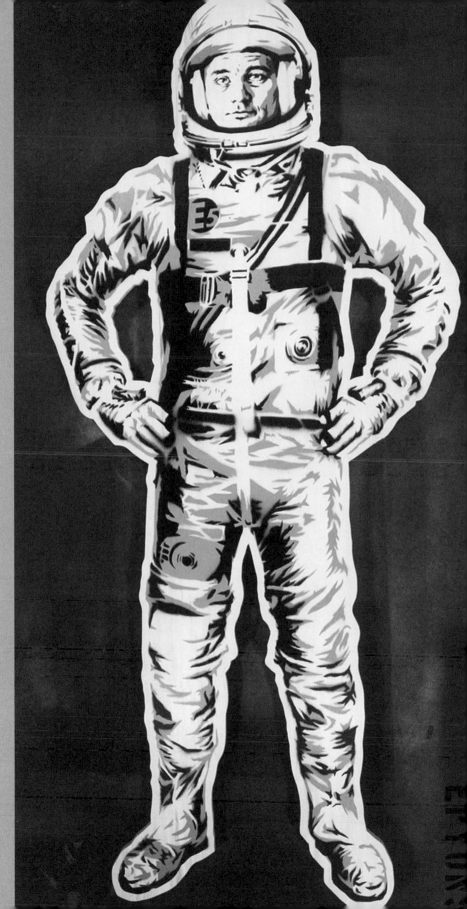

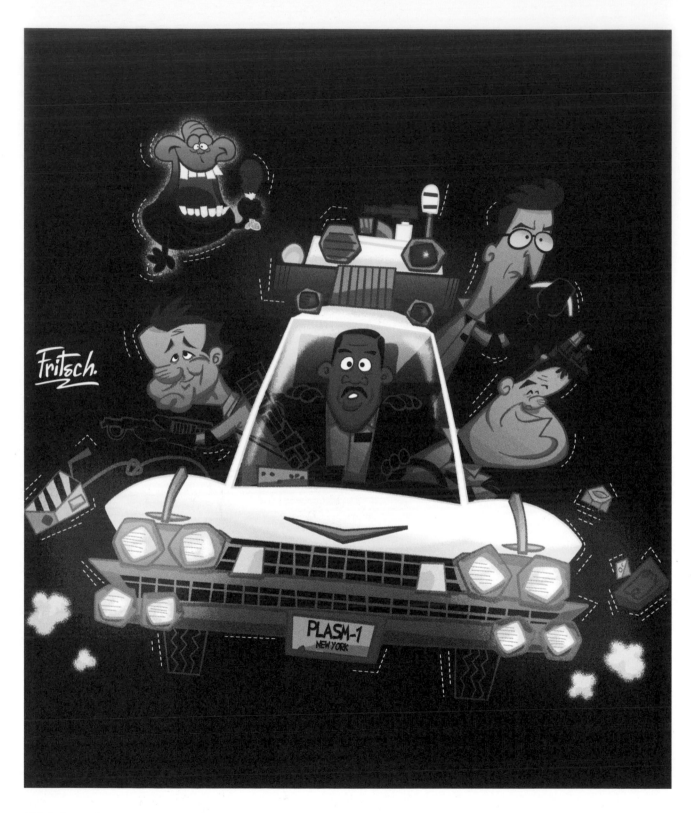

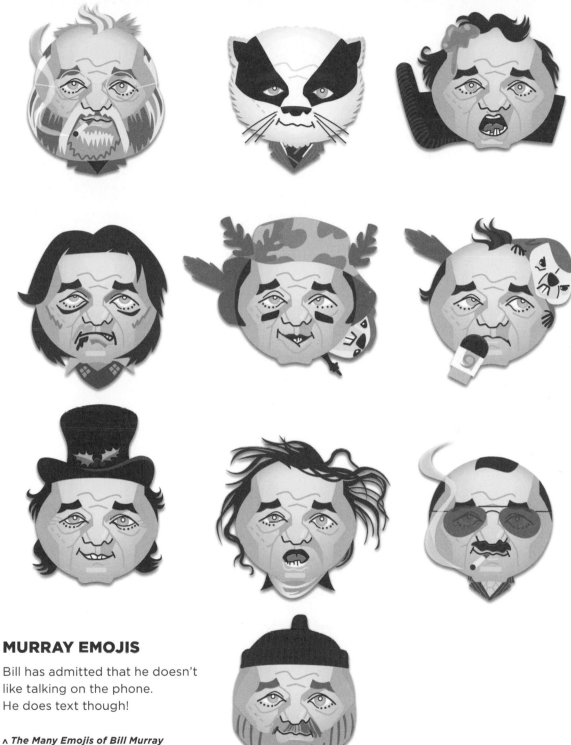

MURRAY EMOJIS

Bill has admitted that he doesn't like talking on the phone. He does text though!

∧ *The Many Emojis of Bill Murray* by Chuck Gonzales

<< *Gonna Call* by Olivier Fritsch

CONTRIBUTORS

Sheldon Allan *Smokin' Murray* (page 30)

Buck Amaya *Dropkick Murray* (page 20)
Acrylic on canvas
18 x 24 inches (46 x 61 cm)
www.theratchetfactory.com
I created this piece for a Bill Murray–inspired art show a friend of mine threw. I wanted to put an emphasis on the eccentric personality he seems to have in both film and real life. Plus, he is known for avoiding conformity and societal norms, living life on his terms, and having fun while doing it. I felt the punk aesthetic and philosophy really embodied that free-spirited and rebellious approach to life and would evoke that same feeling while looking at the portrait of him.

Benjamin Askevold *Barcode Bill* (page 29)
Instagram: @4skevold
There were two foundational ideas that brought *Barcode Bill* from conception to completion: fanboyism of the legend in question, as well as a class project demonstrating a continuous line. I wanted to try something new.

Avalon Cakes *The Steve Zissou Cake* (page 58) and *What About Bob Cake* (page 111)
avaloncakesschool.com
Instagram: @avaloncakes
I created the Bill Murray cake for a cake collaboration called Cakeflix. We all took a movie or actor we loved and created a cake inspired by them! Being a huge Bill fan, obviously, it was the perfect excuse to try to re-create him. He is mostly made of modeling chocolate, which is an edible, almost claylike medium. I actually airbrushed his face originally; as he sat, it oxidized and turned bright orange (like a fake tan gone way wrong), so I had to clean off his face and hand-painted it with food color instead.

BALU *Post No Bills* (page 176)

Mike Bell *Bill Fucking Murray* (page 143) and *Bill Murray Matches 1, 2, and 3* (page 167)
Mike Bell's collection of forty matchbooks of political, celebrity, and pop-culture portraits is currently touring the Ripley's Believe It or Not! museums. His matchbook pieces have also been sold to celebrities such as Bradley Cooper (*Silver Linings Playbook*), Mike Judge (creator of *Beavis and Butthead*), Norman Reedus (*The Walking Dead*), Guy Pearce (*Memento*), and Carice van Houten (*Game of Thrones)* for their collections.

John Benko *Where the Buffalo Roam* (page 145)
www.johnbenko.com
I thought Bill did an amazing job depicting the character of Hunter S. Thompson in *Where the Buffalo Roam*, which was my inspiration for the piece. It is a very underappreciated role for Bill, I think. While painting, my daughter asked me if Bill invented the Bloody Mary. Ha ha!

Anita Beshirs *15 Murrays of Fame* (page 142)
Acrylic on canvas
www.anitabeshirs.com
Instagram: @anitasparklebeshirs
I was inspired to paint Mr. Murray because of the breadth and depth of inspiration to choose from in his body of work. There are nearly endless possibilities, so how do I pick just one Bill to capture his "Bill-ness"? I could not choose just one, so I borrowed the lens of Picasso and began to see how many Bills could come together as one. When I was finished, I counted fifteen film roles that I had captured, plus the plaid smash to capture his true self on the golf course. Can you guess which fifteen films I included in the piece?

Borbay *Dr. Bill Venkman* (page 78)
www.borbay.com
Facebook/Twitter/Instagram: @borbay
In my last "real job," I worked as business director for an ad agency in TriBeCa, right around the corner from the Ghostbusters firehouse (Hook & Ladder Company 8). What was once, as Egon described, "a demilitarized war zone," by 2007, it had become downright chic. Well, in 2009, I took a vacation to Maui, and spent my days reading Hunter S. Thompson books, painting, and sampling the local produce. Upon my return, I gave my notice, left the ad agency, and became a full-time artist on July 2, 2009. Upon returning to my studio, I watched *Ghostbusters* and found a great scene with Bill in the firehouse (an important connection to my ad job) and decided to paint him as Dr. Venkman. Collaged into his right eye—with gel medium applied with a broad paintbrush—is a picture of a gun sign from Little Italy, a shout-out to his former alter ego, Dr. Hunter S. Thompson.

Ryan Borella (aka "Clockwork Octopus") *Acid Invents a Sunny Vent* (page 67)
clockworkoctopus.com
Instagram: @clockworkoctopus
On *Acid Invents a Sunny Vent* (in which the whole title is an anagram of something else), the lightest tone is actually the wood panel itself. Both were made with extensive amounts of FrogTape (sponsored by), Montana Gold, and pure madness. Super-secret fun fact: each contain a particular element, which is something shared with nearly every portrait I've ever done.

Steve Brackett *Hamlet Murray* (page 157)
Oil on canvas
Bill as *Hamlet* and Hunter S. Thompson's skull as Yorick. Inspired by Bill's role in 2000's *Hamlet*, as well as his turn as Hunter, in *Where the Buffalo Roam*. Conceived in a mad vision, and rendered in the grisaille method of oil painting on canvas.

Jason Brueck *Zissou Cruises* (page 156)
Zissou Cruises was inspired by those vintage Art Deco travel posters from the '20s and '30s. I felt it was a perfect tie-in with a lot of the vintage imagery that Wes Anderson weaves seamlessly into a lot of his films.

Adam Carlson *Bill Murray* (page 124)
Oil on linen canvas
adam-carlson.com
Instagram: @adamcarlsonart
I have always been inspired by the old-school masters like John Singer Sargent and Saul Tepper, but also look up to current painters like Gregory Manchess and Malcolm Liepke. My portrait of Bill Murray was painted alla prima with oil on linen canvas, and I was aiming to capture the likeness while maintaining the emphasis on the paint itself.

Tom Carlton *Bill's Last Supper* (pages 158–159)
Acrylic paint
www.tomcarltonart.com
tom-carlton.artistwebsites.com
Facebook: @TomCarltonArt
Normally, one of my paintings only takes a day or two, but this piece took a whole month. I tried to include as many of Bill's movies as I could.

Graham Corcoran *Groundhog Day* (page 109)
www.grahamcorcoran.com
My piece is inspired by Whac-a-Mole games, with Bill Murray as Phil Connors and surrounded by groundhogs, stuck in a constant loop about to be whacked again and again. It was created for a special art exhibition in Dublin celebrating everything Bill Murray.

David Corden *Zombieland Tattoo* (page 24)
Semper Tattoo
https://www.instagram.com/davidcorden/
David used a Swashdrive tattoo machine, as the inspiration was *Zombieland* and *Ghostbusters* was the client's favorite movie ...so it made sense to tattoo Bill Murray!

Epyon5 *It Just Doesn't Matter* (page 86) and *Astro Murray* (page 167)
www.epyon5.com
Instagram: @epyon5
As an artist, I look to the old dead guys for inspiration, particularly the works of Caravaggio (although in real life he was a grade-A asshole). However, why try to paint like them? They already elevated their mediums to some of the highest degrees! So, for me, I wanted to create works that had a similar type of grandeur, albeit through more contemporary means. I found that through the use of stencils and spray paint. It's fast, impulsive, and yet at the same time, able to convey old-world charm and elegance with minimal color and composition.

Christine Delorenzo *The Bitch Hit Me with a Toaster* (page 66)
Acrylic on canvas
Instagram: @christined912
I like playing around with the cropping and close-up in this painting, and I combined it with my admiration for photo-realism in art. This was inspired by my love for *Scrooged*, which I think is underrated.

Juan Duran *Zombie Bill* (page 30)
Oil on canvas
18 x 24 inches (46 x 61 cm)
Instagram: @arte_de_juan
Zombie Bill was inspired by the film *Zombieland* where Bill Murray makes a cameo. As a fan of both Bill and the film, I really just thought it be fun, since it's one of my favorite Bill appearances.

Alissa DeStefano *Bill (Murray) of Rights* (page 65)
www.etsy.com/shop/IgnorantArtDesign
I created my piece after seeing a bunch of "post no bills" graffiti with random celebrities named Bill alongside them. I have always loved Bill Murray—especially as Wes Anderson characters—and was inspired to do something similar. When I think about Bill Murray, I think about Bill Murray the American icon. When I think of America, I think of the Bill of Rights. Boom.

Arturo Espinosa *Bill Murray* (page 142)
Oil on canvas
11 x 14 inches (27 x 35 cm)
www.flickr.com/photos/espinosa_rosique/albums/72157637065378883
I am currently the administrator of a Flickr group called PIFAL (People Illustrious and Famous from Art and Letters). In this group, I try to portray characters I like that have an interesting physiognomy. I admire Bill Murray, and I think he is a great polyvalent actor. That—combined with the peculiarity of his tragicomic face—is why I decided to portray him in oil.

Gregg Firestone *Murray Maze* (page 64); *Murray Seal of Approval* (page 91)
Instagram: @dialgforgregg
The Bill Murray puzzle maze has three different routes that will complete it, but also has dead ends, so it's not a guaranteed success.

Lauren Fitzgerald *Blue Murray* (page 85)
laurenfitzgeraldart.com
Facebook: @LaurenFitzgeraldArt
Instagram: @papercuts_ict
Bill Murray is hands-down my favorite actor, so I was destined to create a portrait of him, and well, what can say, I think the man looks good in blue. I created this homage to Bill, in cut paper, each layer hand- cut with an X-ACTO, layered, one at a time, to create this image. Much like a painter who builds up paint on a canvas, I build up layers of paper; however, the resulting artwork is less like a painting and more like a low-relief sculpture. In this case, I painted all of the paper different shades of blue before I started carving out the layers.

Lesley Fontanilla *Keep Your Five Dollars* (page 49)
Instagram: @fontanillalesley
I'm a huge Bill Murray fan and grew up watching *Ghostbusters*. One of my favorite scenes (and inspiration for my painting) is when Bill Murray's character conducts an experiment using ESP cards. The experiment involves a male and female participant, who are trying to guess what card Dr. Venkman is holding. If they guess incorrectly, they receive an electric shock. During the experiment, Venkman flirts shamelessly with the female subject, sparing her from any shocks for wrong answers, while shocking the male subject for each answer he gives, even if he's right. In the end, the male participant tells Venkman to keep his five bucks (his payment for participating).

Linda Fried *Bill* (page 47)
Oil on canvas
30 x 40 inches (76 x 102 cm)
linfried.com
Instagram: @linfried
As all selfie-takers indulge their own lens, I thought it would be interesting to capture this intimate moment through familiar faces of popular culture. I was thrilled to paint the enigmatic and beloved funnyman Bill Murray. Translating the texture of this coat onto canvas is still one of my most satisfying experiences. Well, that, and peeling glue off my hands.

Oliver Fritsch *Gonna Call* (page 168)
www.mrblacktee.com

Ryan Gajda *Venkman* (page 68); *Phil Connors* (page 111); *Bill Murray Undone* (page 123); and *Team Zissou* (page 126)
Pen and ink with digital coloring
www.ryangajda.com
Twitter/Instagram: @ryangajda
I drew the Venkman piece for Inktober a while back—a tradition where illustrators stop leaving the house and draw one pen-and-ink picture every day for the entire month of October to post on social media. I've been doing this for a few years, and this time around I used '80s movies as a theme for the month. In an ideal world, I'd draw Bill Murray every day, but I started rationing myself to one every twelve months a few years back to stop things from getting weird. I'd already drawn my annual Bill, but I had to make an exception in this case—I wore out my *Ghostbusters* VHS when I was a kid, and I couldn't live with myself if I didn't include Peter Venkman in my gallery of '80s movies characters.

Phil Galloway *Well, I Want to Die* (page 62)
Pencil
www.philgallowaydraws.co.uk
Email: info@philgallowaydraws.co.uk
Twitter: @philthyart
Facebook/Instagram: @philgallowaydraws
YouTube: Phil Galloway Draws
I used my old set of increasingly shrinking pencils to draw Raleigh in one of my many Moleskine sketchbooks. I remember Bill Murray's face looked so pained and forlorn in *The Royal Tenenbaums*, which summed up the inner turmoil and frustration Raleigh was going through. I love early Lucian Freud portraits, and I thought there could be a semblance of similarity in sketching this sad, tortured, yet kind and humorous face. Hopefully I've achieved it, as Raleigh is one of my favorite film characters of all time.

Michael Garfoot *Bill Murray* (page 41)
www.michaelgarfoot.com
This piece was made shortly following graduate school, where I was painting figures as large as seven feet tall (2.1 m). I made Bill to explore the opposite end of the spectrum—a small series of tiny portraits. Going from the big screen to tiny canvases that were inspired by comedians like Bill, who were constant figures in my childhood.

Angelina Gemuend *Bill* (page 110)
Instagram: @angiestwistedthreads
My sister tragically passed away at the age of twenty-seven a few years ago. After her passing, she really inspired me to live double in a way—to try and do more on her behalf. No time wasted. I have always crocheted, but I wanted to experiment more with it. Her crochet portrait was the first one I completed. I used it to display around town to create awareness for PTSD in veterans and suicide. After that, I wanted to stitch up more portraits. I have always been a huge fan of Bill Murray and his genius. So what better way to celebrate him than a huge crochet portrait?

Jennifer Gennari *Bill Murray in Oil* (page 62)
Oil on linen panel
11 x 14 inches (28 x 36 cm)
www.jennifergennari.com

Chuck Gonzales *The Many Emojis of Bill Murray* (page 169)
Pencil and Adobe Illustrator
www.chuckgonzales.com
When I was asked to draw Bill Murray, I decided that he would be perfect as an emoji because he's an icon and *Lost in Translation* is one of my favorite films. The emoji originated in Japan and is a universal language. Very little can get lost in translation using them. I work in Adobe Illustrator, but I draw the image first as a pencil sketch to keep the lines quick and fresh.

Rebecca Gonsalves *Sir Bill* (page 2)

André Greppi *Suntory Time* (page 48)
DRES13.com
Instagram @dres13
Suntory Time is a mix of hand-drawn art and digital design ultimately ending up as a limited-edition screen print for a local Bill Murray tribute art show. The idea for this illustration was inspired by the juxtaposition of Murray's character Bob--an aloof, but out-of-his-element aging American celebrity--against the backdrop of Japan's rich and unique culture and heritage, as seen in one of my favorite films, *Lost in Translation*. Based on one of my favorite scenes in the film, the Japanese text is a translation of Bill's line during the Suntory Whiskey shoot, "For relaxing times, make it Suntory time."

Kent Grosswiler *Serious Delirium* (page 46)
www.kentgrosswiler.com/paintings
Acrylic on 1/2-inch (13 mm) plywood cut to shape
I grew up with Bill Murray on *SNL*, and then watched his foray into movies. Over time, he's continued to become more randomly and eccentrically hilarious in a way that seriously delights my sensibilities. Leading up to painting this piece and while painting it, I watched this clip a few times daily. And even now, I still watch it from time to time.

Frank Harmon *The Tao of Murray* (pages 44–45)
Digital
www.warp-spasm.com
I thought it would be more fun to paint Murray and reference every movie I have ever seen (at that point in time) with him in it. I've also included the "B" sides like *The Razor's Edge*, *Larger Than Life*, and there is even a reference to Bill's lyrical ballad of "Star Wars" in there.

Holly Highfield *Natural Habitat* (page 127)
www.hollyhighfield.com
I wanted to create a surreal environment for Bill featuring the "florescent snapper" and *Life Aquatic*. However, I wanted this piece to be more of a formal portrait, so I made the background to be almost like wallpaper behind him. I love the bizarre combination of his distant gaze, a formal portrait composition, and that psychedelic background.

Pete Hurdle *Murray Monroe* (page 161); *Bobin* (page 162); and *Superbill* (page 162)
www.dphurdle.com
Pete is a graphic artist from Charlotte, North Carolina. He specializes in digital art and design, and takes inspiration from pop culture of yesteryear. He mostly enjoys spending time with his wife and their wonderful cat. His favorite Bill Murray roles are from *The Life Aquatic with Steve Zissou*, *Rushmore*, *Ed Wood*, *Scrooged*, and *Wild Things*.

Andrea Hooge *Where the Bill Murray Roam* (page 59)
Oil
www.andreahooge.com
Instagram: @andreahooge
I painted this piece using oils, and used a reference photo of an older version of Bill Murray to age him more than he appeared in the film *Where the Buffalo Roam*. I greatly enjoy painting faces and find that as subjects age, they gain more interesting and detailed features. This piece was originally shown and sold at a Bill Murray–themed art show titled *Bill You Murray Me*, which took place in Vancouver, British Columbia.

Gulendam Ece Hurmeydan *Bill's Blue* (page 136)
Acrylic paint on a wood panel
I am a big fan of Bill Murray. I think he is a great actor, and I have watched most of his movies. He has played so many different characters and used a variety of different accessories to be in those characters. But his eyes. . .they are always warm, peaceful and deep, which, I believe, reflects his real personality. That's why I chose three photos from different times to show that Bill's eyes have always had that same unforgettable feel.

Yhali Ilan *Staring Out at Sea* (page 144)

Kristy Brucle Jach *Obey Murray* (page 160)
www.speakeasyart.com
Obey Murray is a digital illustration transferred to a silkscreen and printed on paper.

Aaron Johnson *So I Got That Going for Me* (page 28)
Acrylic on canvas
ajohnsonart.com

Vincent Keeling *Bill Murray* (page 84)
Oil on linen
20 x 16 inches (51 x 41 cm)
www.vincentkeeling.com
Email: vincentkeeling@gmail.com
Facebook: @VincentKeelingArt/
Instagram: @vincentkeeling_artist
The inspiration for this painting relates to Bill's soulful side, especially those times when he humbly admits to struggling with staying on track, being present in himself and the moment, and living up to his potential. With this in mind, I've heard him mention a few times that a running joke between himself and his brother is the oft cited phrase, "this is not a dress rehearsal, this is your life."

Sayuri Kimbell *Bolder than Bill* (page 155)
Digital illustration
www.jsayuri.com
Instagram: @spooky_slime_smile
Sayuri is inspired by rock-album artwork, and the way that art reacts to art reacts to art.

Michael Koelsch* *St. Vincent* (pages 164–165)
Mixed media with acrylic, pencil, gold leaf, and varnish
www.sporkunltd.com
*recipient of the Award of Excellence from Communication Arts magazine "Illustration Annual"
I was inspired to do this personal piece after watching the movie *St. Vincent*. It took some time to really filter out everything and capture the character, but Bill Murray is an amazing actor and his expression was perfect for what I was trying to say for the concept. I based the overall idea from the fifteenth-century Byzantine painters, but tried to include elements from the movie that defined Bill's character. (St.) Vincent is one of my favorite characters of his because of his humor, subtlety, and complexity, and I tried to bring that into my painting as well. I get teary-eyed every time I watch the scene where the boy explains why he chose Vincent to be a modern-day saint. The world might be a little better if everyone could see past people's faults and how God made them be.

Kristen Kong *Out for a Ride* (page 40)
www.behance.net/kristenisabeliever
A Bill Murray portrait can be a blessing and a curse. For one reason, I personally value the blasphemous Bill, the adored Bill, the victim of circumstance Bill, and it's difficult to encompass all of that in a single piece. I had to ask myself what job he'd be the worst at. For one thing, he doesn't care about your immortal anything. For another, this is just a job, so maybe you shouldn't take it so seriously. *puff*

Karen Krajenbrink *I Feel Pretty* (page 90)
Instagram: @karenkrajenbrink
I had to marinate about sketching Bill Murray for days, but the clincher was listening to a sound bite of him talking about West Side Story. He spoke specifically of singing "I Feel Pretty" and the absurdity of the statement. Then and there, I knew I had exactly what I was looking for!

Jess Kristin *Suntory Smile* (page 93)
Oil on wood
Knowing that I was going to do a series of Bill Murray, and knowing also that Murray has such a unique way of expressing characters through subtle facial positions, I wanted to pick images that I felt embodied the person he was representing—the essence expression of that character. I make it a point to exaggerate colors in my work to accentuate how I see the world with the rainbow of colors in every shadow or highlight, and it is symbolic in this piece because of the colorful characters he creates in each and every film.

Tabitha Lahr *Bill Murray* (page 126)
Acrylic gouache
www.tabithalahrdesign.com
Instagram: @stabithal
Bill Murray is one of a kind. His laid-back personality reminds me of the octopus, which traditionally symbolizes grace and flexibility. The octopus can also be hypnotic when you sit and watch them in the water. I used acrylic gouache on this piece, which is my preferred medium because of the rich color tones and the chalky matte finish that conceals brushstrokes and prevents them from interrupting your piece.

Harrison Larsen *Golf Clap* (page 129)

Chad Lonius *St. Vincent* (page 138)
Adobe Illustrator and Photoshop and a digital drawing pad
chadlonius.com
My inspiration for this piece was the movie *St. Vincent*. The character Bill Murray portrayed was much more of a hard-edged character than I was used to seeing Bill play. Vincent was a raunchy, rude, profane, and "get off my lawn, you damn kids!" type of character that you despise at first, but who eventually grows on you as you get to know him. One of Bill's finest roles in my humble opinion.

Robert Magliari *Just Bill* (page 82)
Adobe Illustrator and Photoshop
www.robertmag.com
www.behance.net/robertmag
www.facebook.com/robert.mag1
Like many, I have always been huge fan of Bill Murray. Aside from his sense of humor, I've always admired (and being a bit of an introvert, envied) his totally chill attitude in any situation. It's almost like he is in on a secret that no one else is privy too, and I tried to capture this in my illustration.

Wayne Maguire *OG Murray* (cover and page 134; original photograph by Gerhard Kassner/berlinale.de)
Pencil and Prismacolor pencils on paper
www.facebook.com/inkedikons
Instagram: @inkedikons
Murray is part of my OG (Original Gangster) Collection along with De Niro, Walken, Nicholson, and Eastwood, who are some of my favorite actors. The tattoos come from my series of work, *Inked Ikons*, where I add relevant tattoos to my favorite characters and actors.

Jason Matthews *Bill 1* (page 23); *Bill 2* (page 22); *Bill 3* (page 23); *Bill 4* (page 22)
www.studiotricktop.com
I think what attracted me to Bill Murray as a subject was that out of most celebrities, he's an everyman. He doesn't flaunt, or seek out, fame; he just likes to be himself. It's a unique, humbling characteristic to find, especially with celebrities. It also helps that he has acted in some of my favorite movies . . . so, I started off with imagining what other roles he could play. Murray on the bridge of a starship? As a mutant superhero? As Scarlett O'Hara in Gone with the Wind? Why not!

Justin McAllister *Holiday Bill* (page 60); *Murray Mosaic* (page 92); and *AmalgaMurray Junk Drawer Scavenger Hunt* (page 138)
Sharpie markers
Email: autopenjmc@gmail.com
www.facebook.com/Justinian.McAllister
Instagram: @justinmcallistersharpieartist
My mother, Dawn McAllister, had me drawing while I was still in a high chair. She has often told me over the years (sometimes tearfully) that I was going to be an artist and that it would be a really hard road. I met my wife and moved from the United States to Germany, thanks to my work (I love you, Melanie). I came to my style through trial and error, always wanting to use an artistic tool that was not so normal. All of my drawings are done 100 percent with Sharpie markers, primarily in a pointillist style. Various employees at Sharpie have sent me thousands of markers over the years to continue what I do. I have sold over 500 drawings in the last 8 years, including at least 15 to actor Zac Efron. I prefer to be prolific more than any other type of businessman. I've been fortunate to meet the members of three-time Stanley Cup Champions the Chicago Blackhawks and Rock and Roll Hall of Famer Chuck D of Public Enemy thanks to my artwork. I have drawn Bill Murray for over three months of my life, and I am inspired by an uncontrollable addiction to put my heart out there on as many walls as possible.

Warren McCabe-Smith *A Spit of Bill Murray* (page 18); *Mosaic Murray* (page 81)
Acrylics and ink
www.wozarts.com
Facebook/Twitter: @wozartuk
Instagram: @wozarts
In November 2015, I had a large exhibition of work based around folks with mustaches to raise money for cancer research. The likes of Salvador Dalí, Burt Reynolds, Tom Selleck, Frida Kahlo, Frank Zappa, Hercule Poirot, Ron Burgundy, and Albert Einstein were all a part of the show, but there was someone missing. Then it hit me like I had been slimed; I needed to paint Bill "Frickin" Murray with a mustache!

Max McCartney *Coffee Bill* (page 24)
Photoshop, needle, and ink
Instagram: @maxamos
The inspiration for the portraits came from my customers, a brother and sister from England who grew up watching Bill Murray films. Who better to bring people together than Bill? We used Bill's character from my personal favorite movie, *Coffee and Cigarettes*. Bill is WU!

Jessa McClintick *Bill Murray* (page 87)

Sonia McNally *The Murray* (page 61)
www.soniamcnally.com
Bill has given me so many gifts. Laughter is supreme, and expression is crucial. I wanted to show my appreciation through one of my topographical portraits: Eat, Drink, and Be Murray.

Armando Mesías *Ghostbusters* (page 83)
Digital
www.armandomesias.com
Instagram: @armandomesias
The piece is digital, but it has a kind of signature technique I use that emulates traditional media painting. I've always been a huge fan of Bill Murray and particularly *Ghostbusters* (aren't we all?), and did the piece as part of an ongoing series of '80s characters. I keep coming back to all this '80s memorabilia and sort of personal library to rediscover most of it as a grown man. The gag about the dickless guy I always found it to be a bit off-tone, and that's probably why I remember it most. It's a way to reconcile memory within my own practice, while having some fun.

Ken Meyer Jr. *Funnyman* (page 16)
www.kenmeyerjr.com
www.storenvy.com/stores/1107543-art-of-ken-meyer-jr
There is a loose-knit exhibition on the ol' internets called Inktober, in which artists create new ink drawings (in my case, paintings) done in ink, post it, hashtag it, the whole spiel. At some point during this month, I saw a great photo of Bill and the "sad clown" motif popped into my mind, and, well, there ya go!

Angela Meyers *Bill in Profile* (page 118) and *Murray Dreaming* (page 128)
Charcoal
Instagram: @beatnikki66
My pieces are charcoal, which is my favorite medium. I chose to portray Bill in a way that was not whimsical as he is generally portrayed.

Giacomo Agnello Modica *Bill Murray* (page 125)
Pencil and digital coloring
My Murray piece is part of a collection of portraits that I made as final project at Mimaster (master in editorial illustration) in Milan. It's an ABC book called *In Alphabetical Order*. Every letter in the book represents a movie. Inspired by Bill and his performance in *Lost in Translation*, I chose "N is for Neon Nights."

Lori Paine *A Bicycle Built for Two* (page 25); *Bill Murray* (page 63)
Mixed media
voilaartstudio.com
I know Bill Murray likes to play golf. When deciding what to paint, I began to imagine what would have happened if the gophers were still giving Bill trouble after all these years? Would he find himself living in a perpetual *Caddyshack* movie? I realized that Bill's character, Phil Connors, was stuck reliving Groundhog Day over and over, and Punxsutawney Phil was only able to get out once a year. I thought, what if they struck a deal? If Phil Connors was able to help Punxsutawney Phil escape by making a promise that he would take him wherever he went for the rest of his life? Would they both escape Groundhog Day? And if so, what would Phil's life look like today? I've always loved the persona that Bill Murray created for all of us to enjoy. In deciding to paint his portraits, I have taken a renewed interest in Bill's real life. I don't know him personally, but I think he has a kind heart. I remember seeing candid clips of him walking down the streets of NYC raising money and awareness for the people of Puerto Rico after Hurricane Maria. And he loves his Cubs baseball!

Patrushka *The Three of Clubs* (page 166)
Ink, graphite, and watercolor
patrushka.net

Tracy Piper *Bill Murray Can Have This Painting* (page 122)
Acrylic on canvas
30 x 40 inches (76 x 102 cm)
www.thetracypiper.com
Instagram: @thetracypiper
This piece was inspired by the "Bill Murray Can Crash Here" tour around America. I just imagined him showing up and donning a birthday party hat as he patiently waited to karaoke. I invited him to come take the painting on Twitter, but alas, it got snatched up by a collector before he had a chance to claim it. If he's reading this, he can email me and I'll make one special just for him.

Tony Pro *Crying on the Inside* (page 27)
Oil
profineart.com
I was inspired after seeing a Bill Murray bumper sticker on a car one day. I thought it would be great to have Bill as a clown like Rigoletto and smoking a cigarette.

Andrew Rehs *Stevesy* (page 156)
Ink and acrylic on reclaimed barn lumber
42 x 24 inches (107 x 61 cm)
All of my pieces are created using reclaimed material with a history. From your family's porch to Chicago apartment support beams, each piece of wood has a story and a reason to be in the piece. Due to Zissou's excursions at sea, this piece was made with waterlogged Illinois barn lumber to represent the aged and tireless journey to defeat the mythical jaguar shark.

Aaron Reichert *Too Little* (page 120)
www.aaronreichert.com
Acrylic on canvas
48 x 24 inches (122 x 61 cm)

Eddie Rifkind *Murray's Yearning* (page 42)
eddierifkind.com
Instagram: @eddierifkind
I glazed the living crap out of a wooden panel with acrylic transparent as the medium and dozens of layers in a fast, but oil-like, glazing process. In the spirit of the quick, permanent mark, I also used colored pencil and ink in these layers. I started the whole thing as an abstract expression in paint, and slowly used the layers to grow it into the Bill we all love. A little blue perhaps, but still Bill.

Mike Robinson (aka "trapjaw design") *Bill Murray* (page 80)
Photoshop with a Wacom Cintiq tablet
www.mikerobinsonart.com
To begin, I started with a very loose sketch to capture Bill's unique personality, not just with his likeness, but in his expression as well. Next, I started laying in values in gray scale to build form. I find it easier to get the form worked out before adding color. I then began adding color layers on top of the gray-scale image. Once I was happy with the general color of the piece, I started painting opaquely on top until it was finished. I created a lot of custom brushes to mimic the look of traditional paint mediums. I always try to stay loose and free with my brushstrokes to give a sense of fluidity and energy. I'm happy with how the final piece turned out, and I'm a huge fan of Bill, so this was a ton of fun to work on.

Joshua Roman *Steve Zissou* (page 139)
Marker on paper
www.joshuaromanart.com
Instagram: @joshuaromanart
This is the third Bill Murray piece I've done, which is more than any other celebrity, and my inspiration was Steve Zissou from *The Life Aquatic* with Steve Zissou. If you want to see the piece "move," check out the video at www.youtube.com/watch?v=Xv8nQiOZ7wk. Watch it for thirty seconds and then look back at the art!

Jolene Russell *I Dream of Murray* (page 31)
Acrylic, oil, and spray paint
www.jolenerussell.com
This artwork is giant (5 x 6 feet, or 1.5 x 1.8 cm), so I used an unstretched canvas for ease of transport. I also used a grid system to sketch out Murray's face first, and while I was painting, the canvas either needed to be laid out on my floor or tacked to the wall. Murray is painted solely with the acrylic paint, and I layered oil over acrylic to create the flowers around him.

Joshua Ryals *Bill Murray Tobacco Card* (page 160)
My tiny watercolor painting was inspired by the Chicago Cubs finally winning the World Series with Bill there watching it happen. The look of the portrait was inspired by the famous Honus Wagner tobacco card of 1909. The original is, I hope, in Bill's possession. I mailed it to him care of his minor-league ball club with the inscription "Thank you for going to work all these years."

Stephen Schisler *Bill-M* (page 104)
stephenschisler.carbonmade.com
This painting was actually a challenge submitted to me by an old friend who was entertained by the randomness of my paintings. As a joke, she instructed me to juxtapose Bill Murray, Nyan Cat, and a martial arts battle atop the Nyan Rainbow. She was kidding, of course, but then I painted it anyway. It has since become one of my favorite paintings.

Thorsten Schmitt *Shine a Light* (page 38); *Zissou* (page 56)
Digital painting
www.thorstenschmittdesign.com
Facebook: @thorstenschmittdesign
I'm a big fan of Murray's movies, and I'm also always entertained by all the myths and stories surrounding him.

Martin Segobia *Master Murray* (page 154)
Acrylic on canvas
martinsegobia.com
Instagram @martinsegobia
I just liked the idea of Bill Murray casting for the original Star Wars movies. I think he would have made a much more interesting Yoda, and would have brought the franchise out of obscurity. The piece was made on a canvas with acrylic paint, using regular painting brushes, a dirty sponge, and an old toothbrush.

Todd Slater *Zissou* (page 140); *Raleigh* (page 140); and *Rushmore* (page 141)
www.toddslater.net
What I really appreciate about Wes Anderson is that every frame and every still image is considered and thoughtful. As a visual artist, I can think of nothing more inspiring than this approach to art and craft. For me, Bill Murray is at his best when paired with Wes Anderson. It is Murray's deadpan delivery that acts as the perfect complement to the tone and dialogue of Anderson's films.

Peter Slattery *Bill Murray* (page 106)
Digital
www.peterslatteryillustration.com
Instagram: @peteslattery
Rushmore has always been one of my favorite films. The school in the movie always reminded me of a cartoonish version of my own school, so I guess that's why the film spoke to me so much. And Max and Herman are brilliant comedy characters. I love how Bill Murray portrays the defeated Herman Blume, and that scene in the elevator is one of my favorite parts. That's why I chose that image for the piece. It's just a portrait of a character at his lowest. I do most of my painting digitally now. While I do like to paint in watercolor, I'm a little bit impatient and clumsy! So digital painting frees me up to make as many mistakes as I can, while still being able to achieve what I set out to do.

Kristin Smith *Seedy Bill Murray* (page 69)
Seeds & grains (including oat seeds, brown lentils, black lentils, green lentils, rye, pearled barley, sorghum, wild rice, and millet) with acrylic paint on canvas board.
Facebook & Instagram @kristinsmithcreative

Todd Spence *Is It 5:00 Yet?* (page 89)

Andy Stattmiller *Steve Zissou* (page 21); *Groundhog Day* (page 108)
Acrylic on illustration board
www.astattmiller.com
Instagram: @astatt
The Bill Murray pieces started as a series of drawings I was posting on Instagram just for fun. I had been doing ink drawings in my own sketchbook of Bill from each of his movies. When I saw there was a Bill Murray art show at Public Works, I decided I wanted to paint one of those sketchbook drawings. I picked *Groundhog Day* because I love that movie, and I felt it doesn't get much love in the art world compared to *Ghostbusters* and other films. For the *Life Aquatic* piece, I just liked the drawing and wanted to paint it!

Johann Strauss *Thanks for the Memories* (page 19)
http://www.strauss-art.com
Since I'm a commercial illustrator, I mainly work on other people's ideas, but I find it very important to do something I really want to draw for myself every now and then. The Bill Murray—*Thanks for the Memories*—is one of those pieces. Just a piece of artwork that I genuinely *wanted* to do. Something fun and not constrained by a brief...kinda like how I imagine Bill approaches his roles.

Anna Tombácz *Bill-M* (pages 94–95)
Sharpie on matte coated paper
The original, handwritten piece contains more than 180 quotes by every single one of Bill Murray's film and TV characters from the very beginning of his career—from *SNL* as Howard Cosell to the movie *St. Vincent* (his latest then). It took five days to create, but it probably could've been made in less than two if I weren't watching Bill Murray movies while writing the portrait—17.5 movies to be exact.

Luis Tinoco *Bill Murray* (page 122)
Oil on gessoed wood panel
www.grimhearts1985.com/album/portraits-studies/
I was inspired by *Broken Flowers* for this piece, and the painting was executed using the grisaille method to start. The borders on the original piece are also gilded in 23k gold leaf. You can see the step-by-step method of how I painted it here: www.grimhearts1985.com/bill-murray-step-by-step.

Geoff Trapp (aka "Mr. Trapp") *Rushmore* (page 137)
www.geofftrappdidit.com
Instagram: @geoff_trapp_did_it

Post Typography *Groundhog Day* (page 107)

Dana Vermette *King of Comedy* (page 152)
Acrylic on canvas
danavermette.com
Instagram: @eevee_maria
I decided to do a portrait showcasing Bill's quirky personality. The idea of the King of Comedy was a take on old portraits of royalty that were generally very serious, but of course, it would all be a big joke for Bill.

Dylan Vermeul *Stretch* (page 88)
www.dylanvermeul.com
Instagram: @dylanvermeul

Shane Waller *Caffeine Delirium* (page 26)
Oil on a cigar box
cargocollective.com/shanewaller
When I was considering an image and a character to portray Murray, there were two that I knew I would choose between. His greenskeeper role from *Caddyshack* and his great cameo scene in *Coffee and Cigarettes* (a Jim Jarmusch film). In the scene are Wu-Tang Clan members RZA and GZA, having tea instead of coffee, and RZA is teaching GZA about the dangers of caffeine. Out of nowhere comes Bill Murray, wearing a diner worker's attire, chef's hat and all, and he is holding an entire pot of coffee that he seems to be drinking by himself. RZA and GZA are amazed that it's Bill Murray in the flesh and can't refrain from calling him by his full name, "Bill Murray." RZA instantly tells Bill Murray about the dangers of caffeine, number one being caffeine delirium. Bill follows it up with a couple of giant gulps of the black coffee. For the piece, I decided on a mostly black-and-white image of him—to go with the black and white of the movie—but with little accents of lime green and red oils on top of a red cigar box. Bill has had an everlasting imprint on me through his characters. I recently saw him as Hunter S. Thompson in *Where the Buffalo Roam* and it's pure genius. Those two are a great combo, and I don't think anyone would have played him better than the man, the myth, Bill fuggan' Murray.

Emily Wood *The Sailor* (page 43)
Mixed media on wood
www.emilyhartwood.com
Instagram: @the_papermoon_studios
The Sailor was painted using acrylic and mixed media. Originally conceived for *The Mr. Bill Murray, A Tribute Show* at the R&R Gallery in Los Angeles in 2010, the work was also featured in a write-up by the Los Angeles Times about the art show. *The Sailor* was one of my all-time-favorite pieces to create. I was influenced by the fantastic Wes Anderson–style, particularly in *The Life Aquatic with Steve Zissou* and there are a couple of nods to *What About Bob?*, as well, in the painting.

What resonates the most for me about Bill is his playful and endearing spirit, which is what I tried to capture in this piece. Thank you for the magic that you put out into the world, Mr. Bill Murray; it's incredible how much it has inspired!

Melissa Wood *Ecto Bill* (page 70); *The Jacqueline and Bill* (page 70); *Chrysler LeBaron with Wood Paneling and Bill* (page 71); *Bill's Golf Cart* (page 71)
www.mwoodpen.com
Twitter/Instagram: @mwoodpen
A prolific illustrator and a fiendish fan of vintage modes of transport, Melissa Wood leaped at the chance to time-stamp Bill Murray and his iconic film vehicles with her pen and ink . . . though she admits it was almost more fun to draw the assemblage of wacky garb donned by Bill in each movie, a perfect complement to his unforgettable film roles!

PHOTO CREDITS

Page 10 *Meatballs* Courtesy Everett Collection

Page 12 *Where the Buffalo Roam* © Universal/Courtesy Everett Collection

Page 14 *Stripes* © Columbia Pictures/Courtesy Everett Collection

Page 32 *Caddyshack* © Orion Pictures Corp/Courtesy Everett Collection

Page 34 *Tootsie* © Columbia Pictures/Courtesy Everett Collection

Page 36 *The Razor's Edge* © Columbia Pictures/Courtesy Everett Collection

Page 50 *Ghostbusters* © Columbia Pictures/Courtesy Everett Collection

Page 52 *Scrooged* © Paramount/Courtesy Everett Collection

Page 54 *Quick Change* © Warner Bros/Courtesy Everett Collection

Page 72 *What About Bob?* © Buena Vista Pictures/Courtesy Everett Collection

Page 74 *Groundhog Day* © Columbia Pictures/Courtesy Everett Collection

Page 76 *Kingpin* © MGM/Courtesy Everett Collection

Page 96 *Rushmore* © Buena Vista Pictures/Courtesy Everett Collection

Page 98 *Hamlet* © Miramax/Courtesy Everett Collection

Page 100 *The Royal Tenenbaums* © Buena Vista Pictures/Courtesy Everett Collection

Page 102 *Lost in Translation* © Focus Films/Courtesy Everett Collection

Page 112 *The Life Aquatic with Steve Zissou* © Touchstone Pictures/Courtesy Everett Collection

Page 114 *Broken Flowers* © Focus Films/Courtesy Everett Collection

Page 116 *Zombieland* © Columbia Pictures/Courtesy Everett Collection

Page 130 *Hyde Park on Hudson* © Focus Features/Courtesy Everett Collection

Page 132 *Moonrise Kingdom* © Focus Features/Courtesy Everett Collection

Page 146 *St. Vincent* © Weinstein Company/Courtesy Everett Collection

Page 148 *Rock the Kasbah* Courtesy Everett Collection

Page 150 *The Jungle Book* © Walt Disney Co./Courtesy Everett Collection